MARY CASSATT

Mary Cassatt

NANCY MOWLL MATHEWS

Harry N. Abrams, Inc., Publishers, New York
IN ASSOCIATION WITH
The National Museum of American Art, Smithsonian Institution

EDITORIAL NOTE. The source of most of the quoted passages in this book is *Cassatt and Her Circle: Selected Letters*, edited by Nancy Mowll Mathews (New York, 1984). The sources of other quoted passages are included in the Bibliography (p. 154) under the name of the author quoted, with a reference to the relevant page in the original source. Two exceptions are G.-Albert Aurier (see under Chipp, Herschel) and Diego Martelli (see under Nochlin, Linda).

Series Director: Margaret L. Kaplan
Editor: Ruth Eisenstein
Designer: Michael Hentges
Photo Research: Barbara Lyons

Library of Congress Cataloging-in-Publication Data

Mathews, Nancy Mowll.
 Mary Cassatt.
 (The Library of American art)
 Bibliography: p. 154
 Includes index.
 1. Cassatt, Mary, 1844–1926—Criticism and
interpretation. 2. Artists—United States—
Biography. 3. Artists, Expatriate—France—Biography.
I. Cassatt, Mary, 1844–1926. II. Title. III. Series:
Library of American art (Harry N. Abrams, Inc.)
N6537.C35M3 1987 760'.092'4 86–17224
ISBN 0–8109–0793–3

Frontispiece:
Lydia Leaning on Her Arms, Seated in a Loge, fig. 36

Published in 1987 by Harry N. Abrams, Incorporated, New York

Times Mirror Books

Printed and bound in Japan

Contents

Preface

As one of the country's greatest artists Mary Cassatt has entered the ranks of American heroes. Examining the steps Cassatt took to shape her art and ideas, we see an individual always rising to meet new challenges, and we see within her the rare original ingredient that enabled her to leave a legacy that transcends the particularities of her time and speaks quietly but effectively to our own. This monograph offers a mere introduction to the woman and her accomplishments; much biographical information has of necessity been skimmed over in favor of setting forth the major artistic episodes of the artist's long life.

In her art, Cassatt's interest in progressive ideas led her to explore what are still considered "modern" concerns. She dissected and interpreted modern society and endeavored to capture, in her mother and child paintings, a profound modern spirituality. In so doing, she risked offending traditional sensibilities and willingly forsook the safety of academic success to inhabit the marginal world of the avant-garde. In addition, she confronted other concerns of her day: the reconciliation of modernist and old master, of Western and non-Western; the definition of beauty in modern times; and the nurturing of artistic talent and taste in her homeland.

Imbued with a cosmopolitan outlook from childhood, Mary Cassatt was a lively person whose eloquence with words equaled her eloquence with the brush. She surrounded herself with men and women who, like her, looked beyond accepted truths, and as a consequence she entered the circles of the greatest artists and thinkers of two continents.

In carrying out my research, now in its fifteenth year, I have been greatly assisted by the basic work of cataloguing Cassatt's art done by the late Adelyn Breeskin, and I gratefully acknowledge my enormous debt to her. I am also indebted to many others, including Frederick Sweet, Nancy Hale, and Suzanne Lindsay, who have made invaluable contributions to Cassatt studies.

In order to define the sequence of the development of Cassatt's work I have carefully considered the chronology of all the examples illustrated and have in many cases found evidence that conflicts with hitherto accepted dates. Thus the dating of works in this book reflects my own research and thinking.

I take this opportunity to thank once again all the collectors of Cassatt, both public and private, who have generously allowed their works to be reproduced in this volume. My appreciation also goes to the staff at Abrams, who have contributed so much to the final product, most particularly to Ruth Eisenstein. Many

1 Two Women Throwing Flowers During Carnival

1872. Oil on canvas, 21½ × 25″ (sight)
Collection Mrs. James J. O. Anderson, Baltimore

Although this work was at one time thought to have been painted in Spain, it conforms to Cassatt's Parma style and subjects and to the description of the canvas she sent to the Salon of 1872 from that city, which brought her back into the European limelight after the two years spent in America following the outbreak of the Franco-Prussian War.

others have aided this study in various ways, both academic and material; among them I should like to acknowledge especially Ingrid Montecino and Cathy Hemming. Finally, I should like to credit my mother institutions, Randolph-Macon Woman's College and Williams College, under whose protective wings this work was accomplished.

NANCY MOWLL MATHEWS

*Randolph-Macon Woman's College
Lynchburg, Virginia*

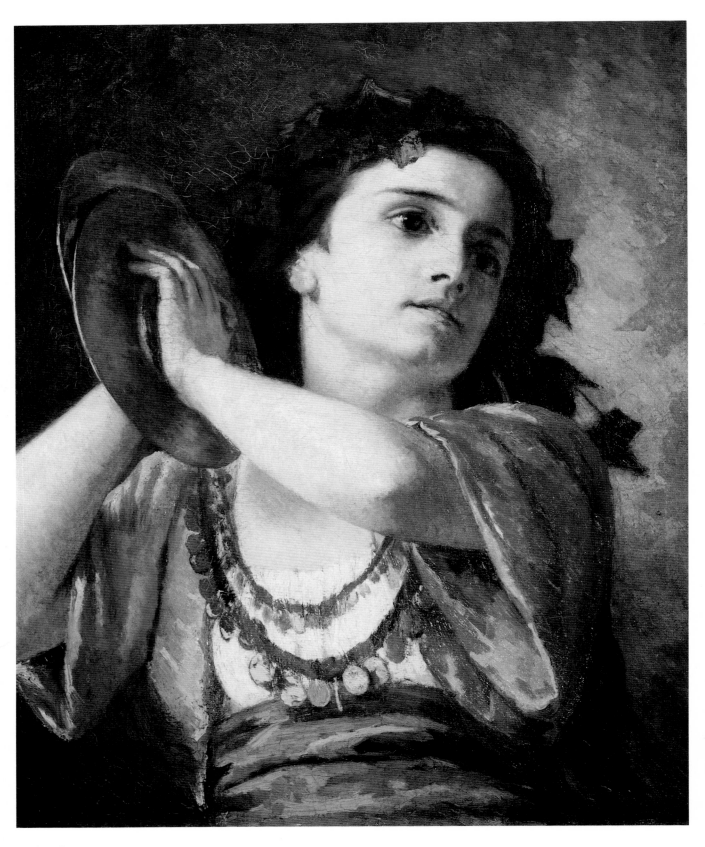

2 *Bacchante*

I. The Early Period (1860–1876)

MARY CASSATT was from her youth a free-spirited, restless, and determined person with a clear goal—to become a great artist. While her entire career reflects these traits, it is in the earliest period that they proved most decisive. As a student she tended to be impatient with the conventional teaching and accepted styles she encountered in Philadelphia and Paris. While she availed herself of the opportunities for study that were at hand, she formed her own opinions and kept an eye out for fresh opportunities, and in her work she was always receptive to a new approach. This made her stand out among her contemporaries and brought her early success, but as time went on it also brought her opposition and a struggle for recognition in the face of the powerful Paris art establishment of the 1860s and 1870s.

Born in 1844, Mary Stevenson Cassatt was fortunate in having parents who sought to provide their children with the best of cultural and educational experiences. Robert Simpson Cassatt and Katherine Johnston Cassatt belonged to the upper circles of Pittsburgh society. He was an investment banker and the mayor of suburban Allegheny City; she was an educated and well-traveled member of an old Scotch-Irish family in Western Pennsylvania. Eschewing the more superficial pursuits of their social milieu, they chose instead a life of travel, learning, and wholesome country pleasures.

In 1851 they left with their five children for an extended sojourn in Europe intended primarily to enable their son Alexander (the eldest of the children) to begin his education for an engineering career. They stayed first in Paris and then moved on to Germany, settling in Darmstadt, where Aleck attended an outstanding technical school. Meanwhile the other children also benefited from European schooling and the cultural advantages of their European homes, among them the early mastery of several languages.

Although Mary was only a child (aged seven to eleven) during this trip, she seems to have been deeply affected by it, and within eleven years she would be back in Europe for her second extended stay. Like James McNeill Whistler, John Singer Sargent, and other Americans who lived abroad as children, she early developed a taste for the expatriate life.

The Cassatts were in Paris during the 1855 Exposition Universelle; in the Salon of that year, which was part of the Exposition, both Delacroix and Ingres were featured. They were still in Paris when, six weeks after the fair, Courbet held his one-man exhibition in the Pavillon du Réalisme that he erected as a pro-

2 *Bacchante*

1872. Oil on canvas, 23⅞ × 19⅞"
The Pennsylvania Academy of the Fine Arts,
Philadelphia. Gift of John F. Lewis

Cassatt chose for this painting a model who had "a splendid head like a Roman." In Parma, surrounded by Correggios and works by other masters of the sixteenth and seventeenth centuries, Cassatt was inspired to use classical motifs for the first and only time in her career.

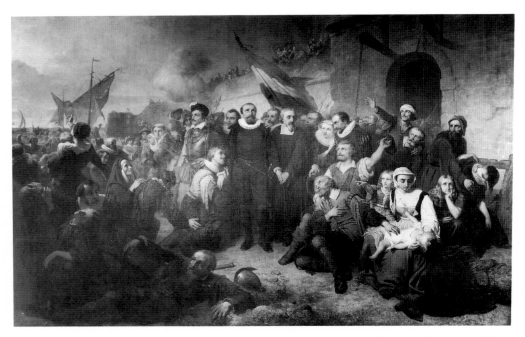

3 Johann B. Wittkamp. *The Deliverance of Leyden from the Siege by the Spaniards under Valdez in 1574*

1848. Oil on canvas, 14′1¼″ × 21′7⅞″
Rijksuniversiteit, Leiden, The Netherlands.
Courtesy The Netherlands Office
for Fine Arts, The Hague

Wittkamp (1820–1885), a Dutch artist, was enjoying considerable success in Europe and America when the Pennsylvania Academy of the Fine Arts acquired this painting, in 1851. The Deliverance of Leyden *was often copied by Academy students in their efforts to master the range of emotional expressions and the painterly technique that Wittkamp was known for.*

test against the Salon. Exposure to these great figures may have had some effect on the eleven-year-old future artist, but more likely it was the excitement surrounding these artists that impressed her. Here was evidence that artists were central to the life and thought of their time: debates about style and art theory were engaging the greatest minds of the day. An intelligent, ambitious young girl could see art as worth devoting her life to.

Upon their return home, the family settled at first in the countryside near Lancaster, Pennsylvania, but soon began dividing their time between a new country house in West Chester and a house in Philadelphia. While it was not Paris, the Philadelphia Cassatt knew in her youth was the second-largest city in the United States and its oldest art center. In addition to numerous private collections, dealers, and auction houses, Cassatt could take advantage of the Pennsylvania Academy of the Fine Arts, which offered art instruction and exhibitions of contemporary and old master art, as well as an extensive permanent collection. Although later Cassatt was critical of it, the leadership of the Academy was unusually active and broadminded, bringing to its students the widest educational opportunities, ranging from lectures on anatomy by medical school professors to exhibitions of contemporary radical art such as the works of the British Pre-Raphaelite Brotherhood (1858). Moreover, the Academy freely acknowledged the limitations of serious study in the United States and encouraged the students to go on to advanced study abroad.

By the time she was fifteen, Mary Cassatt knew she wanted to be an artist. Earnestness emanates from the very way her name, "Miss Mary Stevenson Cassatt," is written in large letters at the top of the list of applicants for the Academy's class in drawing from the antique for Fall 1860. She was so eager to begin that she signed up at the first possible moment to register—in April, a full six months before the class started and a month before her sixteenth birthday, which would bring her to the Academy's minimum age.

Cassatt spent at least two years following the regular Academy program, drawing from casts, prints, and drawings as well as from life. According to her fellow student and best friend, Eliza Haldeman, Cassatt's strength was her grasp of the "ensemble" rather than the "minutia [sic]," her talent for shading rather than form. She was recognized early as one of the ablest in her class, but signs of impatience with the academic routine soon began to surface. Her mistrust of the academic approach to art through the mastery of detailed drawing went hand in hand with her impatience to begin painting, which, since the Academy did not officially sanction it for beginning students, she took up on her own. Without benefit of a painting master, she began to copy one of the heads in Wittkamp's *The Deliverance of Leyden from the Siege by the Spaniards under Valdez in 1574* (fig. 3), an enormous canvas that had recently been purchased by the Academy for its collection.

Her enthusiasm and high spirits during her days at the Academy involved Cassatt in the social doings as well. The students, mostly from prominent families in Philadelphia and the surrounding areas, had similar cultivated backgrounds, and there was a great deal of camaraderie among them. Together they went to concerts and plays and haunted the art galleries and collections of the city. An early photograph gives us a glimpse of the mixture of art and socializing that went on in the Academy's galleries (fig. 4). When one of the young women brought a friend to the Academy to make a plaster cast of his hand, though she "did not know the first thing about casting," the others came to her rescue, and the young man's "experience of Artist life was so pleasant" that he asked their permission to have a photographer called in to immortalize it.

Cassatt happened to embark on the pursuit of an artistic career at a particularly propitious time. Although women still faced tremendous obstacles in becoming professional artists, the generation entering art school in 1860 benefited from the breakthroughs made by the pioneering women of the 1840s and 1850s. In the United States women had recently been accepted in academies both as students and as professional artists. There were American women on the international art scene as well: at mid-century a group of American women sculptors—later dubbed by Henry James "a white, marmorean flock"—had settled in Rome. These professional women were seen by many as heroic figures, their lives an example for the whole of society. In his novel of artistic life in Rome, *The Marble Faun*, published in 1860, Nathaniel Hawthorne wrote:

The customs of artist life bestow such liberty upon the sex, which is elsewhere restricted within so much narrower limits; and it's perhaps an indication that, wherever we admit women to a wider scope of pursuits and professions, we must also remove the shackles of our present conventional rules, which would then become an insufferable restraint on either maid or wife.

A year earlier, in 1859, a book of a different character had endorsed the efforts of women artists. Elizabeth Ellet's *Women Artists in All Ages and Countries*, an encyclopedic review of women artists past and present, offered the young artist the support of history. Thanks to encouragement like this in her youth, Cassatt

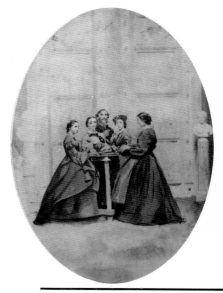

4 Photograph of Mary Cassatt, Eliza Haldeman, Inez Lewis, and Rebecca Welsh making a plaster cast of the hand of Dr. Edward A. Smith at the Pennsylvania Academy of the Fine Arts.

1862. Archives of the Pennsylvania Academy of the Fine Arts Philadelphia

Cassatt (right, holding plaster dish and spoon) and her friends—standing amid sculpture from the past (a replica of Ghiberti's Gates of Paradise *is behind them) and the present (Erastus Dow Palmer's* Spring *is to the side)—re-create with mock solemnity their own sculptural accomplishment: a plaster cast of the hand of a friend, Edward Smith (center).*

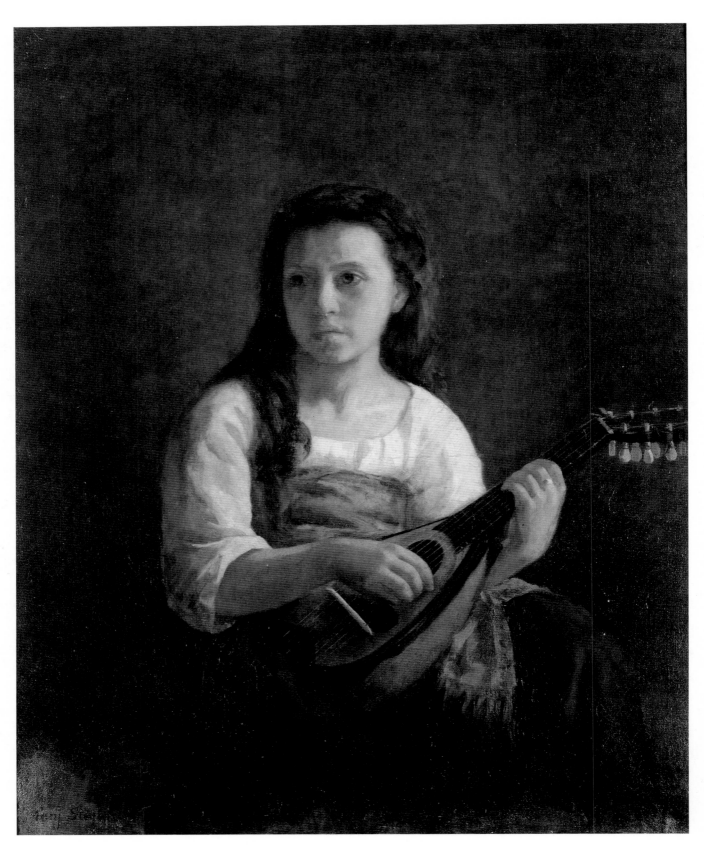

5 *A Mandolin Player*

would continue throughout her career to see herself as part of a great Western tradition rather than as an exception in a succession of great men.

The Pennsylvania Academy of the Fine Arts had begun by admitting women to selected classes; by Cassatt's time all but classes using nude models were open to women, and this restriction was lifted a few years later, in 1868. When Cassatt was a student, in the early 1860s, women constituted approximately 30 percent of the student body. Furthermore, such established masters in Philadelphia as Christian Schussele and Peter Frederick Rothermel accepted women as private students. The women students were conscious of the new social norms they represented in the artistic world and were proud to be in the pioneering tradition. Cassatt's friend Eliza Haldeman wrote indignantly to her father about a male student who questioned her ability: "Mr. Wharton came up and said 'I might as well try to cross Mount Blanc as to draw that head, it was one of the hardest ones in the Academy.' I had a mind to tell him that no less than three ladies had crossed it...."

Cassatt's ambition was rooted in a precocious understanding of the ways of the art world. She scoffed at the "amateurs" in the women's classes and saw herself becoming a true professional, making her living by her art. From the first she dreamed of showing at the important exhibitions, selling her work for high prices, and taking her place among the successful artists of her day.

At age nineteen, in a note to Eliza Haldeman informing her of an impending visit, she wrote:

If perfectly convenient to you I will burden the Pennsylvania R.C. with myself & two canvasses (two in case I should spoil one of them) likewise a carpet bag on Wednesday next. You see I am coming earlier than I expected because I want if possible to have my picture dry enough to be varnished before I send it to the "Cad." Now please dont let your ambition sleep but finish your portrait of Alice so that I may bring it to town with me & have it framed with mine sent to the Exhibition with mine hung side by side with mine be praised, criticised with mine & finally that some enthusiastic admirer of art and beauty may offer us a thousand dollars a piece for them.

This high-spirited optimism would not let her rest content with the training available in Philadelphia. It cannot have come as a surprise to her father that she was determined to spend three or four years abroad and to become a professional artist, since she had now been studying at the Academy and on her own for the past six years and was outspoken about her hopes and plans. Yet Mr. Cassatt's reaction—"I would almost rather see you dead"—was inexplicably vehement, and it is no wonder that Mary remembered it and years later reported it to her biographer Achille Segard. If not forgotten, this harsh statement of opposition was outweighed by the lively interest and genuine support that Cassatt as an artist received from both her parents throughout their lives.

Like a number of fellow art students from the Pennsylvania Academy, she sailed for Paris as soon as possible after the easing of restrictions at the end of the Civil War—probably late in 1865 or early in 1866. Cassatt and her friend Halde-

6 Carte-de-visite photograph of Mary Cassatt taken in Parma

1872
Archives of the Pennsylvania Academy of
the Fine Arts, Philadelphia

Cassatt enclosed this photograph in a letter to Emily Sartain just after Sartain had left Parma to begin studying in the Luminais studio in Paris. The inscription (in Italian) "to the distinguished painter Emily Sartain" is an affectionate reference to Sartain's desire to change from being an engraver to being a painter.

5 *A Mandolin Player*

1868. Oil on canvas, 36½ × 28¾"
Private collection

After a rejection in 1867, Cassatt saw her painting A Mandolin Player *accepted and well hung in the Paris Salon of 1868. The peasant subject was typical of the work of young American artists in the villages around Paris and along the coasts of Normandy and Brittany, but Cassatt's interest in capturing psychological mood rather than anecdotal detail caused her to stand out and brought her a measure of early recognition among her compatriots.*

man found that Paris placed more of an obstacle in the way of women than Philadelphia had, in that the official academy, the Ecole des Beaux-Arts, admitted only men. Cassatt must have felt some resentment at not being able to take classes there with her friends from the Pennsylvania Academy, Thomas Eakins and Howard Roberts. However, even in Paris women were not so easily turned away from art's door. They found alternative types of training—copying in the Louvre, attending classes exclusively for women, and taking private lessons with some of the masters who taught at the Ecole. Cassatt tried all these: she immediately took out her permit to copy at the Louvre; she spent some time in the women's art classes of Charles Chaplin, a popular French master; and she even managed private lessons with Jean-Léon Gérôme, a professor at the Ecole and the French artist most admired by Americans at the time. Thus Cassatt had other opportunities and made the most of them, but perhaps it was her exclusion from the Ecole that inspired in her an increasingly critical attitude toward official French art institutions.

The American art students in Paris were well aware of the radical shifts and changes occurring in the art world. While their attention was fixed on their own favorites rather than on the rebellious Manet and the future Impressionists, still it seemed clear to those in Cassatt's circle that, as one of them put it, "the French school is going through a phase. They are leaving the Academy style and each one seaking a new way consequently just now everything is Chaos. But I suppose in the end they will be better for the change."

The longer Cassatt was in Paris, the more convinced she became that the established art world and the Salon system were urgently in need of reform. In years to come she would join the forces working for change, but her first reaction was to decide that she could get along without Paris. In 1867, only a year after she had arrived in the art capital, she was willing to seek inspiration and instruction elsewhere, and during the next eight years of her European residence she would make only sporadic visits to Paris. With Eliza Haldeman she went to the countryside to sample the various art colonies within a day's journey of the city. First settling in Courances, near Barbizon, then going north to Ecouen and Villiers-le-Bel, she set out to master landscape and genre painting. Since both types of painting were immensely popular in the United States, the small colonies that specialized in them attracted a great number of American art students. Like their compatriots, Cassatt and Haldeman immersed themselves in French village life. They mixed with the village people and took rides into the countryside to hunt for paintable models and picturesque settings. They amused themselves and their families back home with the country ways they found themselves adopting. Writing to her sister, Haldeman gave this wry description of Courances and its challenges:

I have left Paris for a little while and am staying with Mary Cassatt for a companion in this little out of the way French village. . . . Everything is in the most primitive style. The bedroom we have is floored with red tiles, we have a fire place and a wood fire with the accompaniment of tongs shovel and bellows. We have also a bed warmer with a long handle which I need not

7 *Portrait of a Woman*

1872. Oil on canvas, 22⅛ × 18¼"
The Dayton Art Institute
Gift of Mr. Robert Badenhop

This painting was given by Cassatt to her friend and mentor in Parma, Carlo Raimondi. Director and professor of engraving at the School of Engraving of the Parma Academy, Raimondi was impressed with Cassatt's ability and intelligence and guided her through the art world and the social world of Parma.

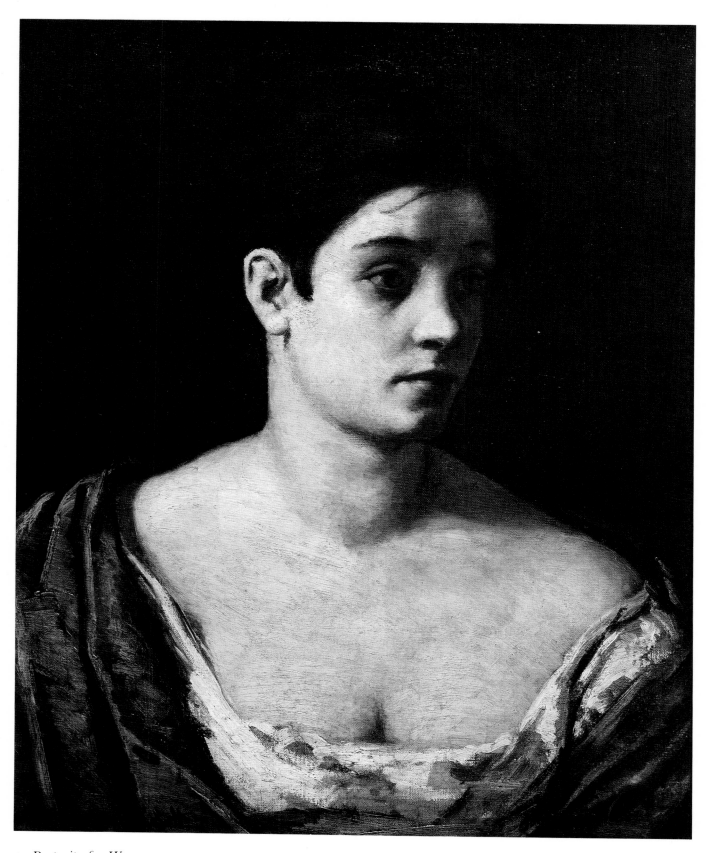

7 *Portrait of a Woman*

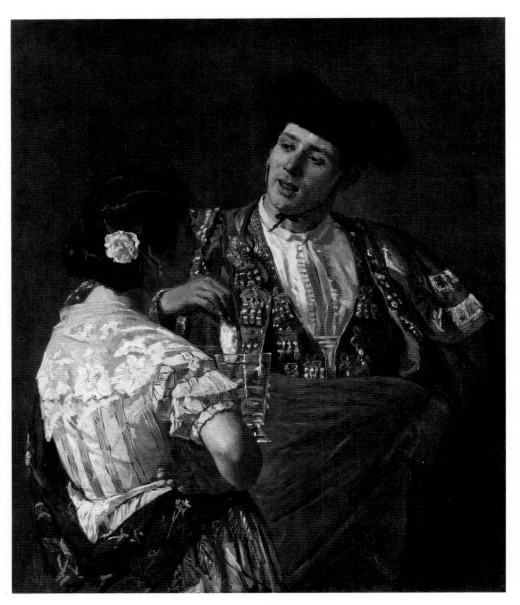

8 Torero and Young Girl

1873. Oil on canvas, 39⅝ × 33½″
Sterling and Francine Clark Art Institute
Williamstown, Massachusetts

When Cassatt was in Spain, she learned not only from the great Spanish masters of the past but also from the artists of her own day who had popularized Spanish subjects. Most prominent among these was the Scottish painter John "Spanish" Phillip (1817–1867), who, ten years earlier, had painted a well-known version of the theme of a young woman offering a traditional drink, the panal, *to a man dressed as a bullfighter.*

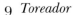

9 Toreador

1873. Oil on canvas, 32¼ × 25¼″
The Art Institute of Chicago
Bequest of Mrs. Sterling Morton

Cassatt had sketched from male models before, but she had apparently not included a male figure in any of her finished paintings until she painted the series of which this work is part, in Seville. Although overall the paintings were well received, she never again attempted a series of works based on a male subject.

tell you I make use of every evening much to Marys amusement. I believe she has written a description of my performance in that line to all her friends, and intends painting a picture of the same at some future date.

In Ecouen, Cassatt and Haldeman made the acquaintance of the two most famous genre painters of the day, Edouard Frère and Paul Soyer. These two artists worked in a style that appealed mainly because of its subject matter: peasant interiors and childhood scenes. They posed the local Ecouen people in picturesque tableaux and painted them with a fluid brushstroke.

In its peasant subject and creamy paint surface, Cassatt's first painting to achieve critical success, *A Mandolin Player* (fig. 5), echoes the Ecouen formula. For its mood, however, we must look to another source, the more dramatic style of Thomas Couture, who was ensconced nearby in Villiers-le-Bel. Couture had achieved fame in Paris for large allegorical paintings like *Romans of the Decadence*,

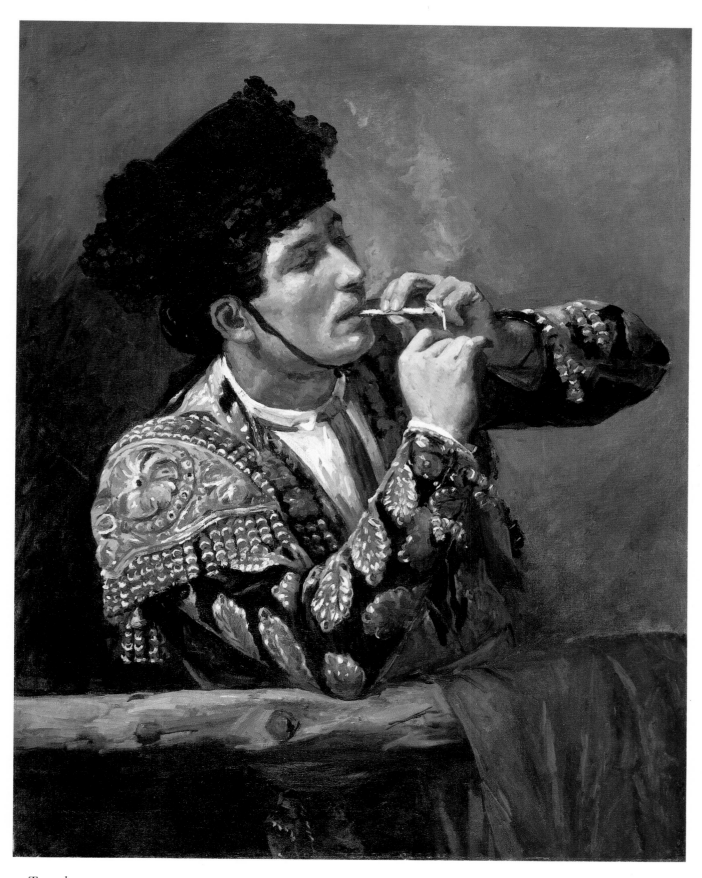

9 *Toreador*

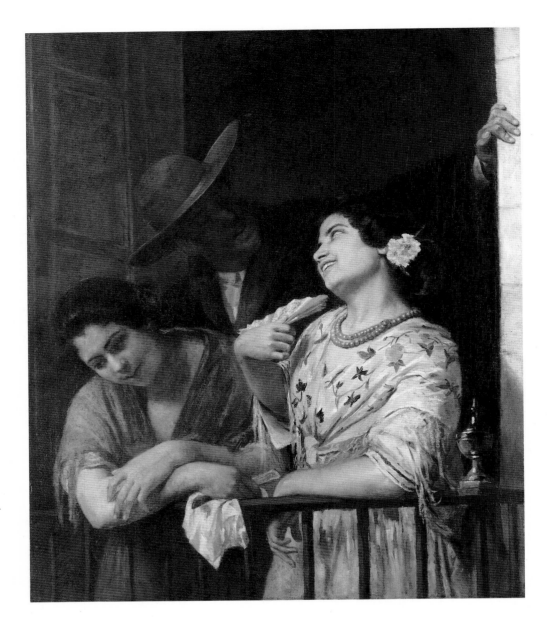

10 *On the Balcony*

1873. Oil on canvas, 39¾ × 32½"
Philadelphia Museum of Art
W.P. Wilstach Collection

*In this return to the balcony theme, paint-
ed a year after the Parma version (fig. 1),
the Spanish influence, particularly that of
Goya, is readily apparent. The foreshort-
ened heads were so difficult to pose, Cas-
satt wrote to her friend Sartain in Paris
that her model "asked me if the people who
pose for me live long."*

and his atelier had attracted a great many students. But becoming disenchanted
with the official art world, Couture exiled himself to the countryside, where he
continued to teach, and where Cassatt was one of his numerous American stu-
dents. In the next several years, she returned to his tutelage periodically, and
traces of Couture's spontaneous, anti-academic style can be seen in Cassatt's
painterly and romantic genre subjects.

If more documented works had survived from these years, we would have a
better picture of this stage of Cassatt's artistic development. What we do know is
that her zealous pursuit of art, coupled with the native strength of style that
emerges in her early works, caused her to be highly regarded among the Ameri-
can art students in Europe. The response of her teachers—as well as of others—
to her work was very encouraging. She saw two of her paintings accepted for the
Paris Salon, *A Mandolin Player* (fig. 5) in 1868 and, in 1870, a painting, now lost, of

18

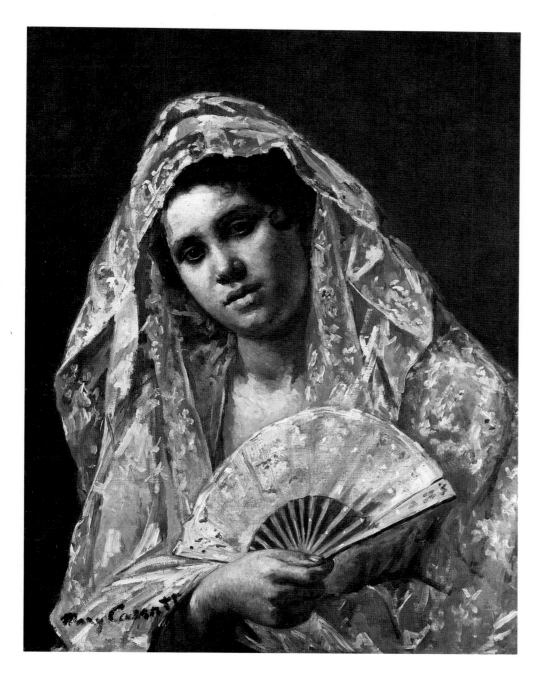

a *contadina* (peasant woman) of Fobello, a small town in the Piedmont region of Italy that she visited in 1869.

These successes persuaded Cassatt to stay in Europe longer than she had originally planned. In fact, she might never have returned to the United States if the Franco-Prussian War had not forced her, along with most of the Americans in Europe, to go home. She set sail in 1870, after having spent the summer in Rome. At first she lived with her parents in Philadelphia, but soon the entire Cassatt family followed Alexander to Altoona, the headquarters of the Pennsylvania Railroad, where he was a rising young superintendent. The contrast between Rome and Philadelphia was painful enough for the sophisticated young artist;

the move to Altoona was more than she could bear. She had just begun to tap the resources of Europe and felt that she might have a chance of becoming a good artist there. At home she met with continual frustration: difficulty in obtaining art supplies, scarcity of models, and lack of space for a real studio. But most of all she felt the absence of the great art, both old and new, whose inspiration and guidance she now fully appreciated.

Despite intense discouragement, Cassatt tried hard for the first year after her return from Europe to continue working. The story of the portrait of Mrs. Currey (fig. 13) demonstrates the problems she faced. She began it as a strong, idealized portrayal of the American black woman who served as a domestic in the Cassatt household; it was to be an American counterpart of her earlier paintings of French peasant workers. Her approach was to concentrate on her model's rich, exotic skin color and to use costume accents such as her turban to set it off. But the sittings stopped abruptly when Mrs. Currey left the family's employ to marry and moved back to Philadelphia. This loss of a subject added insult to injury, since Cassatt had begun the painting over an abandoned sketch of her father (seen upside down in fig. 13), who, she complained, was a failure as a model because he kept falling asleep!

The model scarcity in itself would not have loomed so large had Cassatt felt appreciated in her own country. But during this time her work, although well placed—at Goupil's gallery in New York—was not selling. Never willing to give up, she took the paintings to Chicago, where they were displayed in the window of a shop dealing in jewelry and fine art. As luck would have it, within a few days the Great Chicago Fire of 1871 broke out and this group of important early works was lost forever.

Cassatt began to despair of ever rising above her circumstances. Another trip to Europe—since she would have to finance it herself—seemed a more remote possibility than ever. In 1871 she wrote plaintively to her friend Emily Sartain in Philadelphia, "I cannot tell you what I suffer for the want of seeing a good picture, no amount of bodily suffering occassioned by the want of comforts would seem to be too great a price for the pleasure of living in a country where one could have some art advantages." Salvation came at last in the form of a commission from the bishop of Pittsburgh (whom she met through relatives) for copies for the Cathedral of Pittsburgh of two Correggio paintings in Parma.

In December 1871, the twenty-seven-year-old artist (see fig. 6) began her third trip abroad. This time she traveled with Emily Sartain, who, at thirty, was already an established engraver working in the engraving firm of her father, John Sartain, one of the leaders of the Pennsylvania Academy and an influential figure in American art education. By the time Cassatt had returned to Philadelphia in 1870, Emily Sartain, after completing her studies at the Academy and working professionally, was eager to return to Europe to learn the craft of painting. While later in their lives the two women would take divergent paths (Sartain had an academic career and became principal of the Philadelphia School of Design for Women), in 1871, when they set off for Europe together, their common desire to drink in all they could of art, old and new, forged a strong bond between

13 *Portrait of Mrs. Currey*

1871. Oil on canvas, 32 × 27"
Whereabouts unknown

Cassatt's interest in painting a black model was more European than American in inspiration. She painted Mrs. Currey as an exotic beauty, seeing her in terms of dramatic coloring in much the same way as Degas saw American blacks during his stay in Louisiana two years later, in 1873.

14 *Portrait of a Lady of Seville*

1873. Oil on canvas, 37¾ × 30⅜"
Private collection

Cassatt's cosmopolitanism, her mastery of several languages, and her connections assured her a warm welcome wherever she traveled. Both in Parma and in Seville she was introduced into upper-class homes; thus she was able to give us a glimpse, as in this portrait, of traditional European society.

14 *Portrait of a Lady of Seville*

15 *Portrait of Madame Sisley*

them. Cassatt and Sartain stayed together in Parma for several months, until Sartain went to Paris to study with the popular Salon painter Evariste Luminais.

For Cassatt, the choice of Parma, which was determined simply by the fact of the Pittsburgh commission, proved a fortunate one. This smaller city offered many of the advantages of Paris without its disadvantages. She could study the old masters in the museums and collections without battling the crowds that daily thronged the Louvre. Moreover, the art community there was less sophisticated and more receptive to the needs of a young American artist. In short order she had models, a studio, access to the Correggios she was to copy, and as much guidance as she wanted from the faculty of the Parma Academy. She was especially fortunate in gaining the friendship and support of Carlo Raimondi, director and professor of engraving at the Academy, who opened many doors for her.

In Parma, Cassatt produced several paintings of women, classical and modern, among them *Two Women Throwing Flowers During Carnival*, *Bacchante*, and *Portrait of a Woman* (figs. 1, 2, 7), in addition to a large copy of Correggio's *Coronation of the Virgin*. (The whereabouts of this copy are unknown; there is no record of a second Correggio copy.) The figures in these paintings of women are, like Mrs. Currey (see fig. 13), large and solid and accented with some type of exotic costume element. But Cassatt's exposure to the Italian old masters speaks in the new classical motifs and the more complicated poses and foreshortening. Although she was still basically a genre painter, little trace remains of the Ecouen style.

Two Women Throwing Flowers During Carnival epitomizes Cassatt's work in Parma. A demonstration of traditional techniques—foreshortening, hand gestures, chiaroscuro, and the juxtaposition of two similar figures—the painting was praised in Parma and accepted for the 1872 Paris Salon. Balcony scenes were popular in contemporary art (Manet's *Au Balcon* had been shown in the Salon of 1869), and many of them, like Cassatt's, depicted colorful local customs, such as Carnival, that fascinated Americans on their trips to Europe. A few years earlier, in *The Marble Faun*, Hawthorne had described the Carnival procession down the Corso in Rome and mused on the origins of the flower-throwing ritual:

In the balconies, that projected along the palace fronts, stood groups of ladies, some beautiful, all richly dressed, scattering forth their laughter, shrill, yet sweet, and the musical babble of their voices, to thicken into an airy tumult over the heads of common mortals. . . . At the same time . . . a gentler warfare of flowers was carried on, principally between knights and ladies. Originally, no doubt . . . each youth and damsel . . . flung them with true aim at the one, or few, whom they regarded with a sentiment of shy partiality, at least, if not with love. . . . What more appropriate mode of suggesting her tender secret could a maiden find than by the soft hit of a rosebud against a young man's cheek!

Though as an exercise in combining old master techniques with a modern theme *Two Women Throwing Flowers During Carnival* satisfied Cassatt and impressed her European judges, it did not please some American critics. The brushwork in the background and draperies, which Cassatt had done hurriedly

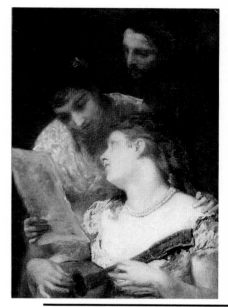

16 *A Musical Party*

1874. Oil on canvas, 38⅝ × 26⅞″
Musée du Petit Palais, Paris

When this painting was shown by Cassatt's dealer in Paris, the response was mixed. Its strengths and weaknesses were described by Emily Sartain in a letter to her father: "[It] is superb and delicate in color. . . . The light on the chest and face of the foreground figure, a blonde, is perfectly dazzling. It is as slovenly in manner and in drawing as her Spanish pochades [sketches], however."

15 *Portrait of Madame Sisley*

1873. Oil on wood panel, 7 × 5½″
Collection Mr. and Mrs. Raymond Jacobs
New York

Alfred Sisley and his wife, favorites in the Impressionist circle, are best known through Renoir's double portrait of them painted in 1868. Cassatt's acquaintance with them is undocumented except for this small portrait, which is inscribed to Mme. Sisley.

17 STOP (pseud. of L.P.G.B. Morel-Retz). Caricature of Cassatt's painting *Ida*, shown in the Salon of 1874, published in *Le Journal amusant* June 27, 1874

Every year Le Journal amusant, *a weekly, published a series of caricatures by the artist-humorist known as STOP of works shown in the Salon of that year. In 1874 for the first time a painting by Cassatt was included, and this caricature of* Ida *serves as our only record of this important work. The caption implies that the model is a striking redhead (Ces rousses ont un éclat).*

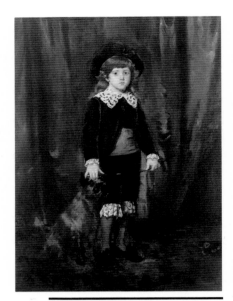

18 *Portrait of Eddie Cassatt*

1875. Oil on canvas, 60 × 45"
Private collection

Edward Buchanan Cassatt (1869–1922), first child of Mary's brother Alexander and his wife, Lois, was born while Cassatt was studying in Europe. Painting this portrait, during a trip home in 1875, must have brought the artist closer to her six-year-old nephew and to her brother's whole family, which now included three other nieces and nephews.

19 STOP (pseud. of L.P.G.B. Morel-Retz). Caricature of Cassatt's painting *Mlle. E.C.*, shown in the Salon of 1875, published in *Le Journal amusant* June 26, 1875

In 1875 Cassatt's portrait of an unidentified young girl, titled Mlle. E.C., *was accepted for the Salon, and STOP made it the subject of one of his caricatures for* Le Journal amusant. *The caption of the caricature can be rendered, "What I find charming about childhood is its naiveté."*

in a baroque manner to make the painting lighter and more spontaneous, was considered too loose. As Cassatt's deeper study of the old masters led her to attempt more in her paintings, and as she achieved greater success and wider visibility, her rejection of academic techniques came under more intense scrutiny. The idiosyncracies of the brilliant student had been indulged; the practicing professional began to be called to task for her nonconformity. Both American and French conservative circles hinted at her eccentricity and her neglect of detail. Thus began a pattern of critical successes and setbacks that would soon become familiar.

In the fall of 1872 Cassatt left Italy for Spain, whose fine museums, beautiful scenery, and low cost of living had attracted artists for decades. After a few weeks of study and copying in the Prado, she left Madrid and moved south to Seville, where she settled in for several months, engaging a studio in the picturesque Casa de Pilatos. Here she painted a series of typical Spanish genre scenes like those painted before her by such diverse artists as the Scotsman John Phillip, the

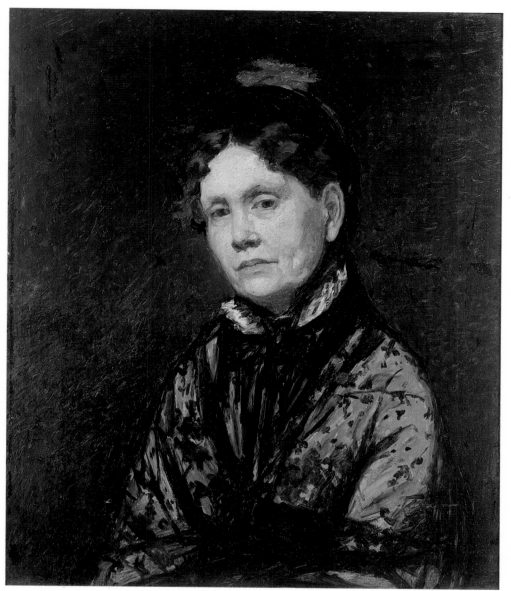

Frenchman Manet, and the American Thomas Eakins. Exploiting the themes of the bullfight (*Torero and Young Girl*, fig. 8, and *Toreador*, fig. 9), the balcony (*On the Balcony*, fig. 10), and Spanish beauty (*Spanish Dancer Wearing a Lace Mantilla*, fig. 11), she produced enough works to provide entries to exhibitions in France and the United States for the next several years.

In these paintings—so strong was the impact of the Spanish realist tradition of Velázquez and Murillo—there remains little of the idealism of Cassatt's Italian studies. Creating movement and animation is no longer paramount; she uses a darker, more somber palette and a thicker paint surface. Since only the most casual of preliminary drawings from this period are documented (see fig. 12), it can be assumed that for the most part she painted directly from life.

To Cassatt, Spanish painting was not just admirable; it was an education. Alone in Madrid in 1872 she had penned the ecstatic plaint: "Oh dear to think that there is no one I can shriek to, beautiful! lovely, oh! painting what ar'nt you." Of Velázquez in particular she wrote: "The men and women have a reality about

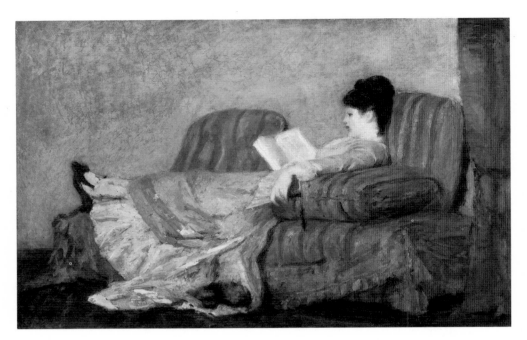

21 Young Lady Reading

c. 1878. Oil on panel, 15⅞ × 24⅜"
Private collection

In informal scenes such as this we can see the influence of contemporary French artists like Manet or, perhaps even more clearly, of Cassatt's fellow expatriate Whistler. The paths of these two Americans crossed often from the mid-1870s on, but the circumstances of their first meeting are undocumented.

22 Young Woman on a Settee with Black Dog

1875. Oil on panel, 13¾ × 10½"
Fogg Art Museum, Cambridge, Massachusetts
Gift of Mr. and Mrs. Peter L. B. Lavan

In paintings like this Cassatt began to make use of her own furniture and accessories, thus evoking an impression of her own personal surroundings. A visitor described Cassatt's studio home in 1876: "Statues and articles of vertu *filled the corners, the whole being lighted by a great antique hanging lamp. We sipped our* chocolat *from superior china, served on an India waiter upon an embroidered cloth of heavy material. Miss Cassatt was charming as usual in two shades of brown satin and rep. . . ."*

them which exceed anything I ever supposed possible, Velasquez Spinners, good heavens, why you can walk into the picture. Such freedom of touch. . . ." And again: "I have found a few French artists copying here, and all with one accord agree with me; I think that one learns *how to paint* here, Velasquez manner is so fine and so simple."

One of the most interesting of the Spanish pictures is the *Portrait of a Lady of Seville* (fig. 14), the earliest of Cassatt's finished portraits to come to light. This portrait has a directness that is often lacking in the genre scenes, which sometimes seem contrived; it is a straightforward rendering of a woman of strong character. Caught in paint are the subtleties of her upright bearing and proud expression as well as the tangibles of her traditional Spanish dress and typical Sevillian home.

Cassatt was ambivalent about portraiture; she knew she was good at it, but her ambition was to be a painter of "pictures," a more creative and prestigious pursuit. Several years earlier, her old friend Eliza Haldeman, in a letter to her parents, had touched on the subject: "Mary wishes to be remembered to you, she laughed when I told her your message and said she wanted to paint *better* than the old masters. Her Mother wants her to become a portrait painter as she has a talent for likenesses and thinks she is very ambitious to want to paint pictures." As much as she could, Cassatt limited the portraits she painted to personal souvenirs of family and friends, though she was not above accepting portrait commissions, especially in the 1870s, when she was just launching her career and needed both the money and the exposure.

The Seville period ended in April 1873 with Cassatt's return, for a brief stay, to Paris, where her *Torero and Young Girl* was currently on view at the Salon. The Paris she found after several years' absence was much different from the city she had known before the Franco-Prussian War. By 1873 it had largely recovered from the physical destruction of the war, but it was irrevocably altered in spirit.

22 *Young Woman on a Settee with Black Dog*

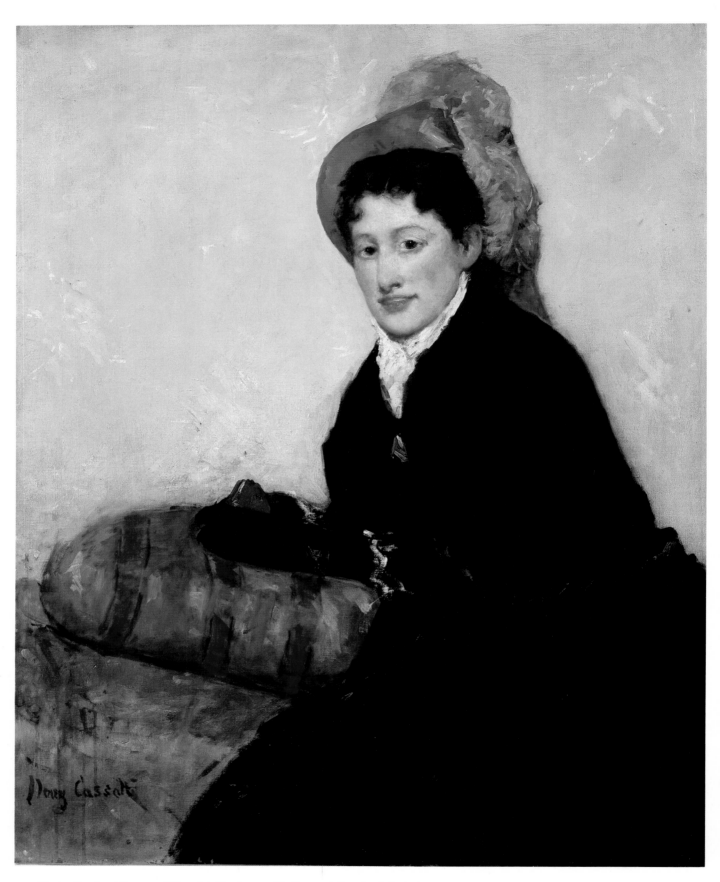

23 *Portrait of a Woman (Harriet Buchanan?) Dressed for the Matinée*

The gaiety and optimism of the Second Empire had retreated before the pragmatism that ruled all spheres of life in the Third Republic. Paris had become the art capital of the world: both the creation of art and the buying and selling of it centered there, attracting artists, dealers, and collectors of all nationalities. As before, Cassatt was put off by the crassness of the Parisian art market and by the stranglehold that the official art establishment had on artistic styles. Furthermore, her recent experience in Italy and Spain had taught her that many artists working outside Paris produced more vital and more exciting art than such lauded favorites of the Salon as Alexandre Cabanel and Léon Bonnat. The fervor of her opinions both thrilled and dismayed her friends. Emily Sartain wrote home to Philadelphia:

Oh how good it is to be with some one who talks understandingly and enthusiastically about Art.... I by no means agree with all of Miss C's judgments,—she is entirely too slashing,—snubs all modern Art,—disdains the salon pictures of Cabanel Bonnat and all the names we are used to revere.... Her own style of painting and the Spanish school which she has been studying all winter is so realistic, so solid,—that the French school in comparison seems washy, unfleshlike and grey—

Notwithstanding her strictures, Cassatt was strongly drawn to Paris. She had access to its inner circles. She was still in contact with establishment artists Gérôme and Chaplin, who had been her teachers; she was well acquainted with the large American community; and she had friends even among the radical French artists, who shared her disdain for popular styles. A small portrait of Madame Alfred Sisley painted in Paris in 1873 (fig. 15) is a clue to the extent of her early penetration into the group soon to be called Impressionists. Cassatt may have also known Renoir and Monet, who met several of her colleagues from the Pennsylvania Academy in Charles Gleyre's studio in the 1860s. Later, in the summer of 1873, she painted daily with Léon Tourny and his wife, close friends of Degas. By temperament and by association she was drawn to these French artists, but her ties to them at this time were not strong enough to persuade her to settle down in Paris; it was only after another year of travel that she saw that it was inevitable.

In that summer of 1873, Cassatt was in Antwerp with her mother, copying in museums and painting from life. It was here that she worked on her first known portrait of her mother (fig. 20). As simple and direct as the *Portrait of a Lady of Seville* and the *Portrait of Madame Sisley*, this unfinished portrait has its own style—somewhere between the grand manner of the former and the sketch-like modesty of the latter. After her mother returned to Philadelphia in the fall, Cassatt traveled on to Rome, where she again concentrated on genre paintings. There are not enough of her Roman pictures to give a clear idea of her direction at this time, but those that we have are intriguing. *A Musical Party* (fig. 16), for example, is thickly painted and modeled with dark darks and white highlights reminiscent of Courbet A painting called *Ida*—now known only by the caricature (fig. 17) that appeared in the satiric *Le Journal amusant*—was in the Salon of 1874, where Degas, going around with their mutual friend Tourny, was struck

23 *Portrait of a Woman (Harriet Buchanan?) Dressed for the Matinée*

1878. Oil on canvas, 39½ × 31¾"
Collection R. Philip Hanes
Winston-Salem, North Carolina

The identification of the subject of this portrait as Harriet Buchanan probably stems from a misreading of Achille Segard's reference to it in his biography of Cassatt as a portrait of the sister-in-law of a friend of the artist's. (Harriet Buchanan was the sister of Cassatt's sister-in-law Lois Buchanan Cassatt.)

by it. It must have shared the qualities of *A Musical Party*, which was considered remarkably luminous. Cassatt recalled that Degas paid her the highest of compliments: "There is someone who feels as I do."

Despite this encouragement, the period that followed was one of the most difficult of Cassatt's career. From 1874 to 1877 she was torn by conflicting aspirations: her interest in nontraditional styles grew, but her determination to become a successful artist led her to make concessions to prevailing conservative taste. Her decision not to pursue her career outside Paris was made grudgingly, but by 1875 (after a visit back to the United States) she was settled in her own studio at 19, rue de Laval. She became an active member of the American artistic community, and, while she continued to be critical of the Salon favorites, she tried out some of their techniques in her own work.

Looking back, she put it this way: "When I came to live in Paris after having painted in Rome & other places, the sight of the annual exhibitions, quite led me astray. I thought I must be wrong & the painters admired of the public right." The work she did in the next few years diverges from the work done in Parma, Seville, and Rome, though she was still painting genre. Now her figures are dressed in luxurious costumes in a modern style and sit comfortably in their Parisian interiors reading, sewing, and playing with lapdogs. Almost rococo in mood, works such as *Young Lady Reading* and *Young Woman on a Settee with Black Dog* (figs. 21, 22) were indeed popular and sold well to American audiences. Although painting potboilers was against Cassatt's principles, these came close to falling into that category.

She also painted a large number of portraits strongly reminiscent of the popular artist Emile Carolus-Duran, with whom the young John Singer Sargent was studying. Two child portraits of 1875—*Portrait of Eddie Cassatt* (fig. 18) and *Mlle. E. C.* (known only through a caricature, fig. 19)—are as charming and moderate as any painted in Paris that year. A large work, *Portrait of a Woman (Harriet Buchanan?) Dressed for the Matinée* (fig. 23) shows how Cassatt updated the grand portrait style of the *Portrait of a Lady of Seville* painted a few years earlier. The image is equally monumental but more worldly. The sitter is posed so that the graceful lines of her back and arms clearly suggest a fashionable woman, and the creamy skin and direct gaze are those of a modern beauty. Cassatt's efforts to conform to prevailing standards were successful: sales and commissions enabled her to be self-supporting even in this competitive environment.

But despite popular success, Cassatt's bid for official recognition became increasingly problematic and finally demanded more compromises than she was willing to make. Every year she sent paintings to the Salon, but elements of her style caused her works to be criticized if not rejected by conservative judges. Cassatt's brushstroke, which she had experimented with since her return to Europe in 1871, was not always controlled enough for their taste, nor was her palette, which was rich, coloristic, and occasionally too light. When given free rein, as in the oil sketch *Head of a Young Girl* (fig. 24), her painting style was original and exuberant, and Cassatt was frustrated at being unable to make it more acceptable. The time was ripe for her to make a major change.

24 *Head of a Young Girl*

c. 1876. Oil on panel, 12¾ × 9″
Museum of Fine Arts, Boston
Gift of Walter Gay

This small oil sketch on wood panel attests to the continued influence of Thomas Couture's teaching on Cassatt's style. Couture emphasized painting quickly and directly from the model, building up a colorful network of brushstrokes to form a rich surface. In 1878 Cassatt gave this panel to a young American, Alfred Q. Collins, who had recently arrived in Paris to begin his art studies.

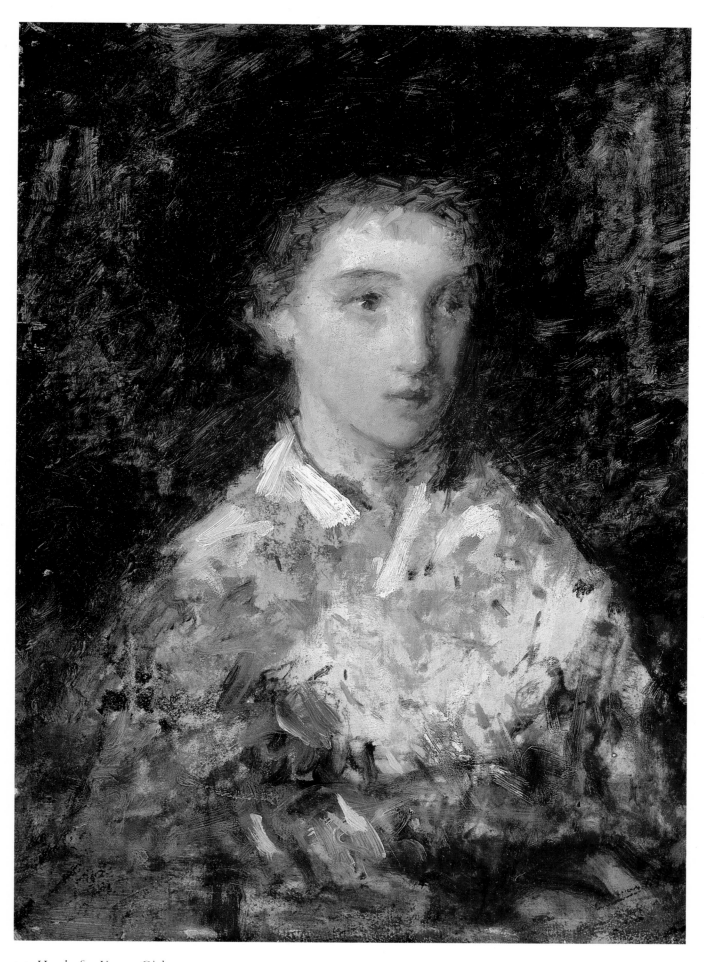

24 *Head of a Young Girl*

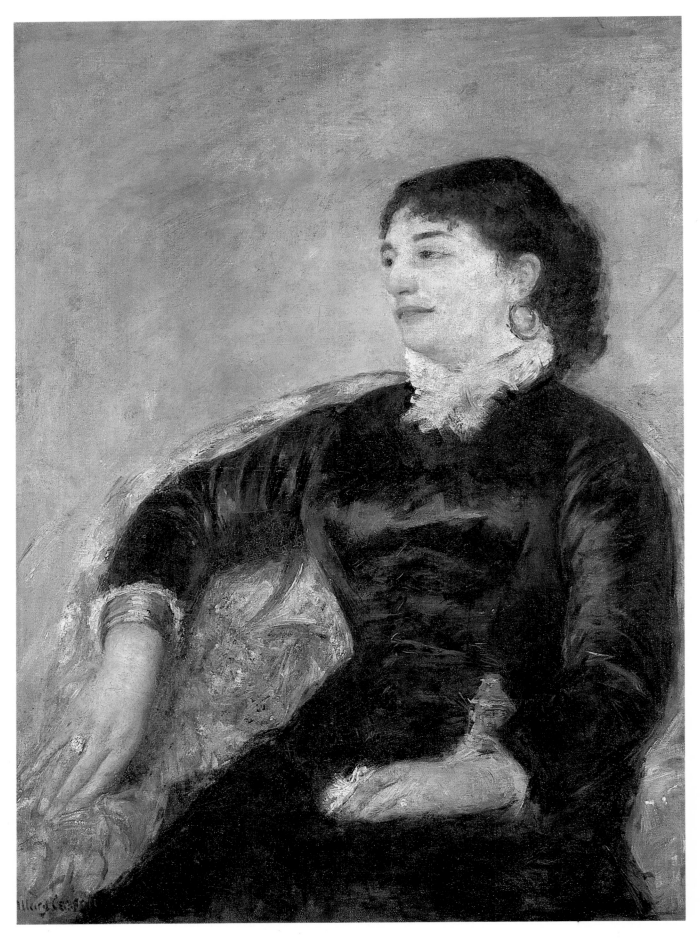

25 *Portrait of an Italian Lady*

II. Impressionist Years (1877–1886)

ALTHOUGH IN HER TRAVELS and through her wide circle of acquaintances Cassatt had come to know some members of the Impressionist group (such as Alfred Sisley), and some friends of members of the group (such as Degas's friend Léon Tourny), her first real awareness of the stylistic impact of Impressionism and of its implications for her own work came through her discovery, in 1875, of a group of Degas pastels in a dealer's window. Degas's name would have become familiar to her during the summer of 1873, when she worked closely with Léon Tourny and his wife in Antwerp, and through the paintings Degas had showed at the Salon every year from 1866 to 1870 (the year he ceased exhibiting there). But she probably had not seen any of the more informal and experimental works he had produced since then. In April of 1874, when Degas was one of the group of artists who exhibited their works as the Société anonyme des artistes peintres, sculpteurs, graveurs, etc.—soon to become known as the "Impressionists"—she was in Rome. The next year, when Cassatt was settled in Paris and would no doubt have attended such an exhibition, the group did not organize one. She was not prepared, therefore, for what she saw in the dealer's window, probably in the early fall of 1875, after she returned from a trip home to the United States. She described the experience many years later in a letter of 1915 to Louisine Havemeyer:

How well I remember, nearly forty years ago, seeing for the first time Degas' pastels in the window of a picture dealer on the Boulevard Haussmann. I used to go and flatten my nose against that window and absorb all I could of his art. It changed my life. I saw art then as I wanted to see it.

Cassatt's enthusiasm had spilled over to her then new friend Louisine Elder (later Havemeyer), whom she first met in the summer of 1874, when Louisine was in Paris for a few months with her mother and sisters. Although Cassatt was over ten years older, she recognized in Louisine a zest and energy equal to her own. It was probably at this time that she persuaded her young friend to spend 500 francs on one of Degas's pastels and thus inspired the earliest purchase of an Impressionist picture by an American collector.

The life-changing episode described by Cassatt probably caused her to seek out Degas (perhaps the introduction was arranged through Tourny), and Degas may have agreed to the meeting because he remembered being struck by her

25 *Portrait of an Italian Lady*

c. 1878. Oil on canvas, 32 × 23⅝"
Hirshhorn Museum and Sculpture Garden
Smithsonian Institution, Washington, D.C.

The title that this painting has acquired is not supported by any documentation establishing the identity or the nationality of the sitter.

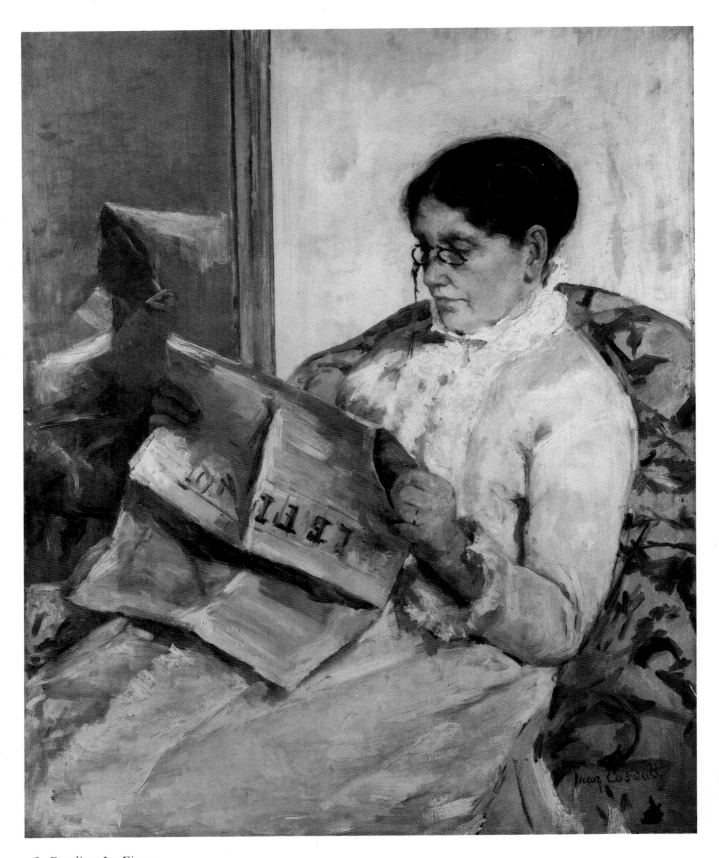

26 *Reading Le Figaro*

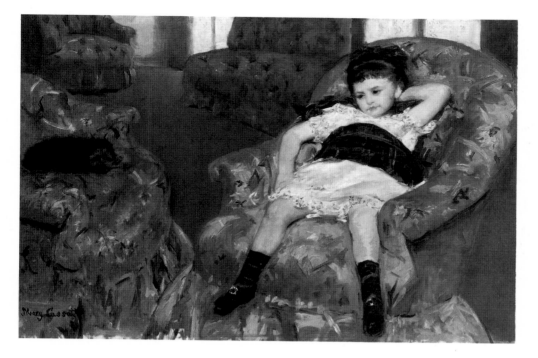

27 *Little Girl in a Blue Armchair*

1878. Oil on canvas, 35¼ × 51⅛"
National Gallery of Art, Washington, D.C.
Collection of Mr. and Mrs. Paul Mellon

The impact of Degas and naturalism on Cassatt's work is dramatically apparent in this portrait of a child. The formality and conventional charm of the 1875 portraits of Mlle. E.C. and Eddie Cassatt have been replaced by an active pose and unexpected details of costume and setting. Predictably, the earlier portrait of Mlle. E.C. had been accepted by the Salon jury, whereas the Little Girl in a Blue Armchair *was rejected.*

painting *Ida* (see fig. 19) in the Salon of 1874, which Tourny had pointed out to him. Two subsequent events may be traceable to this new association. One was her decision to resubmit to the Salon a work that had been rejected in 1875; in a move calculated to please the jury, she darkened the background and to her amusement saw the painting accepted for the Salon of 1876. Then in 1877 her paintings were rejected by the Salon, possibly because she continued to lighten her palette and to adopt some minor hallmarks of Impressionist style or possibly because her association with Degas was enough to stigmatize her in the eyes of a Salon jury. Her style had become officially unacceptable. The injustice of this struck even Cassatt's conservative friends; writing about the fate of various friends at that year's Salon, May Alcott (sister of Louisa May) said, "Miss Cassatt has two refused also, which is more strange than its happening to Rose [Peckham], as the former's work is exceedingly strong and fine, but perhaps it's too original a style for these fogies to appreciate."

It was at this juncture that Degas came to Cassatt with the proposal that she give up submitting her work to the Salon and begin instead to exhibit with him and his friends in the Impressionist group. After her initial exposure to his work in 1875, it took her until the spring of 1877 to decide to stop compromising and embark in earnest on a new course. While exhibiting with the Impressionists would give her the freedom to show what she wanted to show, it meant giving up the chance for success in traditional terms. Because the group ruled that its members might not submit paintings to the Salon, she could no longer hope for official recognition. Nor could she expect popular recognition, since fewer people would see her work in a small exhibition tucked away at Durand-Ruel's or some other private gallery. And, most daunting of all, she would risk being the target of the kind of derision that the first few Impressionist exhibitions had elicited from critics and the public. In the end her commitment to nonacademic art won

26 *Reading Le Figaro*

c. 1878. Oil on canvas, 39¾ × 32"
Private Asset Management Group, Inc., New York

Soon after her parents moved to Paris, in 1877, Cassatt painted this portrait of her mother reading the Paris newspaper Le Figaro, *here a symbol of Mrs. Cassatt's acclimation to her new home. The painting was sent to Cassatt's brother Alexander in Philadelphia, with the following message from her father: "I hope you will be pleased with the portrait, in fact I do not allow myself to doubt that you will be. . . . Here there is but one opinion as to its excellence—"*

28 *Moïse Dreyfus*

out. Forced to make the choice, she followed her own personal inclinations and took the plunge.

Reminiscing thirty-five years after the fact, Cassatt still had strong feelings about the decision; in 1912 she told her biographer Achille Segard, "I accepted with joy. I hated conventional art. I began to live." Clearly, she recalled the years of trying to find her way in the labyrinthine art world of the 1870s, juggling the demands of her conservative American milieu, official taste, and her own independence, as a dark period, and she considered it the turning point of her life when, at the age of thirty-three, she was given the opportunity to paint and exhibit freely.

Original as Cassatt's work may have appeared to an American like May Alcott, a recent arrival in Paris, it was certainly not as original or radical as the work produced by the sophisticated French members of the Impressionist group. Whatever minor changes Cassatt made in the direction of the new style, perceptible enough to a Salon jury, she had not yet shown signs of becoming a true Impressionist. But Degas and the other members, who preferred to be called "Independents," stressed that their shared belief in freedom from the jury system was more important than their stylistic affinities. Degas's tendency was to enlist artists who shared the group's disdain of the academic system in Paris, regardless of the style they practiced. At the very least, Degas saw Cassatt as a respectable ally who would help to swell the ranks of the "Independent" faction.

Perhaps he could see beyond Cassatt's popularizing style of 1875–77 because he had had his first glimpse of her work in 1874. Her synthesis of old master and modern influences, as well as her extreme realism, must have evoked a strong response in him, and the criticism Cassatt's earlier work had received from conservative artists must have seemed all too familiar. The opinion of the Salon favorite Evariste Luminais, for instance (as reported by Cassatt's friend Emily Sartain in a letter home), might have been directed at Degas, at Manet, or at any one of the other radical realists of earlier days:

Luminais has seen her Salon picture and a couple of her sketches that I took him— He spoke of them as having a great deal of talent but mostly talent of the brush, *as [he] called it— You must not repeat this to any one. He also thought it wanting in distinction,—in fact he called it* common.

What Luminais objected to, Degas valued and decided to encourage.

Cassatt's wholehearted adoption of the Impressionist approach soon established her as one of the most intelligent interpreters of the new art outside the original circle. Unfortunately there is a dearth of letters and other documents to illuminate this critical period, but it is clear from her work that Cassatt's entry into the Impressionist group set in motion a profound transformation. Up to this time she had been, for all her dissatisfactions, a conventional artist. She employed tried-and-true devices to give her paintings an interesting flavor: exotic or elaborate costumes, contrived hand gestures, and a romantic moodiness. Her ability was unquestioned, but her theoretical framework was limited.

28 *Moïse Dreyfus*

1879. Pastel on paper mounted on canvas,
32 × 25⅝″
Musée du Petit Palais, Paris
Gift of Mme. Justin Mayer
in the name of Mme. Moïse Dreyfus
and in memory of Moïse Dreyfus

During Cassatt's early years as an Impressionist she undertook more portraits of men than at any other time in her career. In addition to painting her father and her brother Alexander, she portrayed the collector Dreyfus, the writer George Moore, and the artist Marcellin Desboutin. She also painted a portrait of Degas, which was referred to as "destroyed" by Segard in his monograph on Cassatt published in 1913.

29 Study for *At the Opera*

29 Study for *At the Opera*

c. 1878. Pencil, 3¹³⁄₁₆ × 5⁵⁄₁₆"
Collection A.S.
Crans sur Sierre, Switzerland

30 Study for *At the Opera*

c. 1878. Pencil, 4 × 6"
Museum of Fine Arts, Boston
Gift of Dr. Hans Schaeffer

The two studies for At the Opera *(with two others whose whereabouts are unknown) form an unusually complete series of preliminary drawings leading up to a finished painting. They provide a rare glimpse of Cassatt's method of refining an idea into a finished composition. No Cassatt sketchbooks have survived, but it is evident that many of Cassatt's individual sketches were made on sheets from pocket-size sketchbooks of the type used by Degas and others in the Impressionist circle.*

31 *At the Opera*

c. 1878. Oil on canvas, 32 × 26"
Museum of Fine Arts, Boston
Hayden Collection

If this painting is correctly identified with an opera picture shown in the Massachusetts Charitable Mechanics Association exhibition in Boston in 1878, it is the first work on an Impressionist theme that Cassatt exhibited in America. It was shown the next year in New York at the second exhibition of the Society of American Artists; after that it was returned to Paris, where it was held in private collections until 1910, when it was purchased by the Museum of Fine Arts, Boston.

30 Study for *At the Opera*

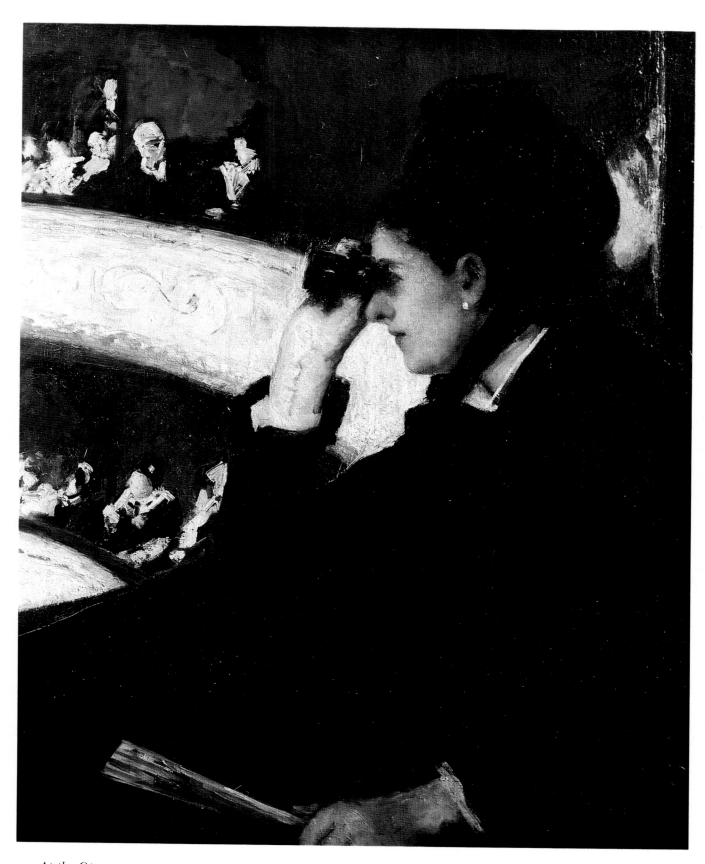

31 *At the Opera*

1879. Oil on canvas, 17 × 29″
Collection Mr. and Mrs. Edgar Scott
Villanova, Pennsylvania

While At the Opera *(fig. 31) was becoming known in America in the late 1870s,* In the Box *was attracting attention at exhibitions and in reviews in Paris. One of the first of Cassatt's works to be handled by the dealer Paul Durand-Ruel,* In the Box *marks the beginning of a cordial lifelong artist-dealer association.*

33 *The Loge*

c. 1880. Oil on canvas, 31½ × 25⅛″
National Gallery of Art, Washington, D.C.
Chester Dale Collection

Conservation treatment of this work at the National Gallery of Art has revealed that the fan was originally delineated in gold paint and then completely overpainted. Cassatt apparently abandoned her idea of duplicating in The Loge *one of the several gold-decorated fans that she owned— the work of Impressionist colleagues.*

The Impressionists, with their emphasis on novelty and their intimate ties to radical writers and thinkers, introduced Cassatt to a new level of aesthetic theorizing. Their style achieved a balance between fragmentation and compositional unity, between coloristic exaggeration and naturalistic tone, as well as other subtle empirical balances of opposite or contradictory elements. Their subjects, drawn from the world around them with an ironic eye, also displayed a fragile balance between the public and the private, discretion and indiscretion, beauty and ugliness. A rigid or uninformed viewer could easily be confused by the transient and shifting effects of this style and, with some justification, feel mocked by these sophisticated artists. However, Cassatt was intellectually nimble and prided herself on her own penetrating opinions on art and society. From her very first efforts to incorporate Impressionist devices into her work she was fascinated with the aesthetic power of a painting's successful balance of contradictory elements.

In April 1877, when Cassatt accepted the invitation to become a member of the Impressionist group, their third exhibition was being shown in an apartment on rue Le Peletier. Viewing the exhibition that year, if she tried to imagine her own paintings hanging alongside the pictures she saw there—Degas's ballet and café concert scenes, Monet's Gare St. Lazare series, and Renoir's *Bal du Moulin de la Galette*—she must have realized that she had a lot of work to do before the next year's exhibition. As it turned out, she had an extra year in which to experiment: the 1878 exhibition, counted on by her until the last minute, was finally canceled so as not to compete with the grand Exposition Universelle, which was to monopolize the attention of Parisians for that season. Her next opportunity came in the spring of 1879, when she was able to present eleven works in the fourth Impressionist exhibition.

33 *The Loge*

34 *Miss Mary Ellison*

If we look at the paintings and pastels of the early days of Cassatt's Impressionist affiliation we can discern her first efforts to achieve the "new realism" touted by the Impressionists. A group of four dating from 1878 and 1879—*Portrait of an Italian Lady*, *Reading Le Figaro*, *Little Girl in a Blue Armchair*, and *Moïse Dreyfus* (figs. 25–28)—are clear reinterpretations of her previous work in portrait and figure studies into an Impressionist mode.

Most striking is Cassatt's interest in capturing life in its normal and unposed state. This was the hallmark of Impressionism as it was of literary naturalism, a movement (led in France by Emile Zola) that Cassatt, who was well read in contemporary French literature, was strongly attracted to. Although a simple concept, the naturalistic effect in art or literature was hard won, requiring subtle adjustments of form and content and a concentrated effort to achieve the appearance of effortlessness.

Compared to such earlier paintings as *Young Woman on a Settee with Black Dog* and *Portrait of a Woman (Harriet Buchanan?) Dressed for the Matinée* (figs. 22, 23), these new paintings display the difference in attitudes, setting, and costume, as well as tonality and application of paint, that in combination produce the "slice of life" quality. In the earlier works there is a studied effect, due in part to the insistent vertical lines of the striped fabrics and the angular configurations of the poses. The more Impressionist-influenced works emphasize instead curved lines in figures and settings—rounded shoulders echoing a rounded armchair, for example—which lend themselves to a more flowing, easy composition. Also, costume and setting are more workaday—lighter, softer fabrics and comfortable furniture rather than the polished appurtenances of a formal decor.

Cassatt's approach to color also changed, as can be seen in her pastel portrait of Moïse Dreyfus (fig. 28), a friend and a collector of her work. Pastel was by no means a new medium for her, but she altered her handling of it in response to the experiments of Degas, Manet, and other pastellists in their circle. She learned to use the linear marks of the pastel sticks to build up forms rather than to describe outline and detail. This more abstract manipulation of a drawing medium contributed greatly to the lightness of form achieved in this portrait. Although M. Dreyfus's features are fully realized, the face is soft and glowing, with the light showing through between the delicate strokes.

In *Portrait of an Italian Lady* (fig. 25) Cassatt adds to the informal pose and the use of white and pastel colors a psychological element typical of Impressionist figure studies. With head tilted and eyelids lowered, the subject seems to be listening to or watching something outside the picture's limits, and this gives the viewer the feeling of having happened on the scene, of sharing with the artist the role of observer.

Since she was deprived of the showcase that the Impressionist exhibition would have given her in 1878, Cassatt was eager to have a public showing that would demonstrate the new direction in her work. And so she submitted two paintings to the American section of the Exposition Universelle—with much the same result as submitting to the Salon might have had. One work, a still unidentified painting of a woman in yellow, was accepted, but another, *Little Girl in a Blue*

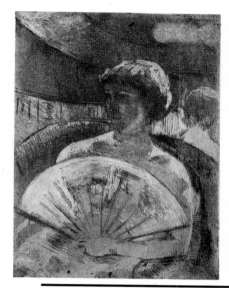

35 *In the Opera Box, No. 2*

c. 1880. Soft-ground etching and aquatint,
printed in gray-black, 8⅜ × 6¼"
The Museum of Modern Art, New York
Gift of Abby Aldrich Rockefeller

Although the journal Le Jour et la nuit *proposed in 1879 was to contain only black-and-white prints, Degas, Cassatt, and Pissarro even at this early date discussed printing in color. It would be another ten years, however, before they would carry out their ideas of producing color prints.*

34 *Miss Mary Ellison*

c. 1880. Oil on canvas, 33½ × 25¾"
National Gallery of Art, Washington, D.C.
Chester Dale Collection

Mary Ellison (later Waldbaum; c. 1856–1936), a fellow Philadelphian, was part of Cassatt's circle of young American women friends in Paris in the 1870s, which included Emily Sartain, May Alcott, and Louisine Elder and her sisters. Cassatt painted a portrait of Ellison in 1877 and also asked her to pose for a scene at the opera. This portrait has traditionally been identified as the opera scene, although hairstyle, facial features, and date make At the Opera *(fig. 31) a more likely candidate.*

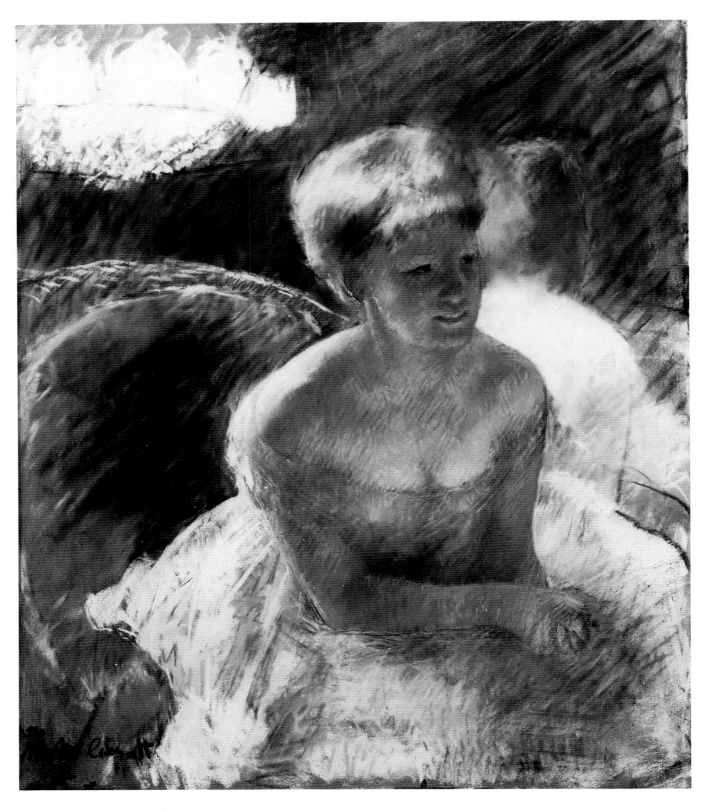

36 *Lydia Leaning on Her Arms, Seated in a Loge*

Armchair (fig. 27), was not. The rejection still rankled some twenty-five years later; in 1903 Cassatt wrote to the dealer Ambroise Vollard about "the portrait of the little girl in the blue armchair":

I did it in 78 or 79—it was the portrait of a child of friends of M. Degas—I had done the child in the armchair, and he found that to be good and advised me on the background, he even worked on the background—I sent it to the American section of the Gd. exposition 79 but it was refused. Since M. Degas had thought it good I was furious especially because he had worked on it—at that time it seemed new, and the jury consisted of three people, of which one was a pharmacist!

Cassatt may have anticipated that the work would encounter such a fate, but the fact that Degas had worked on it may have made submitting it to the jury seem a declaration of her new loyalties—a declaration she was determined to make that spring in whatever forum she could find.

Degas's having worked on this picture signifies how close the two artists had become in 1877–78, before Cassatt's "official" debut, which took place in 1879. Both Degas and Cassatt had had close professional relationships before. Degas had been friendly with Berthe Morisot and her sisters for many years, while Cassatt had formed warm ties with older male colleagues such as her mentor in Parma, Carlo Raimondi. Degas, ten years older than Cassatt, and well established in his position as the Impressionists' philosopher-gadfly, was an ideal associate for the thirty-three-year-old American, who needed guidance but was too well established herself to accept him as a teacher. Their intense personalities meshed and spurred their mutual creativity. Cassatt undoubtedly gained more professionally than Degas did from their relationship, and to the day he died she revered him as an artist, but she was always careful to maintain her independence and to use his art as a springboard to her own solutions rather than as an example to be imitated. As friends they benefited equally; each could provide the brilliant conversation that the other thrived on, while showing interest and concern in a rare unsentimental form. The relationship was not always smooth, but it endured for forty years.

Through Degas, Cassatt had access to the other Impressionists; she began to study and occasionally, whenever her finances permitted, to buy their works. She also had the advantage of associating with others of Degas's friends, among them the Italian author and critic Diego Martelli, the *amateur* and painter Henri Rouart, and the poet Stéphane Mallarmé, a favorite among the Impressionists. Cassatt had never been hesitant when it came to asking advice, debating artistic issues, or employing any means that would lead to the art she wanted to create, and this new milieu offered untold possibilities.

Cassatt's circle had always included personal friends and professional associates of all nationalities, but up to this point she had remained a more or less typical American artist abroad. She had followed fairly conventional paths to masters and museums across Europe, and she had striven for success in terms that the American community in Paris respected. After she formed her association with

37 Edgar Degas. *At the Louvre: Mary Cassatt in the Etruscan Gallery*

c. 1879. Aquatint, 10½ × 9⅛″
The Metropolitan Museum of Art, New York
Rogers Fund

Cassatt posed for Degas's series of prints and pastels of scenes at the Louvre and for his milliners series. Both subjects were appropriate for Cassatt—a connoisseur of both art and fashion. In her graceful stance Degas pays homage to the elegant figure she cut in Parisian circles.

36 *Lydia Leaning on Her Arms, Seated in a Loge*

1879. Pastel, 21⅝ × 17¾″
The Nelson-Atkins Museum of Art,
Kansas City, Missouri. Nelson Fund

Like many others, this work has been traditionally associated with Cassatt's sister, Lydia, but it is more likely that it depicts one of Cassatt's regular professional models, perhaps "the Swedish woman" mentioned in a letter to Berthe Morisot in late 1879. The dramatic results Cassatt achieved with the reddish-blonde model made this work the most discussed of all her entries in the Impressionist exhibition of 1880.

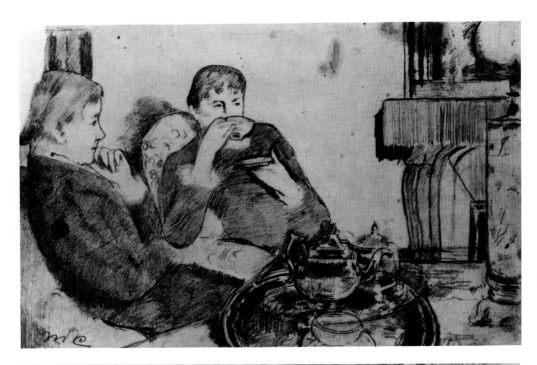

38 Study for *Five o'Clock Tea*

c. 1880. Soft pencil and crayon on paper, 7½ × 11″
Private collection

The ragged upper-left corner of this drawing bears witness to its use. To produce the etching shown in fig. 40, Cassatt placed the drawing, face up, on a copperplate coated with a soft ground and went over the major lines of the composition with a pencil. When she removed the paper, wherever there had been pressure by the pencil the soft ground adhered to it, exposing the plate, and when the plate was immersed in an acid bath the lines of the drawing were bitten into it.

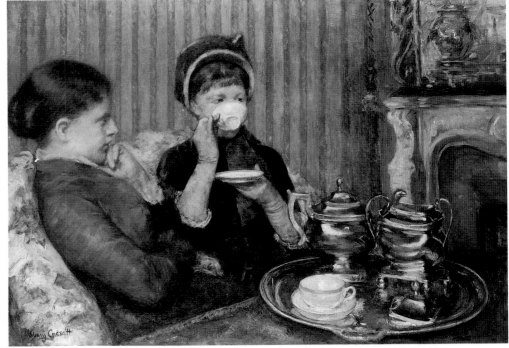

39 *Five o'Clock Tea*

c. 1880. Oil on canvas, 25½ × 36½″
Museum of Fine Arts, Boston
Maria Hopkins Fund

While her opera scenes were recognized as distinctly French, Cassatt's several versions of afternoon tea were regarded as British in character. This one, set in the Cassatts' Paris drawing room, with the family's heirloom silver tea service in use, suggests a typical gathering of American friends. The two young women are clearly not the center of attention but a polite audience for more garrulous members of the party on the other side of the room.

Degas and the Impressionists, she was still active in the American community and submitted works to exhibitions of American artists. Indeed Cassatt strongly maintained her national identity throughout her life. But gradually the combination of the new and exciting group of European friends and the coolness of the staid American community toward Impressionism led her to restrict her American contacts more and more, so that they eventually included only her family and a few old friends. Her social life grew closer to that of the French leisure class in many aspects—her style of entertaining, her regular round of activities (dinner,

IMPRESSIONIST YEARS

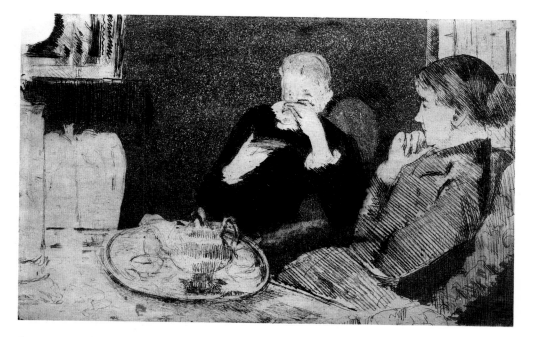

40 *Lydia and Her Mother (?) at Tea*

1880. Etching, fourth state, 7 × 11″
National Gallery of Art, Washington, D.C.
Rosenwald Collection

Based directly on the study for Five o'Clock Tea *(fig. 38), this print probably does not depict actual Cassatt family members, despite its traditional title. The woman with raised teacup resembles the model seen in* Lydia Leaning on Her Arms, Seated in a Loge *(fig. 36).*

the opera, the horseraces), as well as the quarter of Paris she lived in and the places where she spent her summers.

This new French flavor is reflected in the subjects Cassatt began to paint. Most typical was the theater or opera scene, a motif favored by all the Impressionist figure painters. This theme, which reflected the style and glitter of contemporary society, enabled the artist to assume the role of social critic and to examine the artifice and public display of the fashionable people who made up the audience, becoming performers just as much as the actors on stage.

Cassatt's interpretations of theater scenes showed this social interest clearly. Unlike Degas and Eakins, Cassatt was not a devotee of the performing arts. While she attended the theater and the opera with the genuine appreciation of a cultivated person, she did not seek out the company of musicians and actors as Degas was wont to do. Hence in her theater subjects she never paid tribute to performers; instead she focused on the audience the way an anthropologist might study the costumes, artifacts, and gestures of a tribe during a ritual celebration. This objective scrutiny of modern manners and mores was part of the intellectual atmosphere of the period; as an American, Cassatt brought to it the special curiosity of an outsider.

It was consonant with her interest in observing the social scene that in developing her theater pictures Cassatt for the first time made on-the-spot sketches such as the studies (figs. 29, 30) for *At the Opera* (fig. 31). Cassatt had begun to do this under Impressionist influence; earlier she had followed the academic procedure of making sketches in her studio with a posed model, but now she began to carry around a sketchbook to record people or scenes encountered in the course of the day. Her adoption of this practice in the late 1870s represents a radical change in her creative methods, one that would improve her eye for interesting subjects taken from life and her ability to endow finished oil paintings with the spontaneous qualities of the quick sketch.

We can see in the evolution of the design of *At the Opera* how interested Cassatt was in the underlying abstract elements of the composition. The long, curving line that gives grace and flow to the work, created by the continuity of bannister, arm, and hat, sweeps back into space with the continuation of the balcony. Cassatt's ability to translate reality into abstract shapes saves her depiction of the life around her from the stultifying detail that trapped so many of her contemporaries in the realist movement. Perhaps inspired by the linear spatial constructions of Japanese prints, Cassatt dared to integrate foreground and background with her continuous line at the risk of flattening the composition.

Cassatt could vary the expressive outcome of her theater pictures by the way she used abstract lines and shapes. For example, composition dramatically affects the emotional content of two works that are otherwise similar in subject and handling, *In the Box* and *The Loge* (figs. 32, 33). *In the Box* is based on a flowing pattern from the fan to the models' shoulders and from the opera glasses along the lines of the background. The figures are unself-consciously absorbed in their own activities and we, as viewers, are invited to share this comfortable moment.

In contrast to the informality of action of *In the Box* there is an unexpected immobility in *The Loge*. The curving lines of the balconies are not continuous with the foreground design, so that the figures, instead of being integrated into the environment, sit in solemn isolation. This, with their frontal positioning, gives the impression that they are posing (not only for the painter but for the other members of the audience) rather than being caught unaware. These young women, far from losing themselves in the spectacle, are self-conscious and withdrawn, much less at ease than their cousins of *In the Box*. Their bearing and facial expressions reveal a nervous straining after correct behavior; the fan serves more as a shield than as an allurement.

When Cassatt's interest in the mood or psychological state—an interest characteristic of the realist approach in art and in literature—led her to experiment with light and shadow, the results were immediately noticed in her artistic circle. Degas wrote of her experiments to a friend: "Mlle Cassatt . . . whom you know for a good painter, [is] at this moment engrossed in the study of the reflection and shadow of flesh or dresses, for which she has the greatest affection and understanding. . . ." These manipulations of light and shadow and the reaction to them by other artists are mentioned in a letter from Mr. Cassatt to Alexander mailed at the same time as a copy of *La Vie moderne* containing a sketch of *In the Box*. He wrote:

You will see that the front of the figure is in shadow the light coming in from rear of box etc— The sketch does not do justice to the picture which was original in conception & very well executed—and was as well, the subject of a good deal of controversy among the artists & undoubtedly made her very generally known to the craft.

The Impressionists' awareness of the artistic possibilities of private moments in public places, of the mixture of natural and artificial forms of beauty, was commented on by the critics reviewing the group's annual exhibitions in

41 *Lilacs in a Window*

c. 1880. Oil on canvas, 24¼ × 20″
Private collection

This rendering of a vase of lilacs foretells the passionate interest in growing flowers that Cassatt would develop once she had her own house in the country. At the Chateau de Beaufresne, which she bought in 1894, her special pride was a garden of a thousand roses that she tended herself.

41 *Lilacs in a Window*

42 *Woman Reading in a Garden*

c. 1880. Oil on canvas, 35½ × 25⅝"
The Art Institute of Chicago
Gift of Mrs. Albert J. Beveridge

*Despite her fondness for the country, it was
not until 1880 that Cassatt began to show
in her painting an interest in the effects of
sunlight and open air. If the identification
of this work as the painting of a woman in
white reading shown in the Impressionist
exhibition of 1880 is correct,* Woman
Reading in a Garden *is Cassatt's first
plein air painting.*

43 *The Cup of Tea*

c. 1880. Oil on canvas, 36¼ × 25¾"
The Metropolitan Museum of Art, New York
From the collection of James Stillman
Gift of Dr. Ernest G. Stillman, 1922

*In almost all of the eleven paintings and
pastels that Cassatt showed in the Impres-
sionist exhibition of 1881, members of her
family figured;* The Cup of Tea *was
one of at least three paintings of her sister,
Lydia. Lydia and Mary had always been
the closest of companions and had
planned to live together till the end of their
lives—a plan shattered by Lydia's untime-
ly death, in 1882.*

1879, 1880, and 1881. Cassatt was praised for her light effects, her original color
sense, and her ability to render the nuances of modern life. George Lafenestre,
writing in the *Revue des deux mondes* in 1879, paired her with Degas, stating that
they "both have a lively sense of the fragmented lighting in Paris apartments;
both find unique nuances of color to render the flesh tints of women fatigued by
late nights and the rustling lightness of worldly fashions." While Cassatt took lit-
tle stock in the opinions of the press, her family took great pride in every favor-
able mention, making sure that the Cassatts back home in Philadelphia were
apprised of each new triumph.

The isolated figure and the open fan used in *The Loge* to create a distant, con-
templative mood appear again in an oil painting of a sitter thought to be Cassatt's
friend Mary Ellison (fig. 34). But here, in addition, the softly painted face is made
less accessible by the play of shadow and light across it.

What Cassatt had tried out in oil she then employed in a pastel called *Lydia
Leaning on Her Arms, Seated in a Loge* (fig. 36). A dramatic work, this pastel is the
high point of her probing of the possibilities of light and shade. The composition
is executed in strong, parallel strokes that echo the diagonal force from lower left
to upper right. A blazing chandelier at the upper left illumines the young wom-
an's shoulder, hair, and skirt but does not reach her face or bodice; hence the psy-
chological center of the painting is left in shadow. This counteracts the warmth of
the forward-leaning posture, so that distance is ultimately preserved.

Evidently Cassatt considered this subject an extremely important one: she
chose it for an etching that was to be published in a proposed periodic review, *Le
Jour et la nuit*, projected by Degas, Pissarro, and others in 1879. Cassatt made two
versions—one with the face in a bright light that all but obliterates the features,
and another, *In the Opera Box, No. 2* (fig. 35), with the face entirely in shadow. As
in the original pastel, *Lydia Leaning on Her Arms, Seated in a Loge*, light comes from
behind, falling on hair, shoulders, and fan, but here the pose is quieter, and thus
there is more harmony between the subdued pose and the shadowed features.
The effect is an overall duskiness that bespeaks calm rather than distance.

Cassatt's emergence as a printmaker was another outgrowth of her associ-
ation with Impressionist artists. She found that radical artists in France and in
England, notably her fellow American James McNeill Whistler, had revived
etching as a medium of spontaneous and original art in the 1860s and 1870s and
had fired Degas, Pissarro, Renoir, and others with their enthusiasm. It was be-
cause Degas was so entranced with the possibilities of original prints that he per-
suaded some of his confrères to work with him toward the establishment of *Le
Jour et la nuit*, which was to combine their prints with articles by sympathetic jour-
nalists. It would provide another independent showcase for their art (compara-
ble to their "Independent" exhibitions) and bring in much-needed steady
income. In the end the project got no further than issuing one group of individ-
ual prints—in large part, Mrs. Cassatt charged, because of Degas:

*Degas who is the leader undertook to get up a journal of etchings and got them all to work for
it so that Mary had no time for painting and as usual with Degas when the time arrived to*

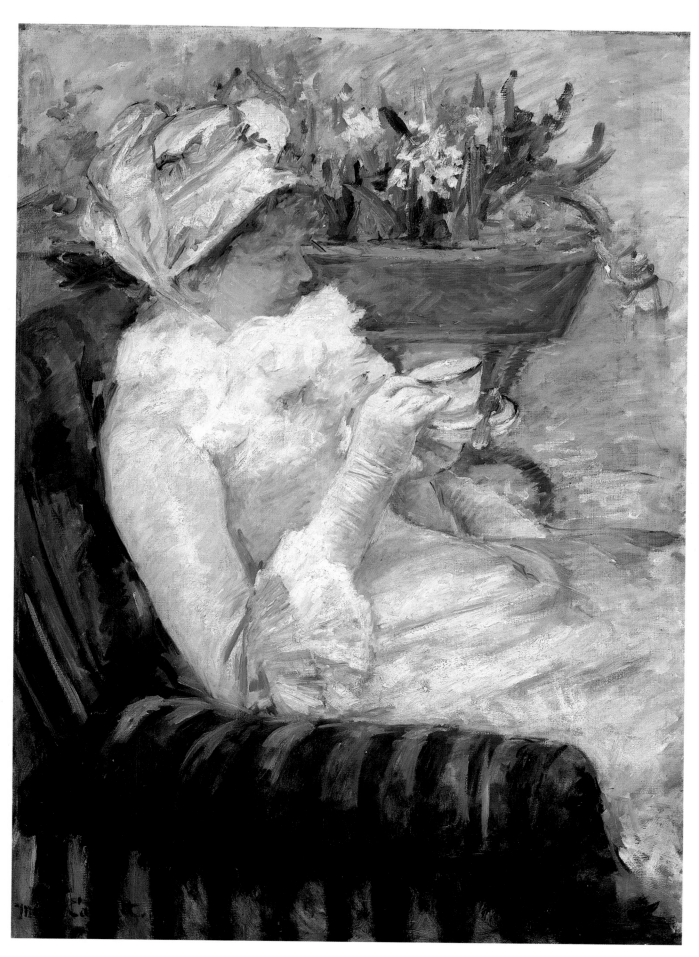

43 *The Cup of Tea*

44 *Mrs. Cassatt Reading to Her Grandchildren*

1880. Oil on canvas, 22 × 39½"
Private collection

While this painting was hanging in the Impressionist exhibition of 1881, Mrs. Cassatt wrote to her granddaughter Katharine: "Do you remember the one she painted of you & Rob & Elsie listening to me reading fairy tales? She finished it after you left & it is now at the exhibition—A gentleman wants to buy it but I don't think your Aunt Mary will sell it—she could hardly sell her mother & nieces & nephew I think—"

45 *Elsie in a Blue Chair*

1880. Pastel, 35 × 25"
Private collection

Elizabeth (Elsie) Foster Cassatt (1875–1949)—seen behind Mrs. Cassatt in fig. 44—was the youngest of the children of Mary Cassatt's brother Alexander. Cassatt completed two pastel portraits of Elsie: this one hung over the mantel of the Cassatts' apartment in Paris; the other was sent to Alexander's home in Philadelphia.

appear, he wasn't ready—so the "Le jour et la nuit" (the name of the publication) which might have been a great success has not yet appeared—

Up to this time Cassatt had had close ties to two print specialists, Emily Sartain, the American friend with whom she had traveled to Europe in 1871, and Carlo Raimondi in Parma. Undoubtedly she learned much about print processes from them, but their reproductive engravings would hardly have served as a model for anyone as determinedly original as she was; the kind of painstaking, controlled drawing that their academic style of printmaking required was what she had always shied away from.

But in 1879 the idea of creating original prints in the more spontaneous medium of etching, as well as working in black and white, experimenting further with patterns of light and shadow, was attractive to her. Despite the foundering of the journal project, she accomplished a great deal in a short time in this new endeavor, and her achievements in printmaking put her in the front rank of graphic artists. Cassatt's print *In the Opera Box, No. 2* makes use of a number of ways of differentiating areas: darks were produced by aquatint and soft-ground etching, lights by stopping out, scraping the plate, and judicious wiping of the ink. Most subtle are the reflections on the face that suggest light on the cheek and under the eyebrow. Degas's print intended for *Le Jour et la nuit*—titled *At the Louvre: Mary Cassatt in the Etruscan Gallery* (fig. 37)—uses many of the same techniques to suggest the dusky atmosphere of the Louvre, the light of the window, and the reflections on the glass showcase. The models, Cassatt and her sister, Lydia, are also distanced in mood, turned away from the viewer and caught up in their own musings.

In addition to studying the psychological subtleties of people seen in public places, the Impressionists, in their quest for "real life" in all its intimacy, also examined their own private surroundings. Most of them used members of their own families as models and their homes and gardens as settings—another prac-

45 *Elsie in a Blue Chair*

46 *Sleeping Baby*

tice that Cassatt had never fully appreciated before. Just as she had never taken a sketchbook with her to record glimpses of the outside world, she had not yet thought to turn the domestic scene to artistic use. Although she had painted portraits of her family and had depicted her own furniture in her interior genre scenes, she had not viewed her everyday environment as artistic material. Now, under Impressionist influence, she began to portray the life of her own day by using her home as an informal life class, sketching her parents, sister, and friends.

This was eminently practicable, for in 1877 Mr. and Mrs. Cassatt and their elder daughter, Lydia, had come to Paris to live, and they were all comfortably ensconced in an apartment at 13, avenue Trudaine, not far from the Place de Pigalle and Montmartre—a respectable address, yet in the heart of the artists' quarter. Mr. and Mrs. Cassatt had previously made frequent trips abroad to visit their daughter, but as they advanced in age (in 1877 Mr. Cassatt was seventy-one and his wife sixty-one), they began to see Paris as an attractive place to spend their retirement. Lydia had also made long, and mutually enjoyed, visits to Mary's Paris apartment. Now forty, she had led a restricted life in America owing to her ill health, so the vast cultural offerings as well as the excellent medical care available in Paris made the idea of a permanent home there seem attractive to her as well.

A drawing that evokes their family life is the Study for *Five o'Clock Tea* (fig. 38). The style of the drawing is unusual. It falls between the academic approach Cassatt had learned at the Pennsylvania Academy and the spontaneity of a rapidly executed sketch. This is a controlled drawing with careful outlines and a skillful use of hatching to suggest three-dimensional form. The composition is not woven together by continuous lines, as are the studies (figs. 29, 30) for *At the Opera* (fig. 31); instead, the space is unified by a tilted and diagonal foreground and overlapping zones in the manner of a Japanese print.

This drawing inspired two works—a painting and a print—that differ immensely in overall effect. The painting, *Five o'Clock Tea* (fig. 39), is restrained in color but exploits the richness of oil paint to endow the scene with the material ease of an upper-class bourgeois setting. Textures of precious substances—the silver tea set and the porcelain vase on the mantel—are highlighted, and decorations have been added to costumes and surfaces that were plain in the drawing. The figure facing forward is now hatted and gloved, the wall sports striped wallpaper, and the fireplace and the frame above it are both more ornate.

The print (fig. 40), quite otherwise, rather than emphasizing material luxury, evokes the atmosphere of a private moment shared by a family in a comfortable home. Through textures and tones achieved by a variety of techniques—aquatint, parallel hatching, and scraping of the plate—an ambience is created that subtly brings out the contemplative mood of the subjects. These two contrasting interpretations of the theme demonstrate Cassatt's thorough understanding and masterly utilization of the expressive potential of the various artistic mediums.

Absorbed as she was in experimenting with effects of interior lighting and familiar, casual subjects in the manner of her mentor, Degas, Cassatt was also inspired by those of her colleagues in the Impressionist group who concentrated

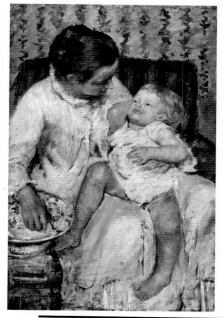

47 *Mother About to Wash Her Sleepy Child*

1880. Oil on canvas, 39½ × 25¾″
The Los Angeles County Museum of Art
Mrs. Fred Hathaway Bixby Bequest

The beautifully painted porcelain washbowl had become a standard motif in Impressionist versions of the toilette *subject. Here Cassatt gives a new twist to the use of the motif: the woman, fully dressed, dips her cloth into the bowl and washes not herself but her child.*

46 *Sleeping Baby*

1880. Pastel, 24 × 16″
Collection Antonette and Isaac Arnold, Jr.
Houston

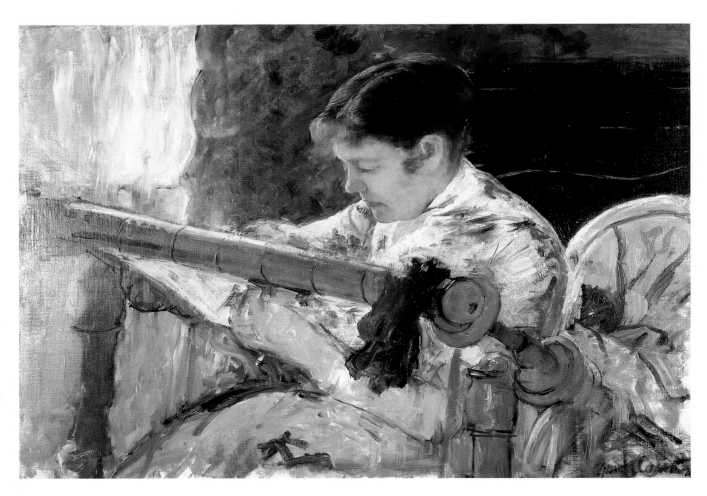

48 *Lydia at a Tapestry Loom*

on the brilliant effects of sunlight and took nature as their subject. In many of the paintings of around 1880, flowers appear, usually as a backdrop. Rarely, flowers are the primary subject, as in *Lilacs in a Window* (fig. 41), a striking still-life composition in which the orderly diagonal lines of the casement, casement bar, and windowsill, frame and point up the organic overflow of the lilacs themselves.

Flowers serve as a backdrop in two paintings of women, *Woman Reading in a Garden* and *The Cup of Tea* (figs. 42, 43). In both cases the lushness of the flowers is sustained in the sumptuous texture of the dresses and in the quality of the paint itself. In both cases the positioning of the flowers behind the women's heads intimates to the viewer that the blossoms symbolize their thoughts (a connection that Redon would make in his more mystical compositions). However, the paintings differ significantly: one is set outdoors, in a garden, while the other is clearly indoors. In the first, the flowers and greenery surrounding the reading woman make for a relaxed image. The second painting is a more formal episode. As compared to the simple, light dress of the reader in the garden, the costume of the tea drinker is elaborate and stylish. The lustrous material, the full ruffles at the neck and elbows, the fashionably shaped and decorated hat, and the long gloves all represent adaptation to the conventions of social life. Similarly, the flowers behind her have been regimented into a flowerbox to serve the purposes of interior decoration.

In the summer of 1880, after Cassatt had been exhibiting with the Impressionist group for two years, her repertory of subjects was enlarged by the arrival on the scene of her brother and sister-in-law, Aleck and Lois Cassatt, and their four young children, Eddie, Katharine ("Sister"), Robbie, and Elsie (the eldest eleven, the youngest five), whom she had not seen in five years. The presence of the children—a source of real happiness—meant that "Aunt Mary" had available child models in daily-life settings, and this reawakened an interest that she had felt only sporadically since her involvement with the Ecouen school of peasant genre over ten years earlier. Her Impressionist outlook now enabled her to take advantage of resources close at hand and to treat with freshness and originality subjects generally susceptible to sentimental cliché.

Some of the paintings that resulted, like *Mrs. Cassatt Reading to Her Grandchildren* (fig. 44), turn to account both the child models and the country setting of the house in Marly-le-Roi where they spent the summer. Although the painting is set indoors, the sunlight from the window behind the figures gives the effect of *plein air*—of a work painted outdoors. Cassatt here conveys the brilliance of light by using a great deal of white throughout the composition, at the same time employing sharp, pure colors as accents in the faces, hands, and clothes. The clear reds and blues used in this manner are bold strokes and become a standard part of Cassatt's technique.

In using members of her family as models Cassatt straddled the line between genre and portraiture. By definition, genre subjects are typical rather than specific; the identity of the models is not relevant to the general view of life presented. But when friends and family pose for a genre painting, the probability of

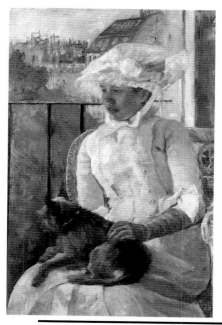

49 *Susan on a Balcony Holding a Dog*

1882. Oil on canvas, 39½ × 25½"
The Corcoran Gallery of Art, Washington, D.C.
Museum purchase

Posing her favorite model of the early 1880s, Susan, on a balcony, Cassatt achieved the brilliance of painting in the open air without losing the urban flavor of Paris. This was one of the few times she depicted the city she lived in for almost fifty years.

48 *Lydia at a Tapestry Loom*

1881. Oil on canvas, 25⅝ × 36⅜"
Flint Institute of Arts, Michigan
Gift of The Whiting Foundation

The freedom of color and brush stroke in this painting does not obscure the accuracy with which Cassatt has rendered her sister's physiognomy and the complexities of the tapestry frame. Nor does the picture's general reference to a long tradition of paintings of women sewing obscure the specific and personal commemoration of Lydia's accomplishments as a needlewoman.

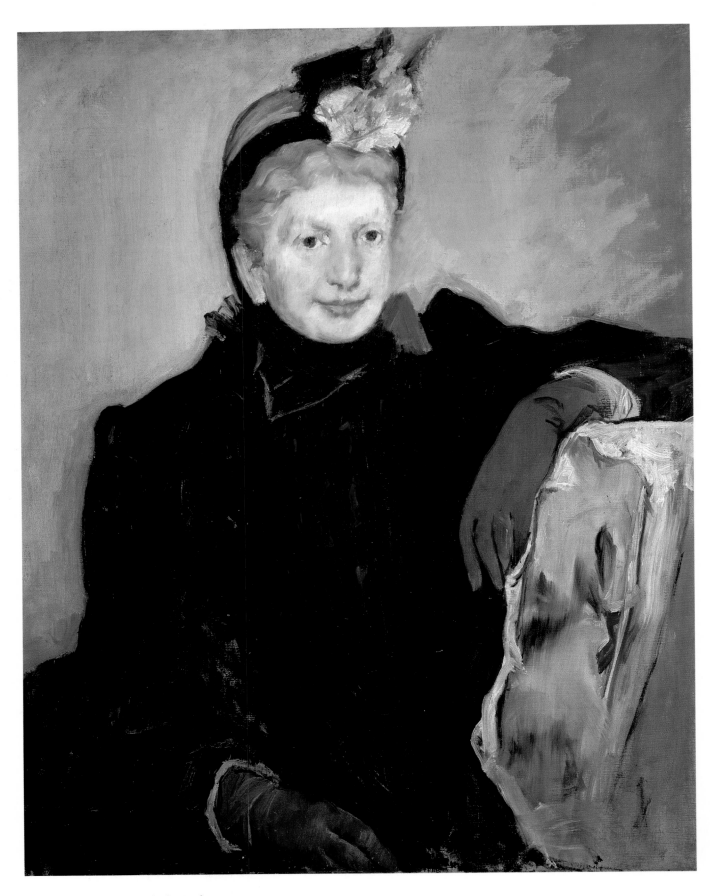

50 *Portrait of an Elderly Lady*

recognition gives the viewer the sense—so valued by the Impressionists—of "modern life" being captured. Manet's use of his brother and a friend as models in *Le Déjeuner sur l'herbe*, for example, made the work a vivid recasting of an older theme into modern guise. Clearly, in painting *Mrs. Cassatt Reading to Her Grandchildren* Cassatt's goal had simply been to turn available subject matter into the most effective work possible. But the genre-portraiture duality inherent in the painting affected its destiny. The picture, much admired when it was exhibited in the Impressionist exhibition of 1881, was purchased by M. Dreyfus, the collector and friend whose portrait Cassatt had rendered in pastel (see fig. 28), but the Cassatt family, regarding the work strictly as portraiture, insisted that she buy it back and give it to her brother, the children's father.

Even when her intention was definitely portraiture, Cassatt used genre devices, depicting everyday life and surroundings as well as her subject. Many times she portrayed her sitters in the poses typical of her studies of unidentified figures—reading, sewing, pouring tea, and the like. Her portrait of her youngest niece, *Elsie in a Blue Chair* (fig. 45), was designed so that the child's softened features constitute a minimal part of the overall effect. Another example is the portrait Cassatt painted of her mother soon after her parents' arrival in Paris in 1877. *Reading Le Figaro* (fig. 26) uses the favorite Impressionist pose of reading a newspaper (in this case French, signifying her mother's new residence). A critic's reaction to this painting when it was exhibited in New York in 1879 testifies to Cassatt's success in avoiding the clichés of portraiture and in capturing the essence of "ordinary life"; reviewing the exhibition held by the Society of American Artists, S.N. Carter wrote:

Among the technically best pictures in the entire collection was Miss Cassatt's portrait, a capitally drawn figure of an agreeable-looking, middle-aged lady, with a clear skin over her well-formed features, and with soft, brown, wavy hair. It is pleasant to see how well an ordinary person dressed in an ordinary way can be made to look; and we think nobody seeing this lady reading a newspaper through her shell "nippers" and seated so composedly in her white morning-dress, could have failed to like this well-drawn, well-lighted, well-anatomised, and well-composed painting.

Spurred by her success in using Impressionist devices to avoid the clichés of portraiture, Cassatt attempted to do the same thing with an even more cliché-ridden subject, mother and child. While she produced only a few paintings and pastels of maternal scenes at this stage of her career, they were noticed and received warmly. A typical reaction was that of the celebrated writer J. K. Huysmans in his review of the 1881 Impressionist exhibition:

Ah! les bébés, mon Dieu! how often have their portraits exasperated me! A whole series of French and English dabblers have painted them in such stupid and pretentious poses! . . . For the first time, I have, thanks to Mlle. Cassatt, seen pictures of children who are ravishing—tranquil and bourgeois scenes painted with a kind of delicate tenderness—completely charming.

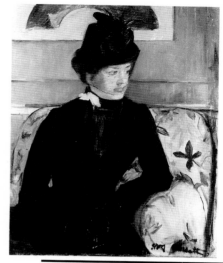

51 *Young Woman in Black*

1883. Oil on canvas, 31½ × 25¼"
The Peabody Institute of
The Johns Hopkins University,
on indefinite loan to
The Baltimore Museum of Art

This painting may be a portrait of Jennie Carter Cassatt, the wife of Cassatt's younger brother, J. Gardner. It was never sent to Philadelphia but remained in the artist's hands until late in her life.

50 *Portrait of an Elderly Lady*

1883. Oil on canvas, 28⅝ × 23¾"
National Gallery of Art, Washington, D.C.
Chester Dale Collection

The sitter in this engaging portrait has yet to be identified.

The apparent spontaneity of the mother and child compositions from the Impressionist period is, of course, an illusion. Cassatt's working methods included developing elaborate sketches of parts of a composition. Thus the pastel sketch *Sleeping Baby* (fig. 46) was done as a study for the painting *Mother About to Wash Her Sleepy Child* (fig. 47). The pose is even livelier and the color even stronger in the pastel sketch, which may have been made from life or from an earlier drawing. As with the paintings for which her nieces and nephews posed, Cassatt often gathered material during a sitting and finished the work after the sitting was over. As much as Cassatt sought the look of immediacy, she did not achieve it without taking painstaking, tedious steps in a long process of developing a painting. She could well have said of herself what Degas claimed in his famous statement "No art is less spontaneous than mine."

Cassatt's family orientation in the years around 1880 also motivated her to use her sister as a model as often as she was well enough to pose. The number of works Lydia modeled for has been greatly exaggerated, however; almost every young woman who appears in a Cassatt painting has been identified as Lydia at one time or another. In fact Lydia's features were very characteristic and are easily recognized, for even when Cassatt was not intending portraiture she depicted her sister's face accurately. Lydia bore a strong resemblance to Mrs. Cassatt in the rather thin, downturned mouth and small, upturned nose. She favored a hairstyle with curly bangs and wore hats that came forward over her forehead, so that her profile was strong and distinctive. Her type of beauty, according to one account, was appreciated more in Europe than in her own country.

Painting Lydia became poignant to a degree when her chronic ill health was diagnosed as Bright's Disease and it was realized that she had only a short time to live. The last year of her life, in which *Lydia at a Tapestry Loom* (fig. 48) was completed, was a painful one, demanding great courage on the part of the whole family. Lydia's final illness and her death, on November 7, 1882, affected her sister deeply. Lois Cassatt, Alexander's wife, arriving in Paris soon after Lydia's death, observed, "She has not had the heart to touch her painting for six months and she will scarcely now be persuaded to begin...." Gradually Cassatt resumed work, but for the next year her depressed state made concentration difficult. In May 1883 her father wrote to Aleck:

Mame, has got to work again in her studio, but is not in good spirits at all—One of her gloomy spells—all artists I believe are subject to them—Hasn't put the finishing touches to your portrait yet—Elsie's still in London—Will send them as soon as possible—By some stroke of Durand Ruels financial policy Mame's pictures (3) were all entered on the catalogue as not for sale—.... Any little contretemps of this kind upsets Mame, & makes her think any thing but favorably of human nature generally—

Not only did Cassatt's personal loss interfere with her work in these years; at the same time she faced a professional setback, the sudden interruption of her annual showing of her work in the Impressionist exhibitions. In 1882, in a factional dispute over the admission of new members, she joined Degas in a boycott

52 *Lady at the Tea Table*

1883. Oil on canvas, 29 × 24"
The Metropolitan Museum of Art, New York
Gift of the artist, 1923

About this portrait of her cousin Mrs. Robert Moore Riddle, who often visited the Cassatts in Paris and had given the Cassatts several presents (including the porcelain tea and coffee service depicted), Mrs. Cassatt wrote in a letter to her son Aleck: "Mary asked Mrs. Riddle to sit for her portrait thinking it was the only way she could return their kindness.... As they are not very artistic in their likes & dislikes of pictures & as a likeness is a hard thing to make to please the nearest friends I don't know what the result will be—" The result was that Mrs. Riddle and her daughter, Annie, did not like the portrait and it stayed in Cassatt's studio for the next thirty years.

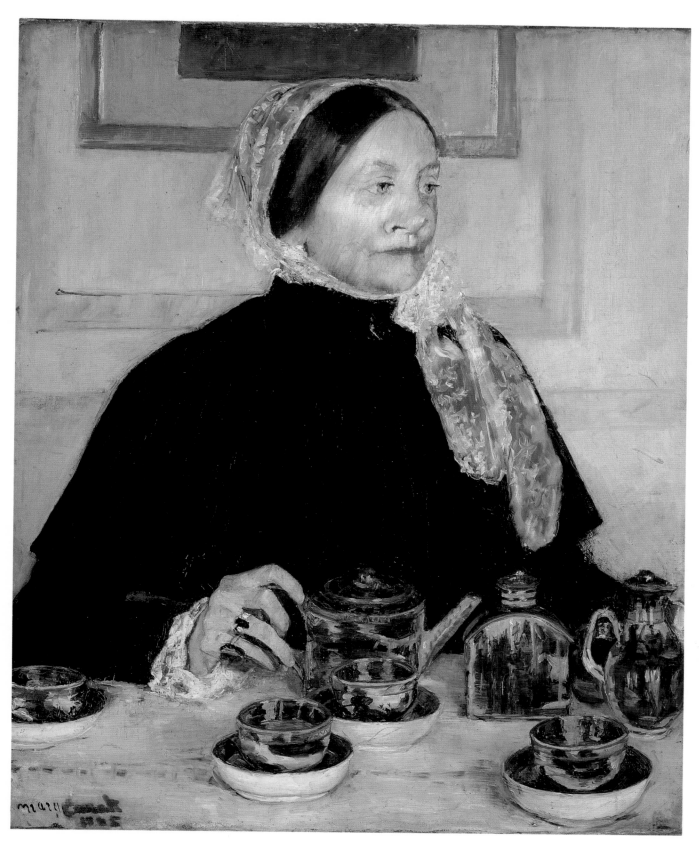

52 *Lady at the Tea Table*

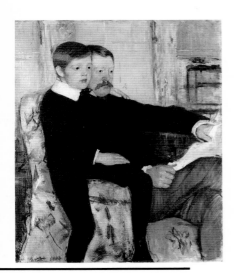

53 *Portrait of Alexander Cassatt and His Son Robert Kelso*

1885. Oil on canvas, 39½ × 32"
Philadelphia Museum of Art
W. P. Wilstach Collection

Alexander "Aleck" Johnston Cassatt (1839–1906), a brilliant young executive with the Pennsylvania Railroad, had retired in 1882 with the rank of first vice-president but maintained his interest in American railroads. In 1899 he became president of the Pennsylvania Railroad and one of the most powerful men in the United States. Years earlier Aleck had written about his artist sister, "Mary was always a great favorite of mine, I suppose because our tastes were a good deal alike. Whenever it was a question of a walk, or a ride, or a gallop on horseback, Mary was always ready. . . ."

of that year's exhibition. Then, because of the group's internal problems and the effects of an economic recession that temporarily crippled the art market, the annual exhibitions were not held for the next three years. Cassatt was left without the focus that these regular group efforts had provided.

These personal and professional troubles resulted in a visible change of direction. While Cassatt continued to associate with the Impressionist group (making her final appearance with them in the last Impressionist exhibition, in 1886), she now began to reassess the style that she had so assiduously mastered and to explore new modes of expression.

One of her last forays into the effects of sunlight in the Impressionist manner is *Susan on a Balcony Holding a Dog* (fig. 49). As in Cassatt's other studies of women from this period, the fabric of the dress and hat are alive with light, here lavender-shadowed. But increasingly she chose a more severe style that emphasized simplicity of form rather than multiplicity of brushstroke and color. *Portrait of an Elderly Lady* and *Young Woman in Black* (figs. 50, 51) show Cassatt lengthening her brushstroke to accommodate the graceful lines of the poses of the subjects. In each case the black-costumed figure silhouetted against a light background bespeaks a social situation that is left up to the viewer to supply.

The most striking of these new severe compositions is *Lady at the Tea Table* (fig. 52), a portrait of Mrs. Cassatt's cousin Mrs. R. M. Riddle. In this painting the brushstrokes, regimented into parallel hatching, give a sense of order and control without detracting from the creamy texture of the paint. The silhouette of the dark-blue dress conceals the figure beneath its bell-shaped symmetry. The upright head and the composed features contribute to the monumental calm of this work, which is broken only by the surprising intensity of design in the fingers curling around the handle of the teapot. In this fine portrait—Degas pronounced it "distinction itself"—the Japanese china tea and coffee service (in the Canton style) is almost a secondary subject: it was Mrs. Riddle's gift to the Cassatts, and the painting itself was a gesture of thanks for this and other kindnesses.

Another example of Cassatt's severe style is the *Portrait of Alexander Cassatt and His Son Robert Kelso* (fig. 53), which although signed and dated 1884 was actually executed in 1885. Aleck and Robbie arrived in Paris on Christmas Day, 1884, as a treat for Mrs. Cassatt, who was recuperating from a lengthy illness. Since the two stayed in Europe for several months—Robbie often residing with his aunt and grandparents while Aleck tended to business in London and elsewhere—Cassatt took the opportunity to paint this large double portrait of father and son, a counterpoint to the mother and child paintings that their visit in 1880 had inspired. The features of the two juxtaposed faces—one a child's, the other a man's—show strong resemblances: especially striking are the two pairs of dark eyes with similar watchful expressions. Father and son are sitting so close together that their dark suits seem to merge. One cannot miss the fact that Cassatt saw a special closeness between her brother Aleck and his younger son, Robbie.

The calm and control of this portrait in its finished state were as much the product of intense effort as the spontaneity of Cassatt's earlier, Impressionist paintings. The preliminary sketches of Robbie for this portrait—in oil (fig. 54)

and pastel—have as much movement as the finished work has poise and restraint. Cassatt's palette in the oil sketch of Robbie consists of dark, warm colors, somewhat akin to those of her pre-Impressionist paintings (see fig. 7).

Two sketches of women—one in pastel, *Woman Arranging Her Veil* (fig. 55), and one in oil, *Young Woman Sewing* (fig. 56)—show the variance in her use of the two mediums. The colors of the two works are related: major tones are tan (for the background) and black (for details of costume). The pastel appears subdued at first, but its strong color accents, such as the yellow in the background and the orange and green in the hair and hat, make it unexpectedly lively. It is in the oil, however, that Cassatt's strongest colors appear—vivid purples and greens around the hands and a strong brown-red for the face. In this period it is the sketches, rather than the controlled, finished pictures, whose qualities form a continuum with the intensity and forcefulness present in Cassatt's works from the start.

In 1886 Cassatt exerted herself once again in behalf of the Impressionist cause by playing an active role in the organization of what was to be the group's final exhibition. Degas, Morisot, another friend, and she underwrote the expenses of the event in exchange for "all profits"—although, as her father wrote, "needless to say they do not hope for or expect any." This enabled the other exhibitors to participate without charge, a tremendous relief for those who, like Pissarro, were not yet financially secure.

The works that were exhibited showed that the entire group, like Cassatt, had gone in new stylistic directions. All the original members were experimenting with ways to gain greater control over brushwork, drawing, and design. Renoir, for example, showed his *Grandes Baigneuses* of 1883, based on his studies of old master drawing, while Degas showed his *Suite de nuds* [sic] *de femmes se baignant, se lavant, se séchant, s'essuyant, se peignant ou se faisant peigner*, which revealed a new classicism in its monumentality and seriousness. The younger faction—more recent additions to the group, such as Seurat and his circle of Neo-Impressionists—were even more clearly interested in imposing greater control on the earlier Impressionist style through systematic color divisions and brushstroke.

Cassatt showed only six oils and one pastel: the years since her last Impressionist exhibition (in 1881) had not been productive ones. But within this small group were works that represented her past concerns and works that foretold future directions. Among them were studies of women in sunlight done in her old Impressionist manner, including *Susan on a Balcony Holding a Dog* (fig. 49), a mother and child pastel (still unidentified) that anticipated her coming preoccupation with this theme, and, finally, a study of a young woman combing her hair that marks the maturing of an idea which was rooted in Impressionist theory but would flower later, in the 1890s. The incident that precipitated the painting of the picture now called *Girl Arranging Her Hair* (fig. 57) is told by Achille Segard in his book on Cassatt:

The story is that one day, in front of Degas, Miss Cassatt in assessing a well known painter of their acquaintance dared to say: "He lacks style." At which Degas began to laugh, shrugging

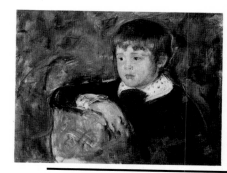

54 *Master Robert K. Cassatt*

1885. Oil on canvas, 19 × 22⅜"
Philadelphia Museum of Art

When Robbie and his father returned home after staying with the Cassatts in Paris over Christmas in 1884, Mary wrote to his mother: "Poor little Rob it seems from your letter that I wrote I was going to amuse him, he got very little amusement; posing for his portrait, did not suit him."

FOLLOWING PAGES

55 *Woman Arranging Her Veil*

1886. Pastel, 25½ × 21½"
Philadelphia Museum of Art
Bequest of Lisa Norris Elkins

Cassatt's first works on the themes of women dressing and grooming appeared around 1886. While Cassatt did not use the nude model until 1890, works like Woman Arranging Her Veil *and* Girl Arranging Her Hair *(fig. 57) reflect a direction that all the Impressionists were now taking—toward subjects of greater intimacy.*

56 *Young Woman Sewing*

1886. Oil on canvas, 24 × 19¾"
The Art Institute of Chicago
Charles B. and Mary F.S. Worcester Collection

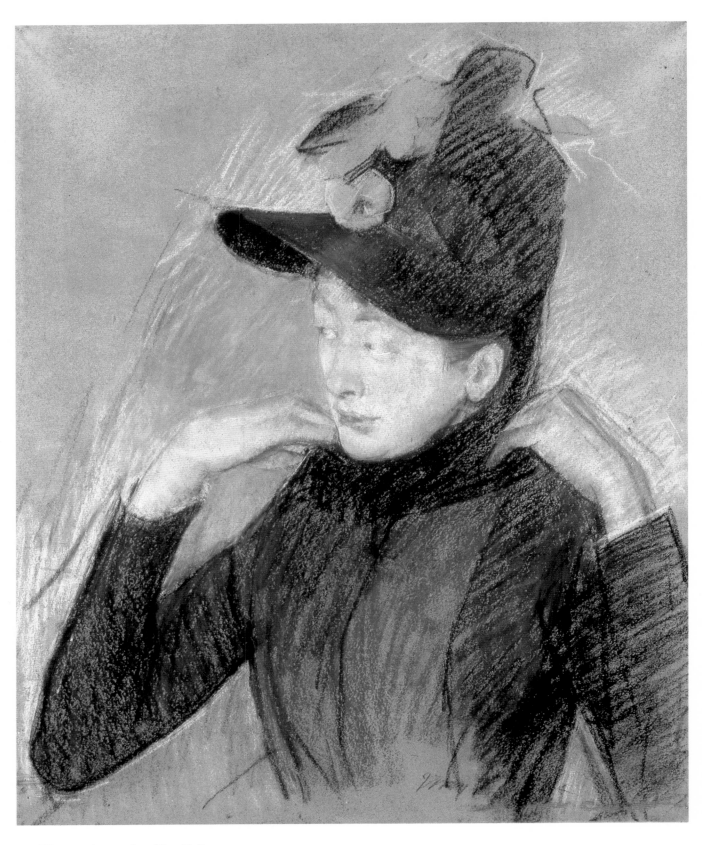

55 *Woman Arranging Her Veil*

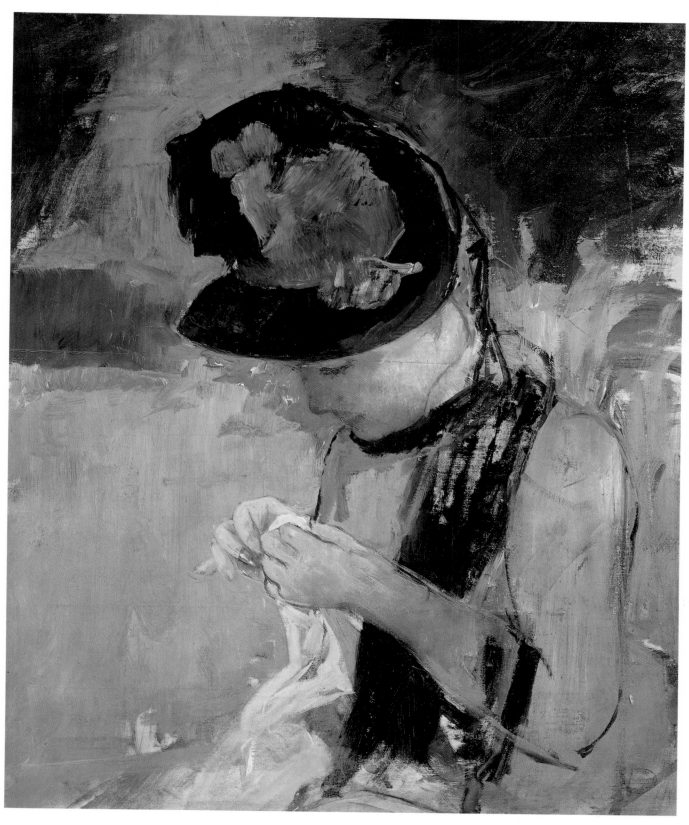

56 *Young Woman Sewing*

his shoulders as if to say: These meddling women who set themselves up as judges! What do they know about style?

This made Miss Cassatt angry. She went out and engaged a model who was extremely ugly, a servant-type of the most vulgar kind. She had her pose in a robe next to her dressing table, with her left hand at the nape of her neck holding her meager tresses while she combed them with her right, in the manner of a woman preparing for bed. The model is seen almost entirely in profile. Her mouth hangs open. Her expression is weary and stupid.

When Degas saw the painting, he wrote to Miss Cassatt: What drawing! What style!

The main point that Cassatt wanted to make was that the subject chosen by the artist was less important in determining the final success of the painting than the artist's skill in drawing, color, and composition. But she made another point that is more daring. This has to do with the mingling of beauty and ugliness so that both contribute to the effect. Some years earlier, in 1879, Diego Martelli, in his noted lecture on the Impressionists, had said: "The relationship between the study of the beautiful and that of the ugly is intimate, and Degas ... had to wed and harmonize these two sentiments. . . ."

At that time Cassatt was experimenting with the relation of the "ordinary" to the "beautiful"—as in her mother's portrait *Reading Le Figaro* (fig. 26)—but only in the mid-1890s did she go so far as to confront the "ugly." From this time on she increasingly posed models with unattractive or plebeian features in attractive, even heroic roles. The piquant effect of this interweaving of contradictory elements was not always appreciated by the general public, but it was a key factor in Cassatt's acceptance into the exclusive avant-garde circle in Paris. Degas said of an artist who was excluded from the group: "He is not wicked [*méchant*] enough for us."

Cassatt's understanding of style and its ingredients changed in the course of her Impressionist years, but her sensitivity to such issues was a key element in her choice of the Impressionist path. She analyzed, experimented, even copied in order to grasp every last nuance of technique and subject matter. Although she was not so accomplished a draftsman as Degas or so free in her brushwork as Monet, she was able to adapt Impressionist principles to her own preferences and limitations more successfully than any but the few artists constituting the inner circle. For this she was recognized by her fellow artists as well as by forward-looking critics in Paris, from Zola to Huysmans.

But Cassatt's purely Impressionist period lasted only a short time. By 1882 she had begun to pull away from brightness and exuberance toward control and stability. Perhaps following the dictates of her own mood after the death of her sister, perhaps joining with Renoir, Degas, and others to reinstate the draftsmanship that had lost ground in the excesses of Impressionist brushwork, perhaps reacting to growing conservatism in the larger world, by the end of this period she had developed a wholly new style. Was she still an Impressionist? In spirit, yes; she would continue to identify with her friends and espouse the cause of freedom from the academic system. But in style and in content she moved on to a personal synthesis that attempted to convey a more universal message.

57 *Girl Arranging Her Hair*

1886. Oil on canvas, 29½ × 24½"
National Gallery of Art, Washington, D.C.
Chester Dale Collection

Degas owned this work from the time it was completed, in 1886, until his death, in 1917. It was then bought by Louisine Havemeyer, who held it until her death, in 1929.

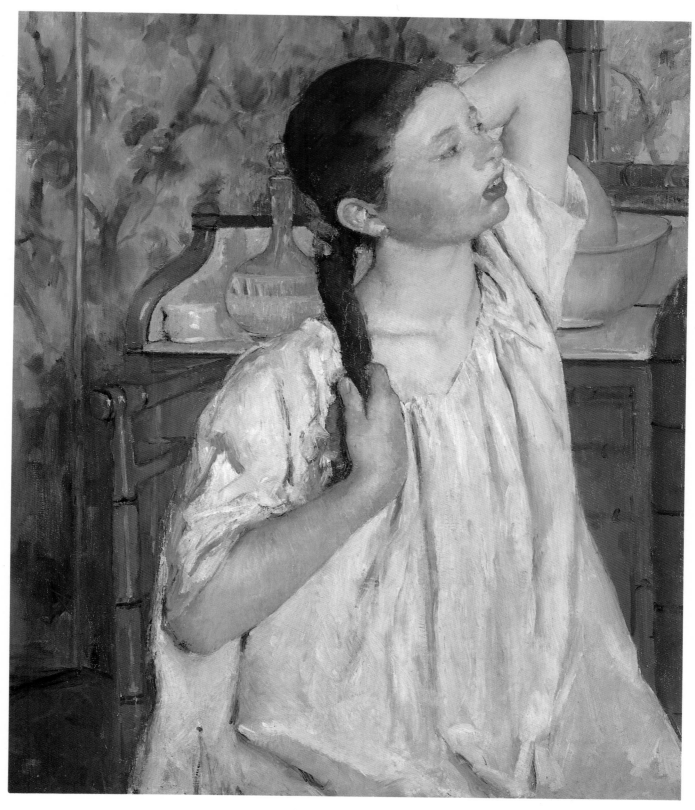

57 *Girl Arranging Her Hair*

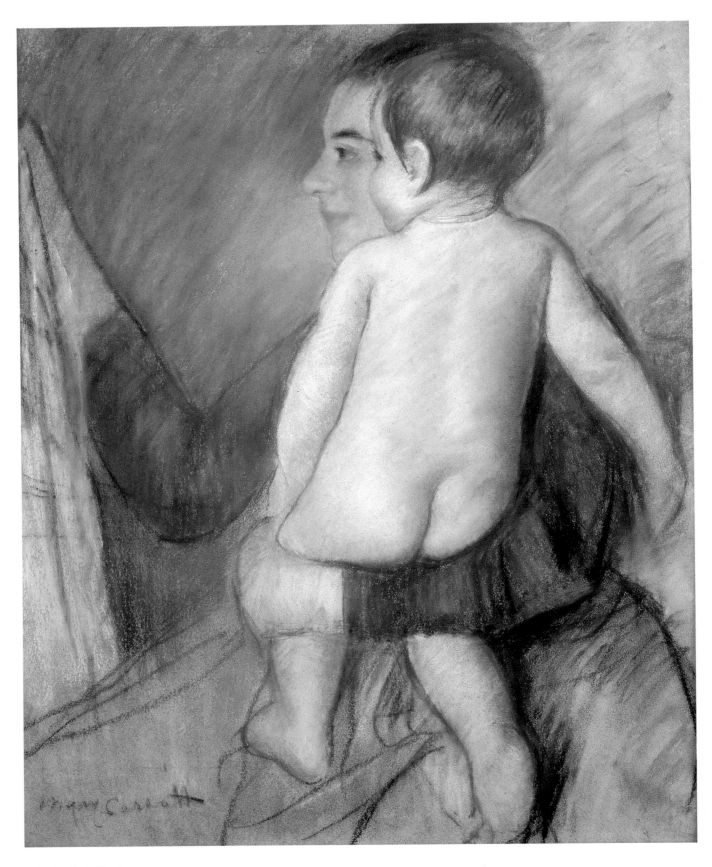

58 *At the Window*

III. The Mature Period (1887–1899)

For the first two decades of her career, Cassatt had confronted the European art world head-on—first squaring off with the Salon system and then braving membership in the Parisian avant-garde—all the while sustaining the highs and lows of expatriate life and membership in a close-knit family. By the late 1880s, however, her life in France had become more settled, and when, in her late forties, she began a new period of intense artistic activity, she no longer looked to established groups for leadership but started subtly, firmly to lay claim to her own territory.

The tenor of her work in the last years of the nineteenth century—the Gilded Age—was affected by the prospering of all the arts. Vast fortunes (including her brother Alexander's), which arose from worldwide industrial expansion, generated art patronage in Europe and America. Artists were encouraged to explore new avenues both in grand-scale projects for the public arena and in private aesthetic enterprises involving increasingly arcane symbolism. As an American living in Paris and moving in avant-garde circles, Cassatt was uniquely situated to take advantage of both trends; she was stimulated simultaneously by the demand for public art and by the intellectual challenge of the Symbolist movement.

Exercising the freedom of this new era, she moved toward new mediums, new design elements, and new subjects. Her first experiments came in printmaking in the late 1880s. Taking up where she had left off after the abandonment of Degas's proposed print journal, *Le Jour et la nuit*, of 1879, she first perfected a distinctive drypoint technique and then progressed to color prints that placed her in the forefront of a new graphic arts movement in Paris. In like manner she began to find new ways of exploiting the linear qualities of pastel, which she had used often in her Impressionist days. Along with this experimentation with technique came a new subject—the mother and child theme—which, like the theater subject of earlier days, was in tune with contemporary artistic trends. In 1892 she began a project that was to have a tremendous impact on her work: the *Modern Woman* mural for the World's Columbian Exposition to be held in Chicago in 1893. Not only was the project itself a challenge; the style that arose from it gave her art a new monumentality. Finally, the last five years of the century she spent exploring portraiture and lighter themes that evoke the delicacy and decorativeness of the age of Art Nouveau.

58 *At the Window*

1889. Pastel and charcoal
on gray paper, 29¾ × 24½″
The Louvre, Paris

69

Cassatt's limited showing in the Impressionist exhibition of 1886 reflected her relative inactivity at that time, and the paucity of critical notice indicated how far she had slipped from her position of high visibility around 1880. The situation was even more obvious in her own country. When the dealer Durand-Ruel held a large exhibition of Impressionist works in New York in 1886, she was represented by only a few entries, mostly older works that were in her brother's collection. Her presence went virtually unnoticed by the New York critics.

This fallow period came to an end, however, in 1889, when Cassatt began exhibiting again with her old comrades in the group known as the Société des peintres-graveurs français, organized by their old etching advisor, Bracquemond. Degas and Cassatt joined Renoir, Morisot, Pissarro, and others in showing their latest experiments in printmaking. For Cassatt this meant an opportunity to present the unique drypoints she had been developing over the past few years.

Cassatt's first major printmaking effort, spurred by the proposed print journal, *Le Jour et la nuit*, had been in etching and aquatint. The etched line, drawn into a coating on the plate and eaten away by acid, was soft and flowing. It was perfect for the effects she was after—palpable atmosphere and dramatic contrasts of light and shadow. The etched line was, in a sense, an Impressionist line. But as Cassatt moved away from this toward a more precise, controlled style, she needed a line that would match the new severity. This she found in the drypoint technique, in which a line is created not by the bite of acid but by the direct scratching of a sharp needle on the metal surface. This process is simpler than etching, and Cassatt said that she used it as a kind of drawing exercise. Although this implies that drypoints should be more spontaneous than etchings, in fact the opposite is true. The aspect of drypoint that improved her drawing was not its spontaneity but its precision. Scratching a design into a metal plate was difficult; the lines did not flow, nor could they be easily corrected, once made. The challenge of drypoint to an artist aiming at a firmer drawing technique is that a linear design which gives the impression of quickness has to be built slowly and carefully.

An excellent example is the drypoint called *Baby's Back* (fig. 59). At first glance it appears to be the most economical of sketches, consisting of only a few major lines barely blocking in the two figures—perhaps five minutes' work. But on closer inspection it is apparent that the major lines, specifically those of the child's back and arm, are actually the result of hundreds of tiny strokes interwoven to suggest not only the outline but also the curve of the form and the shadow it casts on the mother's sleeve. A finished work that was often exhibited, *Baby's Back* is daring in the sparseness of effort it projects.

The reductionism of Cassatt's drypoints illustrates her understanding of the concept of "Synthesis," which was pervasive in radical art theory of the later 1880s. The term was often used by Gauguin (an acquaintance of Cassatt's since their debut with the Impressionists in 1879) in his efforts to pinpoint the essence of artistic expression. "Why are willows with hanging branches called weeping?" he mused. "Is it because drooping lines are sad?" Among a widening circle of artists and critics Synthetism meant simply the reduction of drawing to the neces-

59 *Baby's Back*

1889. Drypoint, third state, 9³⁄₁₆ × 6⁷⁄₁₆″
The Library of Congress, Washington, D.C.

Like Degas, Cassatt had her own printing press. Thus she not only created the design on the plate but printed it herself: the resulting fine art print was entirely from her own hand.

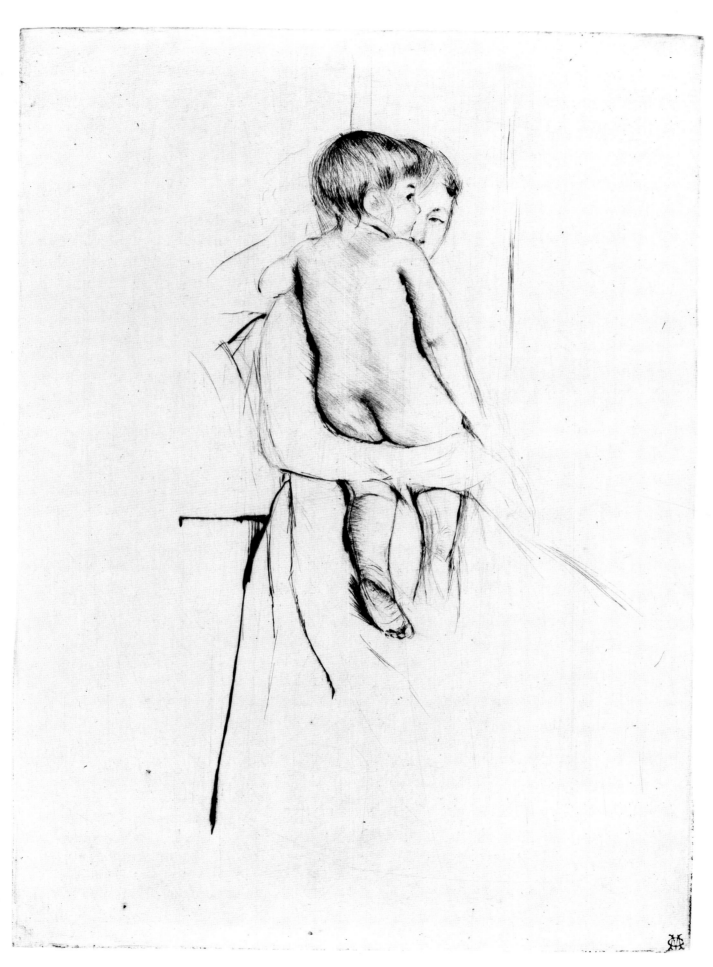

59 *Baby's Back*

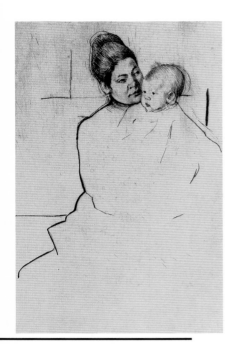

60 *Gardner Held by His Mother*

1888. Drypoint, 8¼ × 5⁷⁄₁₆″
The New York Public Library
Astor, Lenox and Tilden Foundations

Jennie Carter Cassatt, the wife of Mary's younger brother, J. Gardner "Gard" Cassatt (1849–1911), shown here holding their first child, Gardner, was a favorite among the Cassatts. Over the years Jennie and her children appear many times in Cassatt's oeuvre, but there are no surviving portraits of Gard.

61 *Mother and Child*

c. 1890. Oil on canvas, 35⅜ × 25⅜″
Wichita Art Museum
Roland P. Murdock Collection

sary, the vital lines of the movement, and both Cassatt and Degas were recognized as in the forefront of this style, along with Van Gogh and Gauguin. The sources and implications of Synthetism were reported by the astute American critic Cecilia Waern in 1892:

Not to mention the Japanese, who have carried the synthetic treatment of line to such high and singular excellence, or the Greek vase-painters, or Giotto, or countless others, all children and primitive artists are synthesists [sic] after their fashion,—a fashion that seems to meet the high approval of some of the present synthétistes, to judge by specimens of their work. . . . there are . . . in many painters, the most undoubted sincerity, a profound feeling for the charm of mystery, and that longing for and reaching after the deeper spiritual truths of life that are thrilling through many a corner of Paris, undreamt of by the foreigners on the boulevards and the frequenters of the light theatres.

Just as the concept of Synthesis underlies Cassatt's drypoint *Baby's Back* (fig. 59), so it underlies the related pastel *At the Window* (fig. 58), which shows the same design in reverse. The pastel incorporates a similar technique of weaving together hundreds of smaller lines, and, like the drypoint, it is a masterpiece of simplicity. The pastels of this period are often surprisingly dark and velvety rather than being brilliantly colored in the manner of Cassatt's Impressionist pastels.

In both her drypoints and her pastels after 1887 the Synthetist approach to line is indeed, as Cecilia Waern pointed out, coupled with a "profound feeling for the charm of mystery, and that longing for and reaching after the deeper spiritual truths of life." It is in this period that Cassatt takes on the mother and child theme as her specialty, and using her abstract line, she invests the simple, everyday subject with subtle psychological, sociological, and spiritual meaning.

Why the mother and child theme? Cassatt never explained her choice, leaving it to later generations to pile interpretation upon interpretation. The answer probably lies in the combination of pragmatic and idealistic impulses that affected all of Cassatt's choices.

It is relevant that the theme of maternity was one of the most common among artists of all nationalities painting in Paris around 1890. It is found in Impressionist work and even more often in the work of artists in and close to Symbolist circles. Not only did Van Gogh and Gauguin and his followers sanction the theme; others, among them Puvis de Chavannes and Eugène Carrière, who influenced great numbers of artists, helped to popularize it. It is interesting that Americans seemed especially susceptible to the appeal of the mother and child motif; the subject as it was used by artists like George Hitchcock, Gari Melchers, and George de Forest Brush enabled them to endow everyday situations with a spiritual aura.

Reviewing Cassatt's earlier career sheds further light on the appeal of this theme. To begin with, her study of Correggio and other Italian and Spanish old masters had instilled in her a deep respect for the themes and techniques of the past. She had worked hard to apply what she had learned to a modern style. Even while she was immersing herself in the observation of contemporary life that Im-

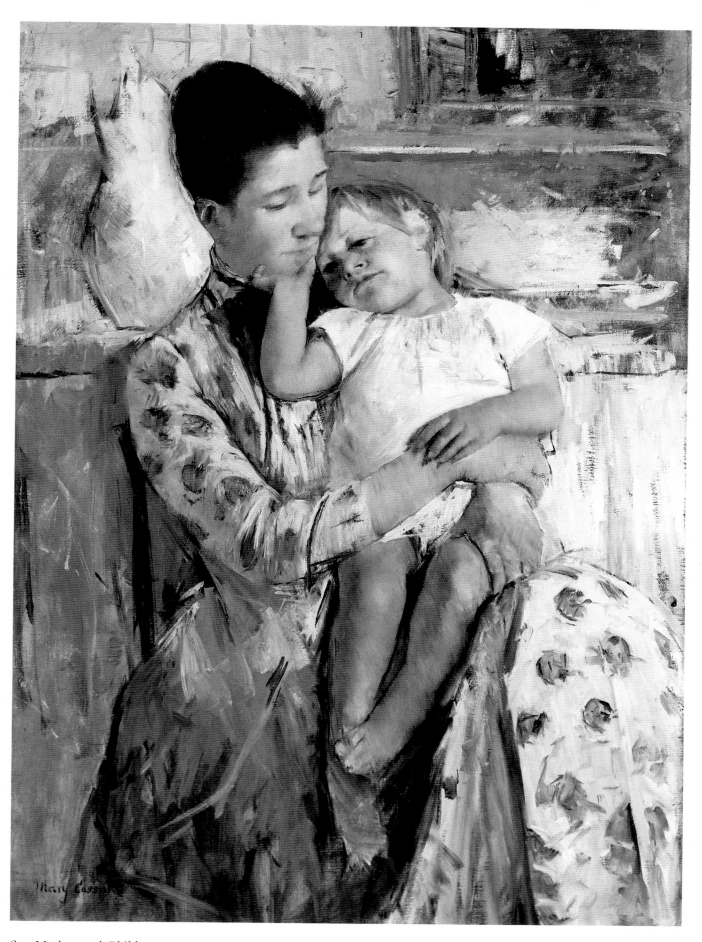

61 *Mother and Child*

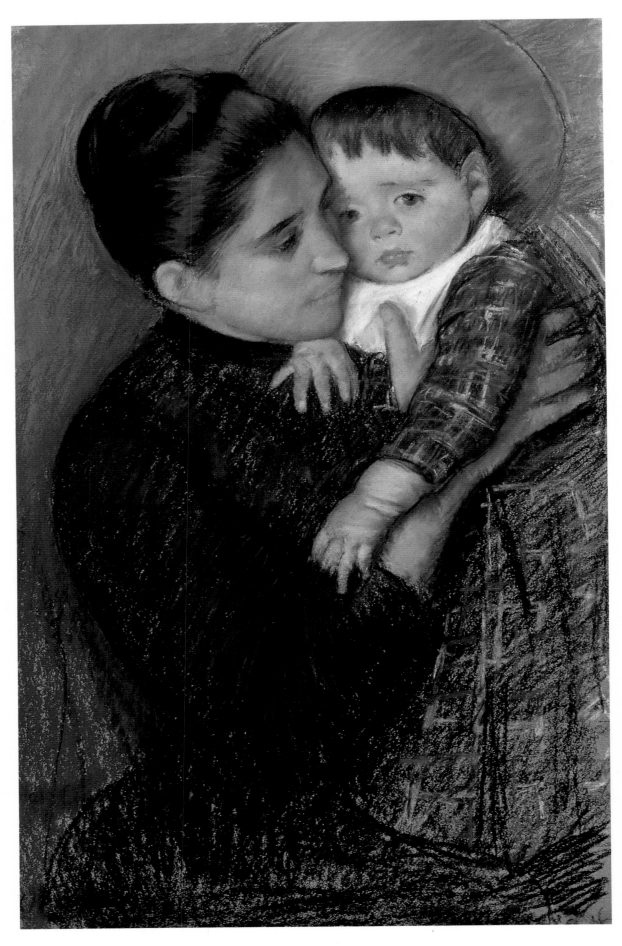

62 *Hélène de Septeuil*

pressionism required she was always seeing echoes of past techniques in the supposedly new discoveries. The subject of mother and child, which her fellow artists were treating as an updated version of the Madonna and Child, enabled her to resolve the conflicts between the old and the new in a satisfactory way. She had, after all, been successful in her paintings of both women and children and had already handled maternal subjects in a few of her Impressionist works. Furthermore, she was adept at painting the fine texture of flesh but not interested in the traditional showcase for this talent—the female nude.

Access to maternal scenes in her daily life, eliminating the necessity for professional models, was apparently not a factor. Except for a few instances, Cassatt found she had perhaps less access to such tableaux than colleagues with children of their own. For the most part she chose her models carefully—both the women and the children—for the special effects she wanted to achieve; they were seldom actually mother and child. But her brothers' families did occasionally provide models for her pursuit of the theme—perhaps even the original stimulus.

The earliest dated maternal scene of this period depicts family members—the drypoint *Gardner Held by His Mother* (fig. 60), inscribed "Jan/88." The Cassatt family, after many years of considering Aleck's children *the* nieces and nephews, had gained a new nephew, the child of Mary's younger brother, J. Gardner Cassatt, and his wife, Jennie. Mary was much closer to this sister-in-law than she was to Aleck's wife, Lois, and consequently became very fond of their children, of whom Gardner, Jr., was the first. Young Gardner was eighteen months old at the time of the drypoint.

Once Cassatt had incorporated the mother and child theme into her oeuvre she tended to treat it in a serial manner as her colleagues, from Monet to Eugène Carrière, were doing with their favorite subjects. This serial approach came naturally to her, since it had long been her habit to derive a number of compositional schemes from working with particular models and then to develop these into full-scale paintings, pastels, and prints. One can see the same serial treatment of other themes that Cassatt used in the 1890s, such as individual women and children, boating, music playing, and conversation. Even in the case of portraits there are spin-offs. With the mother and child theme distinct periods of interest, rather than a constant outpouring, can be discerned. In fact, she may not have intended to return to the theme after the initial series but did so under the dual pressures of critical praise and a favorable market after its success established the motif so firmly as her hallmark.

Cassatt's initial mother and child series, as yet uncorrupted by the public's expectations, in many ways has a simplicity and chasteness that she would never recapture. Directly related to the drypoints of these years, the works emphasize linear clarity, restraint in gesture and facial expression, compressed compositional space, and frontality. These characteristics are reminiscent of the Early Renaissance painters and relief sculptors, whom Cassatt and her contemporaries referred to as Primitives. Indeed seeing such works as *Mother and Child, Hélène de Septeuil, Baby on His Mother's Arm, Sucking His Finger,* and *Mother's Goodnight Kiss* (figs. 61–63, 65) together might put one in mind of a gallery of these early Ma-

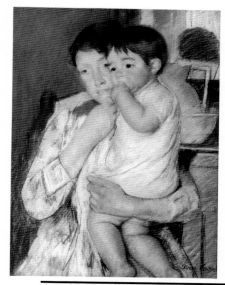

63 *Baby on His Mother's Arm, Sucking His Finger*

1889. Pastel, 25 × 19"
Cabinet des Dessins, The Louvre, Paris

Mother and child compositions of this period entered the collections of some of the most prominent collectors of contemporary French art, among them Théodore Haviland, Paul Gallimard, Sir William Van Horne, Mr. and Mrs. Potter Palmer, Mrs. J. Montgomery Sears, and Mr. and Mrs. H.O. Havemeyer. This pastel was bought by the artist Henri Rouart, who had a notable collection that included both old master and contemporary art.

62 *Hélène de Septeuil*

1889. Pastel on beige paper, 25¼ × 16"
The William Benton Museum of Art
The University of Connecticut
Louise Crombie Beach Memorial Collection

For this pastel (shown in her first solo exhibition, at the Durand-Ruel gallery in 1891) Cassatt posed a little girl, Hélène, from the village of Septeuil, where the Cassatts spent the summer of 1889. Hélène is identified in the inscription on one of the drypoints that Cassatt made of this composition.

64 Pages 118–19 of *Legends of the Madonna as Represented in the Fine Arts* by Anna Jameson (London: Longman, Green, 3rd ed., 1864)

Anna Jameson first published her famous Legends of the Madonna, *with her own illustrations in etching and woodcut, in 1852. She described the mother and child motif as "as subject so consecrated by its antiquity, so hallowed by its profound significance, so endeared by its associations with the softest and deepest of our human sympathies, that the mind has never wearied of its repetition, nor the eye become satiated with its beauty."*

65 *Mother's Goodnight Kiss*

1888. Pastel, 33 × 29″
The Art Institute of Chicago
Potter Palmer Collection

donnas or of a page in a book on the subject—in particular the most famous such book at the time, Anna Jameson's *Legends of the Madonna as Represented in the Fine Arts* (see fig. 64). Cassatt's dealer, Paul Durand-Ruel, forced the comparison by calling Cassatt the painter of "la sainte famille moderne." One of the mother and child paintings, which her friends Louisine and Henry Havemeyer had bought from the Durand-Ruel private collection, was always referred to by them as Cassatt's "Florentine Madonna." These quiet images evoke the most inward aspect of the mother and child relation and fit easily into contemporary humanist interpretations of spiritual experience.

Four of these early mother and child paintings and pastels were shown in 1891 in a small exhibition (fourteen works hung in a single room) at the Durand-Ruel gallery in Paris—Cassatt's first solo exhibition and one of the most important of her career. It came about because that year the Société des peintres-graveurs français, to which Cassatt had contributed for the previous two years, decided to exclude non-French artists, and Cassatt and Pissarro found themselves suddenly outsiders; to ameliorate the situation, Durand-Ruel offered each of them a separate room in the gallery so that they might show their work at the same time as the Société. Fortunately Cassatt was prepared to make the most of the opportunity, since she had recently completed an extraordinary series of ten etchings printed in color.

In the spring of 1890 the Ecole des Beaux-Arts had mounted a large exhibition of Japanese woodcut prints borrowed from French collections. Cassatt visited it several times and soon thereafter began her own series. For years artists in Paris had been admiring the colorful woodcuts of the ukiyo-e style, which had developed in Japan beginning in the seventeenth century, and many tried to imi-

76

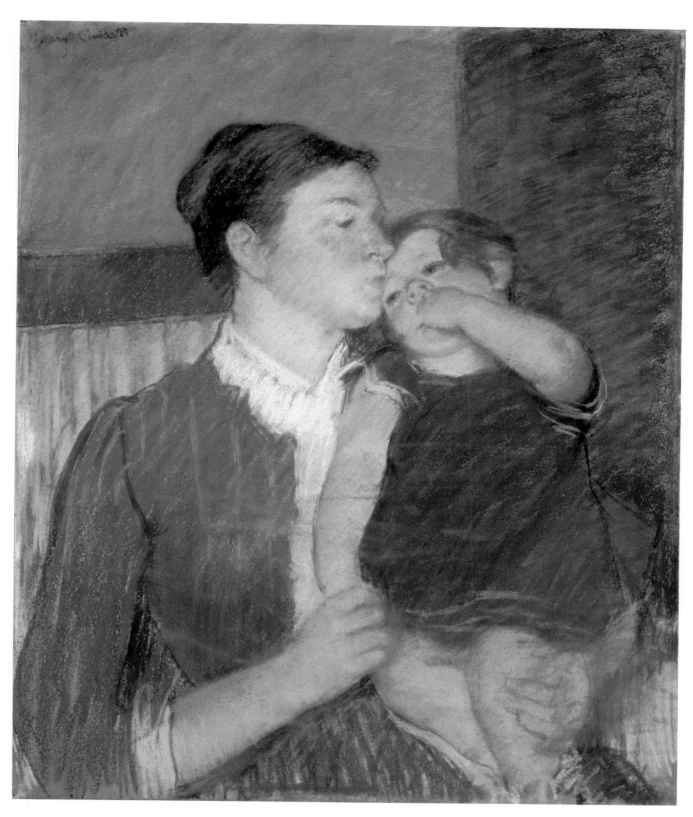

65 *Mother's Goodnight Kiss*

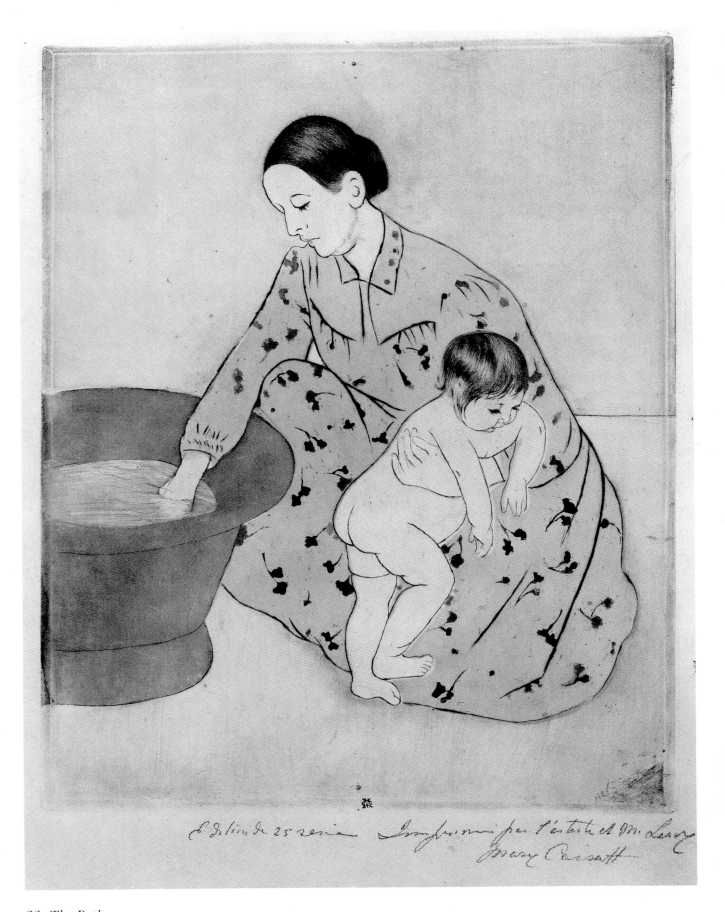

66 *The Bath*

tate their exotic effects. Above all, the prints were considered highly decorative—the perfect pictures to add color and pattern to the walls of Parisian apartments. The subjects were also agreeable, mostly views of the countryside, scenes of daily life, and portraits of famous actors and great beauties.

The Japanese influence affected different artists in different ways. Artists like Degas, Monet, Whistler, and Van Gogh were intrigued by the brilliant color and interesting spatial patterns of the woodcuts. Printmakers were also fascinated by Japanese elements of design but, curiously, were slow in adopting the color printing processes that made the Japanese works so distinctive. Gauguin, for example, borrowed Japanese motifs in the series of zincographs he exhibited at the Café Volpini in 1889 (in the Japanese manner, he bound and sold the series as a set), but he applied the color by hand instead of using color inks in the printing process.

Cassatt was the first artist to imitate successfully all aspects of the ukiyo-e prints, including their color. Her accomplishment was appreciated most by those also engaged in the attempt, among them Pissarro, who described her prints glowingly in a letter to his son: "The tone even, subtle, delicate, without stains on seams: adorable blues, fresh rose, etc.... the result is admirable, as beautiful as Japanese work, and it's done with printer's ink!" In her series Cassatt combined simplicity of design, Oriental spatial patterns, flat areas of color, and daily-life subject matter to create a Western version of this Eastern art form.

Only the first print in her series could, according to Cassatt, be called a true imitation. In this, *The Bath* (fig. 66), she used at least three plates and went through a bewildering number of states (alterations of the plates) to achieve the desired effect. Some years later she explained that in the series' other nine prints she reverted to a more "atmospheric," Western style, that is, she added a more complete background to the composition. But despite this change in "atmosphere," it is obvious that many Eastern effects remain, including perspective, simplification of planes, decorative patterning, and color. There is, in addition, an occasional hint of Japanese facial features throughout.

Cassatt's assimilation of Japanese style may be studied by comparing a preliminary drawing for *The Coiffure* with the finished design (figs. 67, 69). The starting point is clearly a study from life that includes heavy shading in the figure. In refining the drawing to the essence of form and movement Cassatt seems to have referred to a Japanese print, *Girl at Mirror* by Sukenobu (fig. 68), which helped her pare the figure down to its outlines and suggested certain conventions for the drawing of the breasts and the bend of the elbows.

However, Cassatt's source for the color prints was not necessarily exclusively Japanese. The fact that she incised the lines into a metal plate (an intaglio process) rather than creating raised lines on a woodblock (the relief process used by the Japanese) suggests that she studied Western color print processes such as those used in eighteenth-century color aquatints and mezzotints. The interest in color printing around 1890 brought to light the long history of European work in this area; particularly admired were the delicate productions by French printmakers of the previous century such as Philibert-Louis Debucourt. The popular

66 *The Bath*

1890–91. Drypoint and aquatint in color,
12⁵/₁₆ × 9 ¹³/₁₆"
The Metropolitan Museum of Art, New York
Gift of Paul J. Sachs

Impressed with the amount of work Cassatt was putting into the new series of color prints of which this was one, her mother wrote: "It is very troublesome also expensive & after making the plates of which it takes 2 or 3 or 4 (according to the number of colors required), she has to help with the printing which is a slow proceeding and if left to a printer would not be at all what she wants."

68 Nishikawa Sukenobu. *Girl at Mirror*

1731. Woodcut
The New York Public Library
Astor, Lenox and Tilden Foundations

Nishikawa Sukenobu (1671–1751), one of the most popular and prolific masters of the Japanese print, produced over 300 books depicting all aspects of the daily life of his time. Because his woodcuts were in black and white rather than color, they were less well known in the West, but they were appreciated by connoisseurs such as Cassatt and Degas.

67 *The Coiffure*

1890–91. Pencil, 5¹³⁄₁₆ × 4⅜″
National Gallery of Art, Washington, D.C.
Rosenwald Collection

69 *The Coiffure*

1890–91. Drypoint with aquatint in color,
14⅜ × 10½″
The Metropolitan Museum of Art, New York
Gift of Paul J. Sachs

The few examples we have of female nudes by Cassatt are prints. Of these, The Coiffure *and another print from the series exhibited in 1891,* Woman Bathing, *are the best-known. In a sense, they are the culmination of Cassatt's interest in scenes of women bathing and grooming, which began with* Girl Arranging Her Hair *(fig. 57) five years earlier.*

69 *The Coiffure*

rococo subjects were women bathing, at their toilette, writing or reading a letter, and conversing with their maids—the same subjects as Cassatt portrayed in her series.

There is an eroticism in the rococo prints that casts an interesting light on Cassatt's series. Her prints have a seriousness and a modesty that are immediately striking. But underneath there is a subtle sensuousness that pervades the calm of the women in their various states of undress; it is perhaps at its height in her portrayal of the woman licking the envelope in *The Letter* (fig. 70). The scenes of women with children have another kind of physicality, the warmth conveyed by the soft, nude children's bodies and the closeness of mother and child. The preciousness of the etching process (it produces only a small number of prints) and its association with the past may have persuaded Cassatt to choose it over lithography, which was more popular for color prints among her contemporaries.

The exhibition of the series of ten color prints in 1891 solidified Cassatt's fame as a printmaker, which had been growing in the previous few years among French collectors and *amateurs*. Her French success was so marked as to cause her to be disappointed in the reception of her prints in New York later that year. While the set of prints entered some American collections, such as that of Samuel Avery in New York and Mrs. Kingsmill Marrs in Boston, on the whole she did not find the American buyers she expected. In discussing a sale of the prints in Paris she wrote to Joseph Durand-Ruel, "Of course it is more flattering from an Art point of view than if they sold in America, but I am still very much disappointed that my compatriots have so little liking for any of my work."

Cassatt could not have known that soon afterward she would attract a very important American collector who would bring her work home to America on a monumental scale. The collector was Bertha Honoré Palmer, prominent in Chicago society and president of the Board of Lady Managers for the Woman's Building of the World's Columbian Exposition to be held in Chicago in 1893. In March 1892, Mrs. Palmer came to Paris to engage two American women artists to paint murals for the two large tympana of the Hall of Honor of the Woman's Building. She learned of Cassatt's work through an American art agent living in Paris, Sara Hallowell, and was so taken with what she saw that she bought one of the mother and child pastels, *Mother's Goodnight Kiss* (fig. 65), and offered Cassatt the commission for one of the murals. She also engaged Mary Fairchild Mac-Monnies, an artist whose work was more academic and better known in America; to Cassatt she assigned the theme "Modern Woman" and to MacMonnies "Primitive Woman." The two murals demonstrating the advancement of women throughout history were to face each other at opposite ends of the Hall of Honor.

Preparations for the lavish Columbian Exposition impelled hundreds of American artists to tackle projects of a scale and import that they had never before confronted. Whereas in Europe the state-supported academies were charged with producing artists who could make the proper allegorical statements in large-scale painting and sculpture for public monuments, in the United States this type of training was difficult to find. Suddenly, as the United States en-

70 *The Letter*

1891. Color print with drypoint and aquatint
13⅝ × 8¹⁵⁄₁₆"
National Gallery of Art, Washington, D.C.
Chester Dale Collection

Cassatt regarded her color prints, which would sell for far less than her paintings and pastels, as original works of art accessible to a wider public. Thus she went to great lengths to ensure that every print was unique: she hand-inked the plates each time they were to pass through the press, often remixing the colors to obtain a different effect. In the case of The Letter, *variations of color occur from print to print in the bib, the dress, and the flowers in the wallpaper.*

70 *The Letter*

71 *Modern Woman*

(mural for the south tympanum of the entrance to the Hall of Honor of the Woman's Building of the World's Columbian Exposition, Chicago, 1893)

Oil on canvas, 12 × 58′
Whereabouts unknown (presumed destroyed)

To accommodate this enormous canvas Cassatt, then working at her summer home in Bachivlliers, had a special glass-roofed studio built; a large trench dug in the ground enabled her to raise and lower the canvas with winches, obviating the need to work on ladders.

72 Study for *Young Women Picking Fruit* 1892. Print (?) 17¼ × 11″
Whereabouts unknown

Whether this study was a drawing or a print, or a combination, cannot be determined, since we know it only from a surviving photograph. The standing woman is wearing the dress seen in the painting Woman with a Red Zinnia *(fig. 83), but the cut of the bodice is reversed. Also, the figures are reversed from their positions in the final painting (fig. 73), which suggests that this study was intended for a never executed color print based, like* Gathering Fruit *(fig. 78) and* The Banjo Lesson *(fig. 80), on themes from the mural* Modern Woman.

tered the Gilded Age, public sculpture and mural painting were in demand, and American artists had to rise to the challenge.

Cassatt's experience with the *Modern Woman* mural (figs. 71, 74) is an interesting example of an artist with little preparation approaching the problems of public art. In some ways her career up to this point was as little calculated to serve her in this effort as it could be. Her most recent accomplishment was in the small-scale medium of the print. Indeed the ten color prints she had shown the year before were the ultimate in non-public art in that they were designed as a portfolio and were not necessarily intended to hang on a wall. As a genre painter, then an Impressionist, then a specialist in the mother and child theme, she had been concerned with intimate subject matter and the depiction of private moments. The conventions of rhetorical gesture, pose, and expression that she had been immersed in while studying at the Pennsylvania Academy and while copying old master paintings in the great European museums had had to be restructured when she chose a more radical direction.

But in other ways Cassatt was an ideal candidate for this project. She had always hoped for a prominent position in the art world, painting pictures (works of the artist's invention) rather than portraits. Through her study of Correggio and others she had gained a lasting admiration for and knowledge of the grand traditions of Western art, and they distinguish her work even though she consciously avoided the conventional. This was especially true in the series of mother and child paintings and pastels she had just completed, which required an inexhaustible supply of new compositional ideas. Furthermore, the theme, "Modern Woman," was consonant with her own interests. Not only did she rely on female subjects, but through her involvement with Impressionism she was devoted to the depiction of contemporary life and all that that signified about style, manner, and behavior. While she had not yet participated in the feminist political movement of her day in the United States or France, she clearly subscribed to feminist tenets, advocating the participation of women in the entire range of human endeavor, and regarded her own life as an example.

As for the conceptual aspects of mural painting, Cassatt adhered not so much to the conventional idea of the mural as public statement as to the idea of the mural as decoration, a concept that had been the subject of much discussion in Impressionist circles—and of even more in Symbolist groups inspired by Puvis de Chavannes, Gauguin, and other heroes of the era around 1890. The modern decorative mural was intended not to serve nationalistic or commercial purposes but to reflect the basic concerns of the people themselves. As the Symbolist theoretician G.-Albert Aurier put it in his 1891 article on Gauguin, "Decorative painting is, strictly speaking, the true art of painting. Painting can be created only *to*

THE MATURE PERIOD

decorate with thoughts, dreams and ideas the banal walls of human edifices." A later example of a large-scale Symbolist work is Gauguin's *D'où venons-nous? Que sommes-nous? Où allons-nous?* of 1897. But few Impressionists or Symbolists had an opportunity to practice new ideas about mural decoration; such commissions typically went to academic artists. Cassatt's mural gave her a much-envied arena for experimentation.

Since the mural, like the Woman's Building for which it was painted, was a temporary display and was demolished after the close of the exposition, we can study it only through the photographs taken at the time and through paintings based on its designs. They show at once the mixing of the old and the new, Western and Eastern influences, familiar and arcane Symbolism that was typical of the Post-Impressionist period. Critical reaction to the mural was, on the whole, cool. Its import was not altogether clear to contemporary viewers, and to this day its meaning remains elusive.

According to Cassatt's own account, she divided the surface of the canvas into three scenes, bordered by a design reminiscent of Persian miniatures. The central composition was *Young Women Plucking the Fruits of Knowledge or Science*, the left *Young Girls Pursuing Fame*, and the right *Arts, Music, Dancing*. Her "ideal would have been one of those admirable old tapestries brilliant yet soft." The center, with women picking fruit and handing it down to young girls and babies, is a gentle allusion to the strides of women in educating themselves and providing for future generations. The image of pursuing fame is less accessible: three girls with their arms outstretched toward a small flying figure above the horizon, with, on the left, a gaggle of geese snapping at their heels. This depiction, with its comic overtones, contrasts in mood with the central panel. On the right, the three figures in quiet poses of dancing, strumming a banjo, and observing the scene are similarly removed in tone from the rest of the mural.

The message of the *Modern Woman* mural is obviously not couched in narrative form. Rather than a literal depiction of what modern women do, Cassatt attempted something subtle and abstract. Through color, costume, and symbol it was her purpose to communicate the ideas of rejoicing (or celebration), modernity, and the charm of womanhood ("if I have not conveyed some sense of that charm…if I have not been absolutely feminine, then I have failed"). The color, brilliance, and gaiety of the composition would come through style and fashion; "femininity" would be expressed by the exclusively female figures and the babies. But while creating the atmosphere of "a great national fête" in the mural she "reserved the seriousness for the execution, for the drawing & painting"—to her the most important aspect of the work.

More effective than photographs in giving an idea of what the mural looked like are the paintings, pastels, and prints that Cassatt executed from sketches for the mural. She divided the multifigured allegorical composition into smaller segments, showing women and children in scenes similar to but not identical with the mural. In most cases the models wear the same modish dresses that Cassatt had commissioned for the mural to indicate "modernity." It was previously thought that these works may have been done before the mural, but it seems

73 *Young Women Picking Fruit*

1892. Oil on canvas, 52 × 36"
Museum of Art, Carnegie Institute
Pittsburgh, Patrons Art Fund, 1922

When this painting was purchased by the Carnegie Institute, in 1922, Cassatt wrote to the director of fine arts, "It may interest you to know what Degas said when he saw the picture you have just bought for your museum. It was painted in 1891 [in fact 1892] in the summer, & Degas came to see me after he had seen it at Durand-Ruels. He was chary of praises but he spoke of the drawing of the woman's arm picking the fruit & made a familiar gesture indicating the line & said no woman has a right to draw like that."

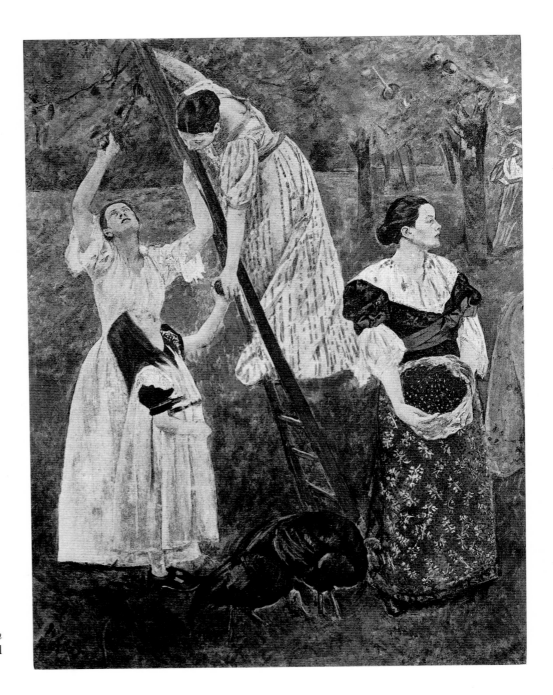

74 *Young Women Picking Fruit* (detail of central panel of *Modern Woman* mural). Chicago Historical Society

75 *Sketch of a Young Woman Picking Fruit*

1892. Oil on canvas, 23½ × 28¾"
Collection Mr. and Mrs. Sigurd E. Anderson II
Des Moines

clear from Durand-Ruel's stockbooks that she was finishing and delivering them to the gallery a few at a time while she worked on the mural and after she finished it. (Deliveries were made in August 1892, January 1893, and November 1893). At least nine of these paintings, pastels, and prints were exhibited in a large show of her works at Durand-Ruel's at the end of 1893.

The theme that inspired the greatest number of mural-based works was the mural's central image: women picking fruit. In figs. 72–75, 77, 78 we can see this theme in an array of renderings, from preliminary sketches to finished oils and color prints. Cassatt adapted the tree of knowledge theme, with its biblical connotations of disobedience, sin, and sexuality into a modern statement about inde-

75 *Sketch of a Young Woman Picking Fruit*

76 Line Drawing of Albrecht Dürer's *Madonna and Child* from Anna Jameson, *Legends of the Madonna as Represented in the Fine Arts* (London: Longman, Green, 3rd ed., 1864)

Jameson used Dürer's Madonna and Child *to illustrate a version of what she called the* mater amabilis, *the most personal and intimate of Madonna types.*

77 *Baby Reaching for an Apple*

1893. Oil on canvas, 39½ × 25¾″
Virginia Museum of Fine Arts, Richmond

This was one of the last of the paintings inspired by the **Modern Woman** *mural to be completed and sent to Durand-Ruel for the Cassatt exhibition held in Paris in November 1893. The color print* Gathering Fruit *(fig. 78) was also shown in that exhibition; it is possible that the oil was painted after, and based on, the print.*

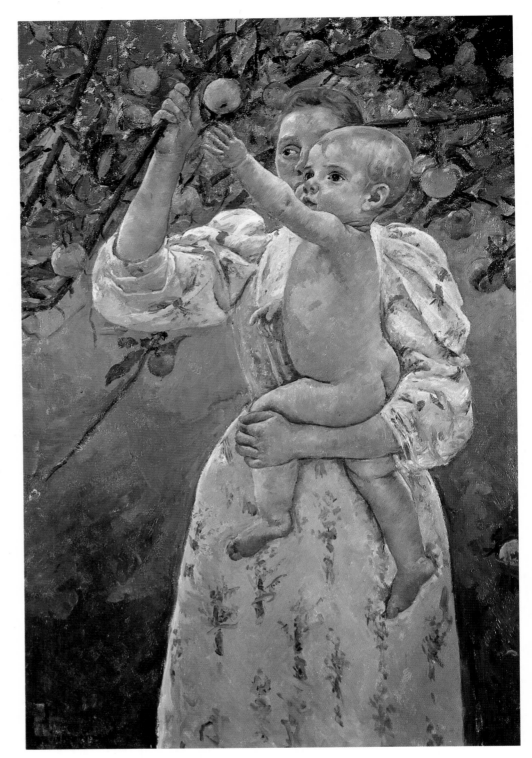

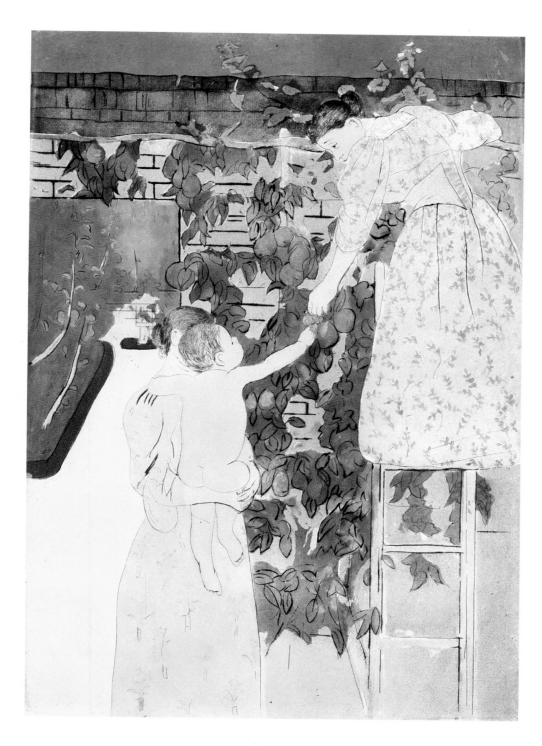

78 *Gathering Fruit*

1893. Color print, 16¾ × 11¾"
Collection Mrs. Adelyn D. Breeskin
Washington, D.C.

*Between her exhibitions of 1891 and
1893 Cassatt's concept of the color print
changed, and in the later exhibition she
showed not only finished prints like this
one but several preliminary states as well,
indicating that she felt her experimental
and unfinished work in this medium could
also have an appeal for the public.*

pendent women taking upon themselves the pursuit of knowledge and its
dissemination. The seriousness that had characterized her portrayals of women
in her Impressionist days reemerges here, giving the theme an aura of deeper
meaning. André Mellerio, in his essay for the catalogue of the 1893 exhibition,
described a typical figure as having the "grandeur and simplicity of a young
priestess in an antique procession."

The style of beauty found in this period of Cassatt's work is indeed one of
grandeur and simplicity. The elegant dresses that the models wear barely soften

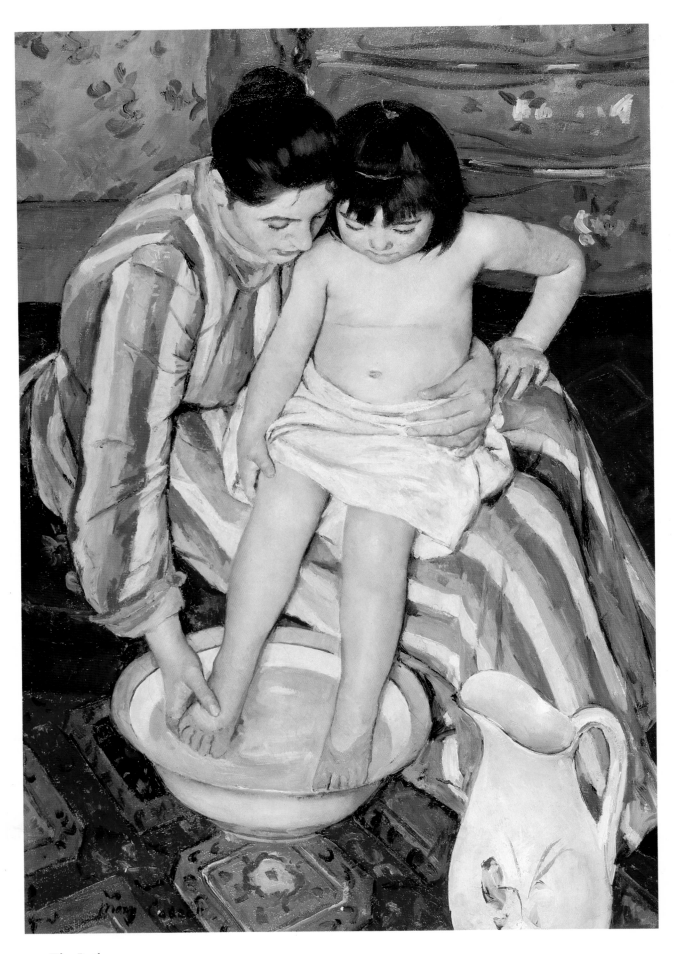

79 *The Bath*

the large, powerful bodies underneath; even the current hairstyles have been modified to reveal the shape of the head. Cassatt's primary model (who appears in these and several other works from this time) has rather plain features and a distinctive strong neck. She wears the elegant costumes but does not tailor her movements to match—they remain stiff and angular.

The two studies for *Young Women Picking Fruit* show how the concept of the painting evolved. The oil sketch (fig. 75) concentrates on movement in the composition, using the low viewpoint to show the woman's thrown-back head framed by the radiating lines of the boughs behind her. The other sketch (fig. 72) is, oddly, a full view of the composition but in reverse. Furthermore, the costumes, arm gestures, and details of the setting are slightly different. The final version shows a more conscious play of abstract design, for example, the zigzag pattern that the diagonal folds and arm create in the standing figure.

In the case of *Baby Reaching for an Apple* and the color print *Gathering Fruit* (figs. 77, 78) it would seem that the painting was done after the print, since it shows the same compositional direction. Making prints from the mural designs was uppermost in Cassatt's mind as she wound up the great work and sent it off. Since this and one other, *The Banjo Lesson* (fig. 80), are the only color prints based on the mural designs, it is possible that she was diverted from the series by the need to produce more large-scale works for exhibition and sale. Her dealer, Durand-Ruel, apparently discouraged her printmaking efforts, sensing that other works, particularly pastels, were in greater demand.

Cassatt took liberties with spatial and anatomical rendering that can in some cases be linked to contemporary Post-Impressionist tendencies toward distortion and in others may be the result of ideas gleaned from such sources as Anna Jameson's well-known *Legends of the Madonna*. The peculiar juxtaposition of the baby's head and the mother's eye in *Baby Reaching for an Apple* (fig. 77) is strikingly similar to that in Dürer's *Madonna and Child* (fig. 76) as it is rendered by the crude line drawing in Jameson's book, while the pastel *In the Garden* (fig. 82) has a flat, patterned background in the manner of Vuillard and other Nabis.

Cassatt's use of color also takes on a Post-Impressionist boldness and haunting quality in this period. The pastel titled *The Banjo Lesson* (fig. 81)—which seems to have been done after the color print (fig. 80)—employs a vivid royal blue in the modeling of the flesh tones. While this is not unusual in Impressionist work, here the color is so intense as to be shocking in its departure from literal realism.

Of all the works done in the wake of the mural, perhaps the most unusual are those on the theme of the contemplative woman. Working in oil, pastel, and print mediums, Cassatt varied the theme little, once she established its very powerful characteristics. Here again we see her preferred model with her rather homely face, powerful neck, broad shoulders, and angular arm gestures. In each work she sports a different costume, but none changes her forceful personality. In *Woman with a Red Zinnia* (fig. 83) the model's air of withdrawal may be related to her solitary contemplation of nature, although this is barely suggested. In *Clarissa Turned Right with Her Hand to Her Ear* (fig. 84), Cassatt recasts the theme of

79 *The Bath*

1891–92. Oil on canvas, 39 × 26″
The Art Institute of Chicago
Robert A. Waller Fund

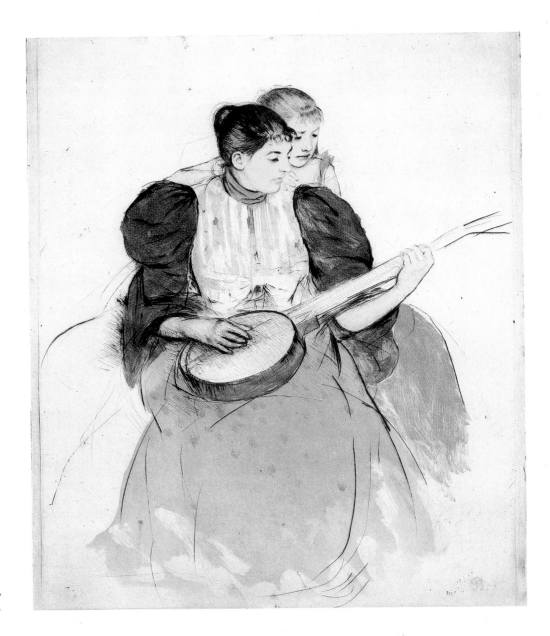

80 *The Banjo Lesson*

1893. Color print, fourth state, 11⅝ × 9⅜″
The Library of Congress, Washington, D.C.

81 *The Banjo Lesson*

c. 1894. Pastel, 28 × 22½″
Virginia Museum of Fine Arts, Richmond
The Williams Fund

*In the late 1880s the banjo had been "dis-
covered" and was a fixture of polite draw-
ing rooms. Its novelty may have inspired
Cassatt to use it in her* Modern Woman
*mural and subsequent prints and pastels
as a means of updating the traditional al-
legorical representation of music.*

private contemplation in a public, social setting that she had first explored in her Impressionist opera subjects. This pastel also has the boldness of color found in *The Banjo Lesson*. The neck, for instance, already a prominent feature of this model, is shaded with a green veil of pigment.

Hints of this treatment of the contemplation theme can be seen in earlier drypoints. *The Parrot* (fig. 86) is a forerunner of *Woman with a Red Zinnia* in its suggestion of absorption in nature. The drypoint *Reflection* (fig. 85), a strong frontal view of a woman, conveys much the same psychological distance, in a public setting, as *Clarissa Turned Right with Her Hand to Her Ear*. The attention to costume in these works seems ironic in view of how little the women themselves reflect the social and public situation suggested by what they are wearing.

These works represent the flowering of the experimentation with beauty and ugliness Cassatt had begun in the mid-1880s with *Girl Arranging Her Hair*

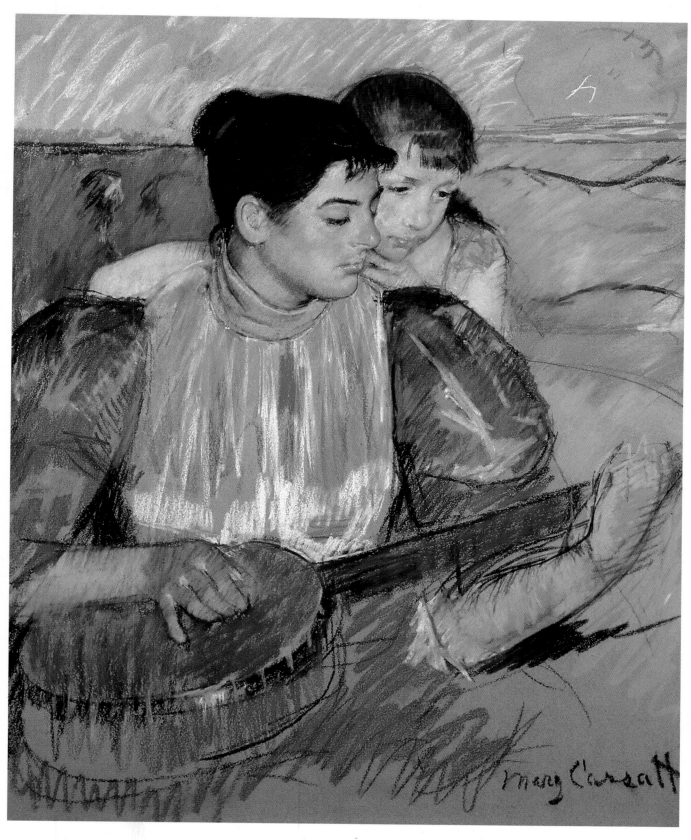

81 *The Banjo Lesson*

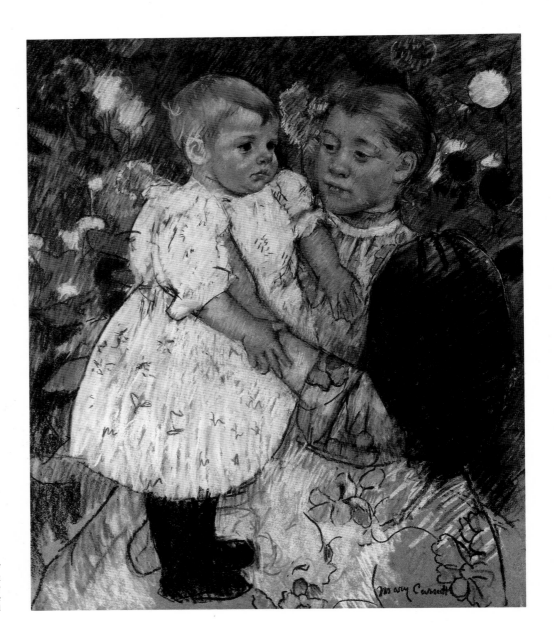

In André Mellerio's introduction to the catalogue of Cassatt's *1893* exhibition (in which this painting is listed as **Reverie**), he commented, "It has been rightly said that Miss Cassatt has never painted any women but those 'who have a serious soul.'"

(fig. 57). Years later (1911) in a letter to a friend she responded to criticism of this drastic device:

So you think my models unworthy of their clothes? You find their types coarse. I know that is an American newspaper criticism, everyone has their criterion of beauty. I confess I love health & strength. What would you say to the Botticelli Madonna in the Louvre. The peasant girl & her child clothed in beautiful shifts & wrapped in soft veils. Yet as Degas pointed out to me Botticelli stretched his love of truth to the point of painting her hands with the fingernails worn down with field work!

A work done soon after the mural but not based directly on it is *The Bath* (fig. 79). Delivered to Durand-Ruel in November 1893, this painting was immediately hung in the major exhibition of Cassatt's works being held in their gallery. Like

THE MATURE PERIOD

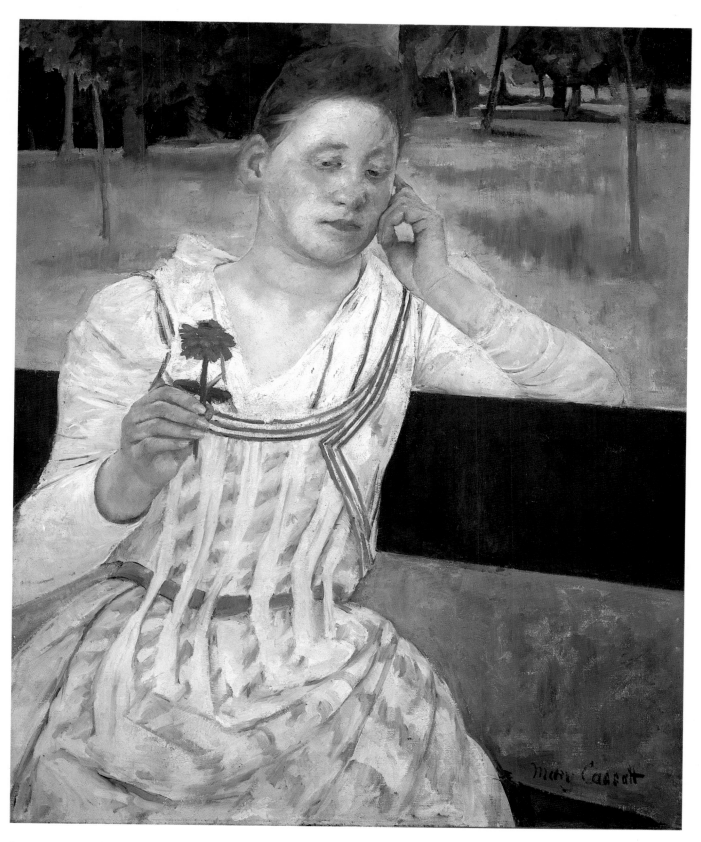

83 *Woman with a Red Zinnia*

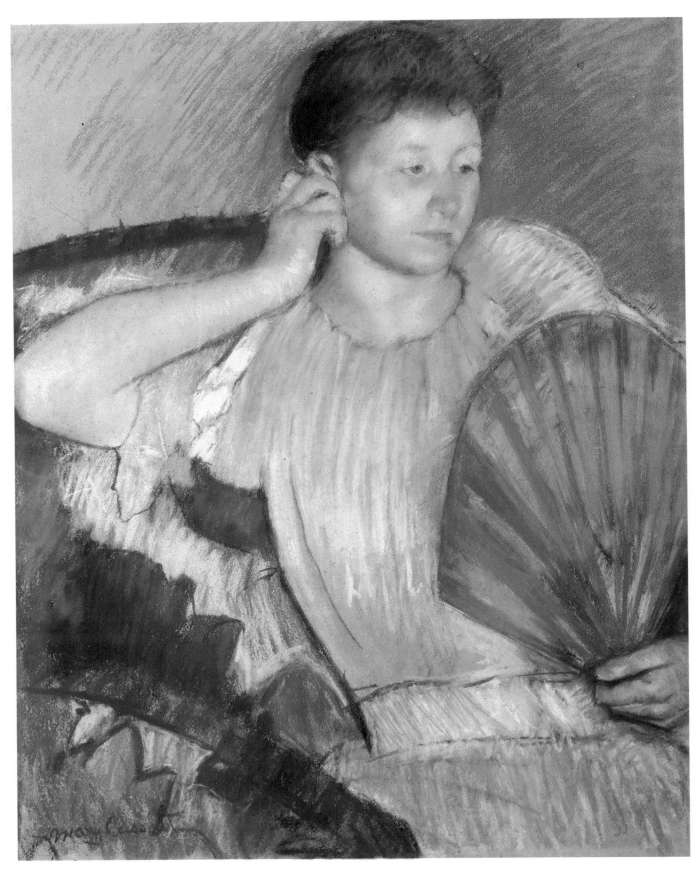

84 *Clarissa Turned Right with Her Hand to Her Ear*

the other works of this period, it displays a grandeur and psychological distance that differentiates it from the mother and child pictures of a few years earlier. The bird's-eye perspective allows both figures to be seen at full length even though they are seated and gives a more complete view of the space around them. Because of the extreme perspective their facial expressions are somewhat obscured. The linear design of the woman's dress emphasizes the straight line of her arm, while the child's straight legs and arm echo it. Both mother and child are solemn. These figures are not in the least relaxed or playful in their solitude. They are as formal as if they were engaged in a sacred rite; the mother's concentration suggests the Madonna washing the feet of the Christ Child. Their orientalizing facial features add another cryptic note to the composition, making them seem even less an ordinary mother and child.

Cassatt's experience with the *Modern Woman* mural caused her to produce a group of works so coherent that it forms as much of a series as did her earlier drypoints, color prints, and mother and child paintings. It was a productive time, and in general, despite some critical failures, it was satisfying to her. The financial success of this period, thanks in part to the efforts of Durand-Ruel, made it possible for her to buy a house in the country. She chose an eighteenth-century chateau, Beaufresne, at Mesnil-Théribus, not far from her friend Pissarro at Eragny. The chateau was located about fifty miles northwest of Paris, so that she could travel easily between it and her apartment in town. She no longer had to make new arrangements every year to rent a summer residence and was now able to entertain family and friends for long visits, a pleasure she enjoyed until the end of her life.

In the 1890s Cassatt's family life, always an important influence, entered a new phase. Her elderly father and mother, who had lived with her since 1877, died—Mr. Cassatt in 1891 and Mrs. Cassatt in 1895. The loss of her parents was a severe blow, but it was in part assuaged by the birth of two nieces, Gardner's daughters Ellen Mary, her namesake, born in 1894, and Eugenia, born in 1897. As with Aleck's children a decade earlier, she devoted a great deal of love and attention to Gardner's son and two daughters.

In comparing the portraits of these young relatives with her earlier portraits of nieces and nephews we see interesting parallels. The similarities of pose between *The Sailor Boy: Gardner Cassatt* (fig. 87) and *Master Robert K. Cassatt* (fig. 54), and between *Ellen Mary Cassatt in a White Coat* (fig. 88) and *Elsie in a Blue Chair* (fig. 45) make the family resemblances stand out. In coloring, hair, and facial features, the children are quite like one another. These very similarities are so marked as to make the change in Cassatt's style strikingly apparent. In particular, a comparison of the portraits of Elsie Cassatt and Ellen Mary Cassatt points up the new breadth in the artist's approach to the figure. In the latter portrait, using the voluminous costume and the strong lines of the composition, she creates a child with new weight and solidity; the Impressionist lightness of stroke and activity of pose have given way to a grander, more solemn image. The older nieces and nephews (Aleck's children) still played a large role in Cassatt's life, now as young adults. Katharine Cassatt, who was portrayed listening to her grandmoth-

84 *Clarissa Turned Right with Her Hand to Her Ear*

1893. Pastel on paper, 26 × 20″
Private collection

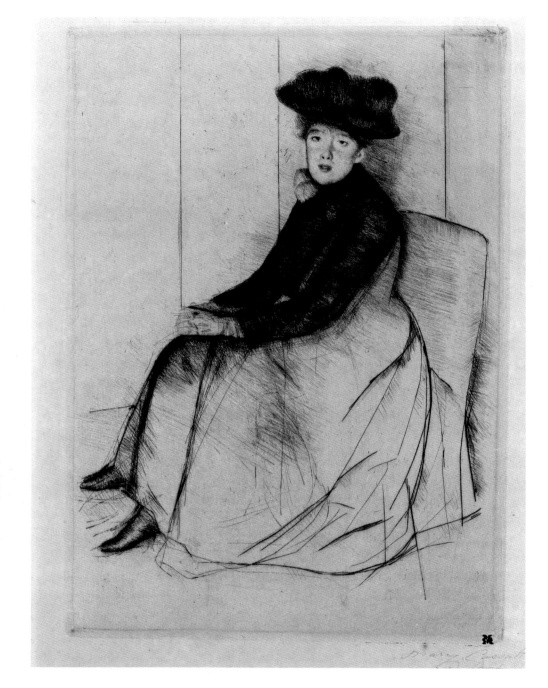

85 *Reflection*

1889. Drypoint, 10¼ × 6¹⁵⁄₁₆″
The Metropolitan Museum of Art, New York
Bequest of Mrs. H.O. Havemeyer, 1929
The H.O. Havemeyer Collection

86 *The Parrot*

1889. Drypoint, 6⅜ × 4¹¹⁄₁₆″
The New York Public Library
Astor, Lenox and Tilden Foundations

In The Parrot *and in other drypoints of the series she exhibited in 1890, Cassatt harks back to themes of the 1860s and 1870s; her woman with a parrot is a down-to-earth translation of the two sensuous versions of the same theme by Manet and Courbet painted in 1866. Manet's* Woman with a Parrot *was in the news in 1889—the year of Cassatt's drypoint—when it was given to the Metropolitan Museum of Art by an American who had bought it in 1881.*

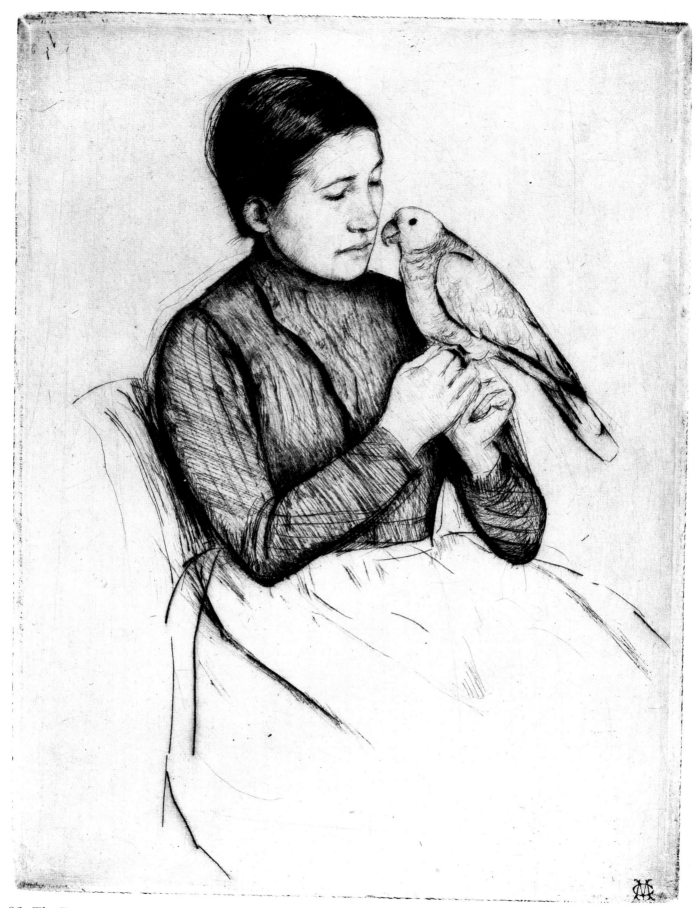

86 *The Parrot*

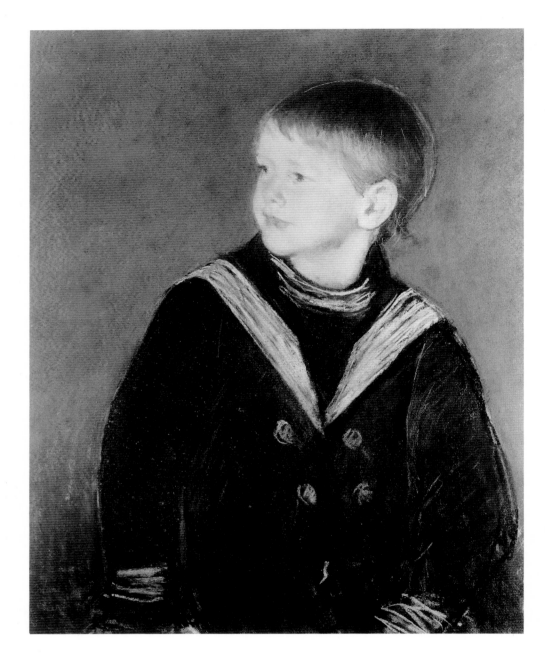

87 *The Sailor Boy: Gardner Cassatt*

1892. Pastel, 28 × 23″
Philadelphia Museum of Art
Given by Mrs. Gardner Cassatt

Now a boy of five, Gardner Cassatt (seen as an infant in fig. 60) had come with his mother, Jennie, to be with the Cassatts in France during the final illness of Mary's father, and Cassatt took great comfort from their presence. This portrait was done during the period of adjustment and recovery after Mr. Cassatt's death.

88 *Ellen Mary Cassatt in a White Coat*

c. 1896. Oil on canvas, 32¼ × 24″
Museum of Fine Arts, Boston
Anonymous gift in honor of Ellen Mary Cassatt

Of all her nieces and nephews, Ellen Mary Cassatt (1894–1966) was the closest to her Aunt Mary. She was a frequent model for Cassatt from earliest childhood. Ellen Mary was the one who most delighted in visiting her aunt in France, and it was she who inherited the Chateau de Beaufresne—a tribute to the liveliness she and her friends had brought to its halls during Cassatt's declining years.

er read fairy tales in 1880 at Marly-le-Roi, was becoming a fashionable young woman when her aunt next painted her portrait (see figs. 44, 89).

A new ingredient in Cassatt's life initiated in 1893 was her annual trip to the south of France. For several years she went to Antibes, where she was able to combine some work with the amusements of the Mediterranean resort. This experience in a region of brilliant sunlight, coupled with living in her new country house, led her to take up landscape motifs once again although in general she was interested in landscape only as a background for figures. While in Antibes in 1894 she painted *The Boating Party* (fig. 90), which is unusual not only for its setting but also for its inclusion of a male figure: except for portraits of her father, brother, and nephews, the male figure can be found only in the occasional sketch, never in the

THE MATURE PERIOD

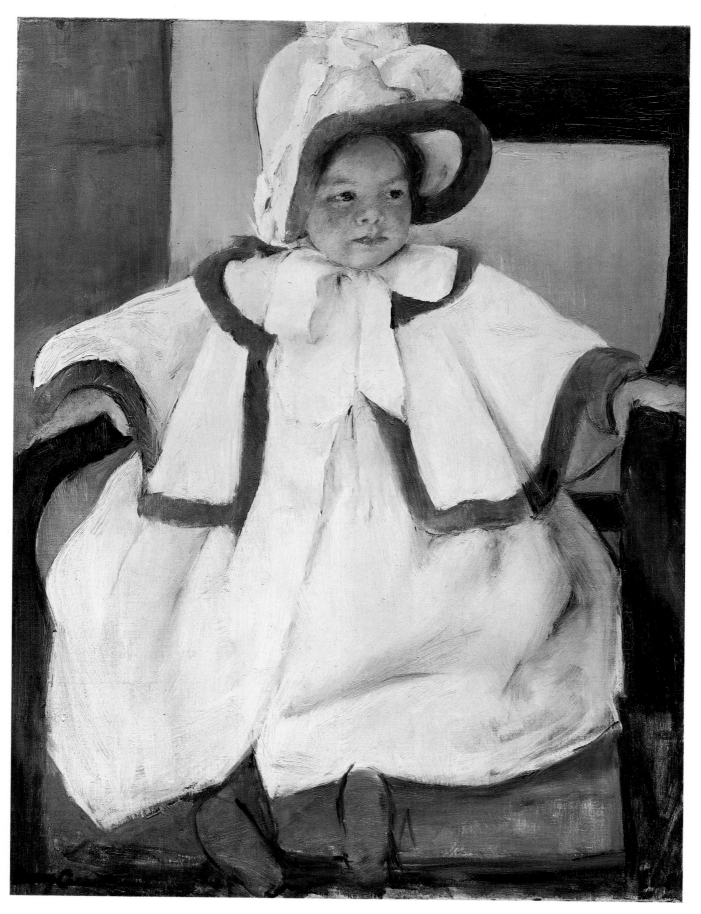

88 *Ellen Mary Cassatt in a White Coat*

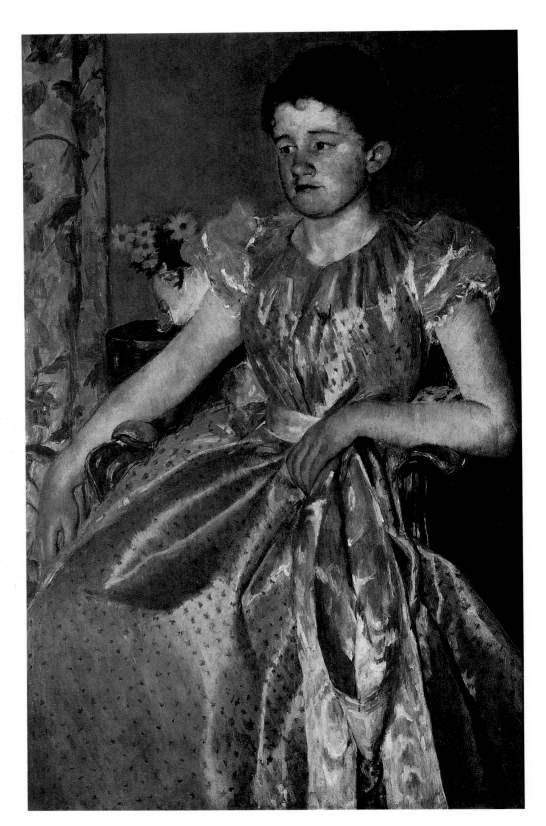

89 *Portrait of Katharine K. Cassatt*

1888. Oil on canvas, 39 × 26″
Private collection

Katharine Kelso Johnston Cassatt (1871–1905), the eldest of the Cassatts' granddaughters, was the object of a great deal of fond attention as she was growing up. This undated portrait, skillfully capturing the awkwardness of a teenager, may have been painted during a visit to France in 1888. About three years earlier Cassatt had written to Katharine's mother: "So Katharine is beginning to care for dress, we hear that she is growing very pretty, how time flies—I suppose she will soon be grown up—"

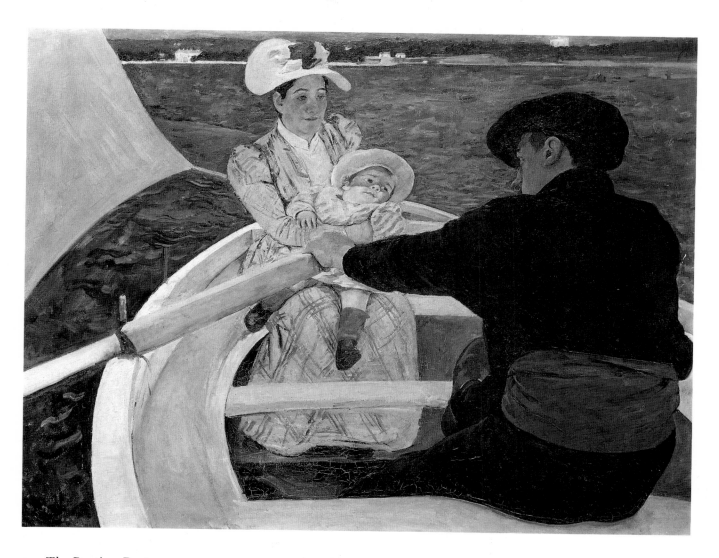

90 *The Boating Party*

1894. Oil on canvas, 35½ × 46⅛″
National Gallery of Art, Washington, D.C.
Chester Dale Collection

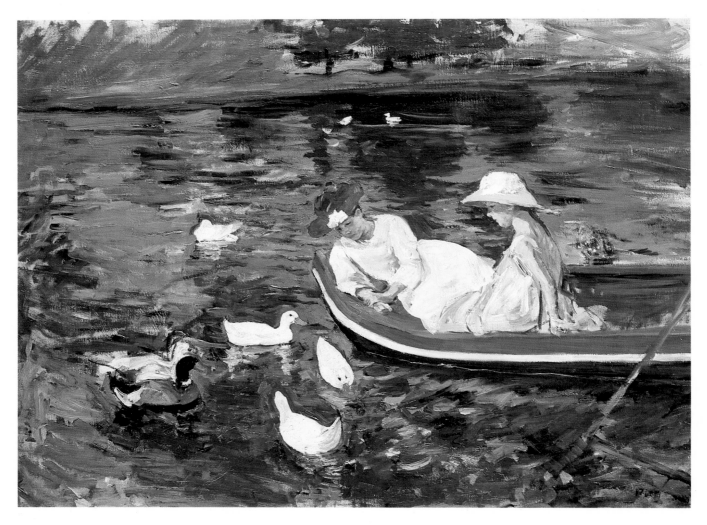

91 *Summertime*

1894. Oil on canvas, 28⅞ × 39⅜"
Armand Hammer Foundation, Los Angeles

92 *Portrait of Mrs. H.O. Havemeyer*

1896. Pastel, 29 × 24"
Shelburne Museum, Shelburne, Vermont

This was the second portrait of Louisine Elder Havemeyer (1855–1929) that Cassatt had rendered in a two-year period. In 1895 she had posed Mrs. Havemeyer with her elder daughter, Electra; in 1896 she concentrated on capturing a direct and sensitive likeness of her oldest friend.

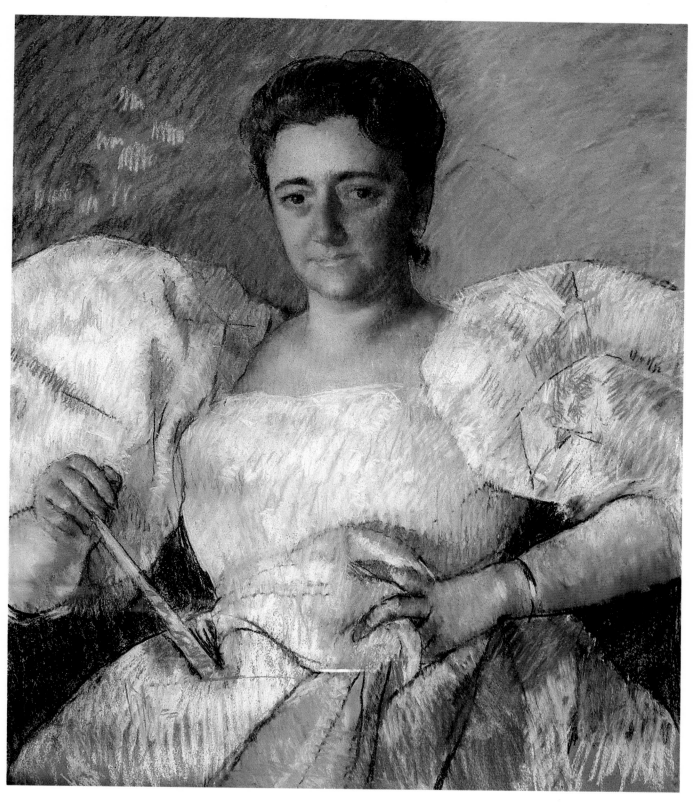

92 *Portrait of Mrs. H.O. Havemeyer*

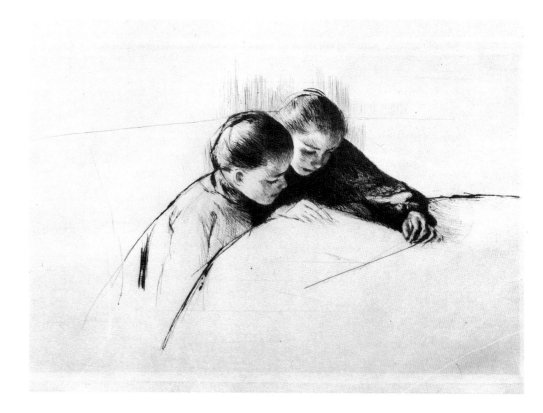

93 *The Map*

1889. Drypoint, second state, 6¼ × 9³⁄₁₆"
The Metropolitan Museum of Art, New York
Bequest of Mrs. H.O. Havemeyer, 1929
The H.O. Havemeyer Collection

94 *The Conversation (Two Sisters)*

1896. Pastel on paper laid down on canvas
25½ × 32"
The Regis Collection, Minneapolis

finished work of these years. Consequently *The Boating Party* must be linked to the new, expansive style of the post-mural period, with its various experiments in composition and subject matter. The large size of the painting and its carefully designed composition indicate that it was meant as a kind of showpiece, perhaps to answer critics of the mural who complained of the absence of men in her interpretation of the "Modern Woman." But like the other monumental paintings of this period, this scene has a mysterious quality, especially in the relation of the oarsman to his well-dressed passengers.

A less problematic painting is the smaller boating scene *Summertime* (fig. 91). This shows the looser, sketch-like treatment that, contrasting with that of the more finished oils of this period, foretells the emergence of another shift in style. It is both a revival of her old Impressionist style, with short brushstrokes appear-

96 *Nurse Reading to a Little Girl*

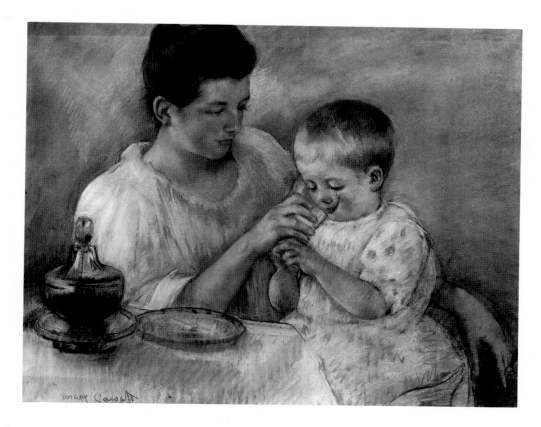

97 *Mother Feeding Her Child*

1896. Pastel, 25½ × 32″
The Metropolitan Museum of Art, New York
From the collection of James Stillman
Gift of Dr. Ernest G. Stillman, 1922

ing in selected areas of the composition, and a move toward the more densely painted, decorative works of the Nabis and the lighter themes of Art Nouveau.

Cassatt's lifelong relation with her friend Louisine Elder Havemeyer, whom she had met when they were young women in Paris in 1874, is marked in this period by a portrait painted about 1896 (fig. 92). Now a prominent New York society matron, Mrs. Havemeyer, with her husband, Harry, often traveled to Paris to visit Cassatt and to keep up with the major art exhibitions and auctions. The friendship of the two women had grown deeper over the years: Mrs. Havemeyer admired Cassatt as an artist and a connoisseur, while Cassatt found in her an intelligent collector, as interested in all aspects of modern culture as she herself was. Theirs was a rare meeting of minds. Cassatt's portrait of her friend at the age of about forty-one is strong and formal, its strength and formality made even more effective by the decorative qualities of costume and setting. The stylishly puffed sleeves give a monumental dimension to shoulders that would in the future bear the weight of social concerns on many levels; Mrs. Havemeyer had an active role in the women's suffrage movement in the United States.

Friendship was celebrated many times in Cassatt's work of this period. From the drypoint of two young girls poring over a document on the table (fig. 93) to the pastel called *The Conversation* or *Two Sisters* (fig. 94), these works have the same psychological intimacy as her depictions of mother and child. Poses and gestures that bespeak taking comfort from the presence of another are natural in both themes. The subject of female closeness was treated by other Impressionists, particularly Degas; one of the most memorable examples is his etching of the Cassatt

96 *Nurse Reading to a Little Girl*

1895. Pastel, 23¾ × 28⅞″
The Metropolitan Museum of Art, New York
Gift of Mrs. Hope Williams Read

Like Nurse Reading to a Little Girl, *Cassatt's other pastels after 1895 show the influence of her study of the work of Maurice Quentin de Latour, of whom she wrote: "He was an artist, most simple most sincere, no 'brio,' no facility of execution, but his portraits are living & full of character." The outdoor settings in these pastels may reflect Cassatt's enjoyment of Beaufresne, her new chateau at Mesnil-Théribus, where she lived and worked during the summer.*

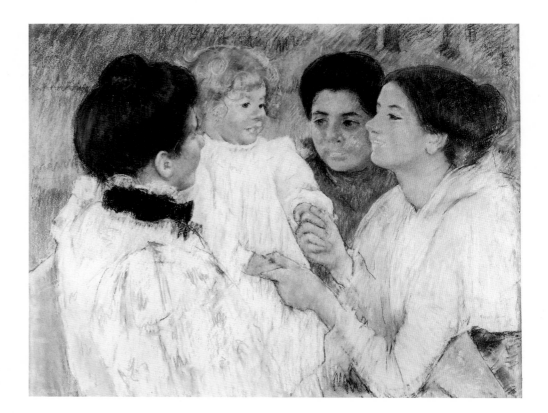

98 Women Admiring a Child

1897. Pastel, 26 × 32″
Detroit Institute of Arts
Gift of Edward Chandler Walker

99 Under the Horse Chestnut Tree

c. 1896. Aquatint, 15⅞ × 11⁵/₁₆″
The Metropolitan Museum of Art, New York
Bequest of Mrs. H.O. Havemeyer, 1929
The H.O. Havemeyer Collection

Perhaps in anticipation of her trip to the United States the next year, Cassatt was unusually prolific in 1897. In addition to producing a large number of pastels, she once again began to make color prints. These may be distinguished from her earlier prints by the unusual amount of modeling with drypoint on the face and figure; like Under the Horse Chestnut Tree, *they are often set outdoors.*

sisters in the Louvre (fig. 37). (Cassatt may have posed for others of his pictures of two women, such as those in the milliners series.) In an age when female subject matter was favored, this was an attractive motif since it showed not one but two fashionably dressed women.

From 1894 to the end of the century, after she finished her series of works based on the *Modern Woman* mural, Cassatt devoted herself to a single medium (pastel) and a single theme (mothers and children). Over the years the solemnity of the mural-based works relaxed into a lighter, more charming depiction of familiar scenes. Through renewed study of pastel techniques of the old masters, especially Maurice Quentin de Latour, she refined her own handling of the medium.

In 1895 Cassatt had her first solo exhibition in the United States, at the Durand-Ruel galleries on Fifth Avenue in New York. This was in part a recreation of her 1893 show in Paris and in part a forum for new work. The most prominent new piece was the large *Boating Party* (fig. 90); in addition she showed a new series of mother and child pastels. These were based on the same models, wearing the same costumes but arranged in different poses. In *Young Thomas and His Mother* (fig. 95) the mother's face is partially obscured by the child's shoulder—a device dictated by the same uncompromising aesthetic as underlies *Baby Reaching for an Apple* (fig. 77).

Within a year, however, Cassatt had revised her approach in favor of a more colorful and decorative manner. The scene is less often a hieratic Madonna and Child and more often a genre scene showing childlike activities, as in *Nurse Reading to a Little Girl* and *Mother Feeding Her Child* (figs. 96, 97). Previously in her

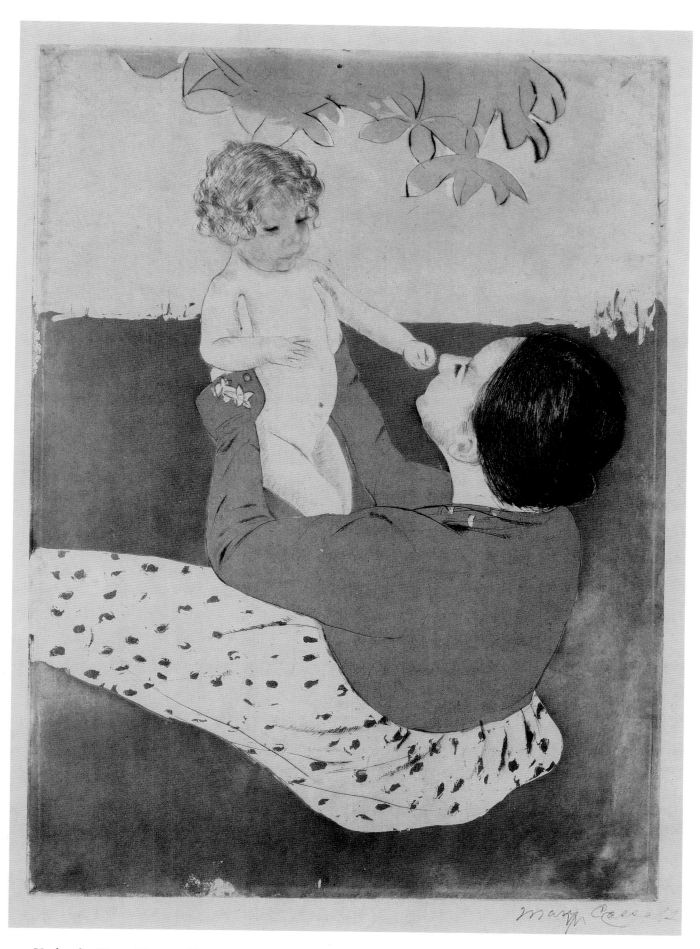

99 *Under the Horse Chestnut Tree*

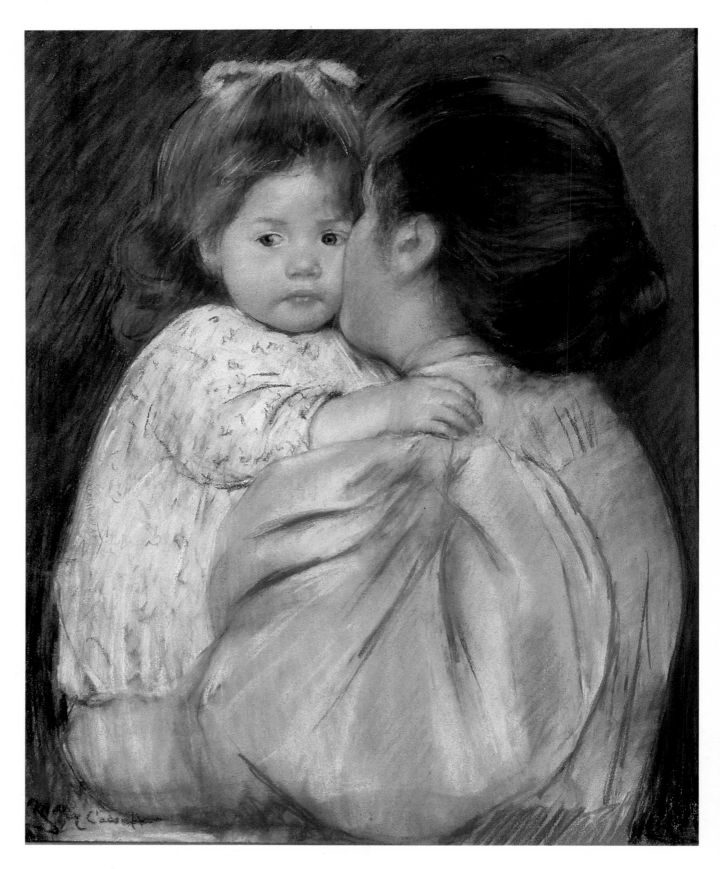

100 *Maternal Kiss*

mother and child compositions there had been little or no activity, except for the occasional bathing or dressing of the child, which tinged the subject with adult seriousness. When Cassatt reintroduced narrative content, she returned in a sense to a more Impressionist approach, harking back to such works as *Mrs. Cassatt Reading to Her Grandchildren* (fig. 44). Along with this shift in subject matter came a lightening of her palette and a more frequent use of *plein air* settings. However, her pastel technique was very different from that of her Impressionist days. Although it varied from piece to piece, it was generally more controlled and often achieved a silky smoothness and refinement that raise it to the highest level achieved in the nineteenth century.

When she returned to the non-narrative mother and child compositions, Cassatt brought to them a similarly lighter and more decorative approach. The figures are still subdued in mood, but the expressions are less distant and contemplative. In *Maternal Kiss* (fig. 100) the facial expression is softened by decorative details of hair, ribbons, and costume rather than the chaste accouterments of earlier pastels of mothers and children. In *Nurse and Child* (fig. 101) the composition is more complex—an even richer interpretation of the simple mother and child theme. Here affection is expressed primarily through an exchange of looks. The diagonal axis created by this activates the space and finds parallels in the lines of the sleeves and the position of the child's arm. The child's pose—mobile, flexible, and informal—affirms the charm of childhood rather than its symbolism. The soft pink and white in the dresses add both sensuous appeal and abstract design to the composition.

In the process of making the mother and child composition more decorative, Cassatt shifted interest more and more to the child. In earlier examples it was the mother who was the focal point, as if it was motherhood that was being extolled, and to this the seriousness of the mood contributed. But as the century came to a close, the child began to receive more attention in Cassatt's work. Her child models from this period have distinctive features and their expressions and gestures reveal more individualized personalities. An example is the blonde child used for several works of 1897, among them *Women Admiring a Child* (fig. 98) and the color print *Under the Horse Chestnut Tree* (fig. 99). In both, the child is the center of attention, and her playful mood sets the tone for the whole composition.

Hand in hand with the change in emphasis in the mother and child compositions came an increased interest in child portraiture. While Cassatt had turned out portraits of children throughout her career, they tended to be family portraits, sentimentally inspired. Her renderings of non-family members, such as *Portrait of a Lady of Seville, Moïse Dreyfus*, and *Lady at the Tea Table* (figs. 14, 28, 52), were of adults. By the late 1890s she began to acquire a reputation as a specialist in child portraiture. In fact, when Sargent was asked to paint the children of one of his Boston patrons, Mrs. Gardiner Greene Hammond, he recommended Mary Cassatt instead. The result was a group of sketches and finished pastels, among them the *Head of Master Hammond* (fig. 102).

100 *Maternal Kiss*

1896. Pastel on paper, 22 × 18¼"
Philadelphia Museum of Art
Bequest of Anne Hinchman

In 1898 Cassatt returned to the United States for the first time in over twenty years, and while there she worked exclusively in portraiture. This eighteen-month trip took her to the homes of her brothers in Philadelphia, to the Hammonds in Boston, and to her friends the Whittemores in Naugatuck, Connecticut. At every point she produced portraits of family and friends. The series of portraits continued when she returned to France in 1899. There she executed a triple portrait of Mme. Aude, daughter of Paul Durand-Ruel, with her two children (fig. 103). Mme. Aude was a neighbor of Cassatt's in the country.

The finished pastels, such as the *Portrait of Mme. A. K. Aude and Her Two Daughters, Gardner and Ellen Mary Cassatt*, and the *Portrait of Mrs. Cyrus J. Lawrence with Grandson R. Lawrence Oakley* (figs. 103–5), are all painstakingly accurate likenesses of the sitters. There is more physical detail in these portraits than in the more generalized depictions of the models in the mother and child compositions. The modeling is precise and the colors are often dark. The playfully decorative qualities of the recent scenes of children have been put aside. But within the restraint of the technique there is a great deal of expressiveness in subtleties—the tilt of the head, the casual embrace or joining of hands, the details of costume. The intelligence of Cassatt's design makes these portraits immensely pleasing.

A different kind of satisfaction is afforded by the portrait sketches from this period. The *Head of Master Hammond* (fig. 102) is infused with the exuberance that characterized Cassatt's first response to a sitter, and it clarifies her method of composing a work rapidly. She establishes the major lines of the composition at once, usually producing a radiating pattern with the face at the center of the configuration; she uses the lines of the costume to suggest the body underneath as well as to create diagonal movement. She makes the hat an important element in providing movement upward from the face into the top part of the composition. The quick strokes of the pastel stick help to define figure and ground, as well as offering a preliminary color pattern. The face itself, obviously the most important part of the development of the work, is usually highly finished. The features are well defined, the direction of the gaze and the expectant expression captured early on. Finally, the creamy texture of the flesh is evoked through the thick application of very soft pigment, which is then rubbed and highlighted.

While Cassatt's pastels of the years 1895–1900 reflect the lighter mood evident throughout European and American art as the century came to a close, they are very much her own personal statements. Dividing her time between Paris, Mesnil-Théribus, and the south of France, she no longer felt strong ties to a particular art community with whose work she wanted to link her own. She numbered many artists among her friends, but none excited her interest the way Degas, Pissarro, and the others of the avant-garde had for the previous twenty years. Hence it is hard to find parallels for the works Cassatt produced in this period. If her portraits, for instance, are seen alongside those of Cézanne, an artist whose work Cassatt admired, it is clear that she has not allowed her interest in an abstract, Synthetist line to take her in the direction of fragmentation of form. Nor did she follow the direction in which her decorative interests might have led her, that is, toward the increasing softness and aestheticism of a style such as

101 *Nurse and Child*

1896–97. Pastel, 31½ × 26¼"
The Metropolitan Museum of Art, New York
Gift of Mrs. Ralph J. Hines, 1960

Cassatt delivered this pastel to Durand-Ruel in February of 1897 with two others depicting the same models. All three were quickly placed; Nurse and Child *was bought by the Boston artist and patron Mrs. J. Montgomery Sears.*

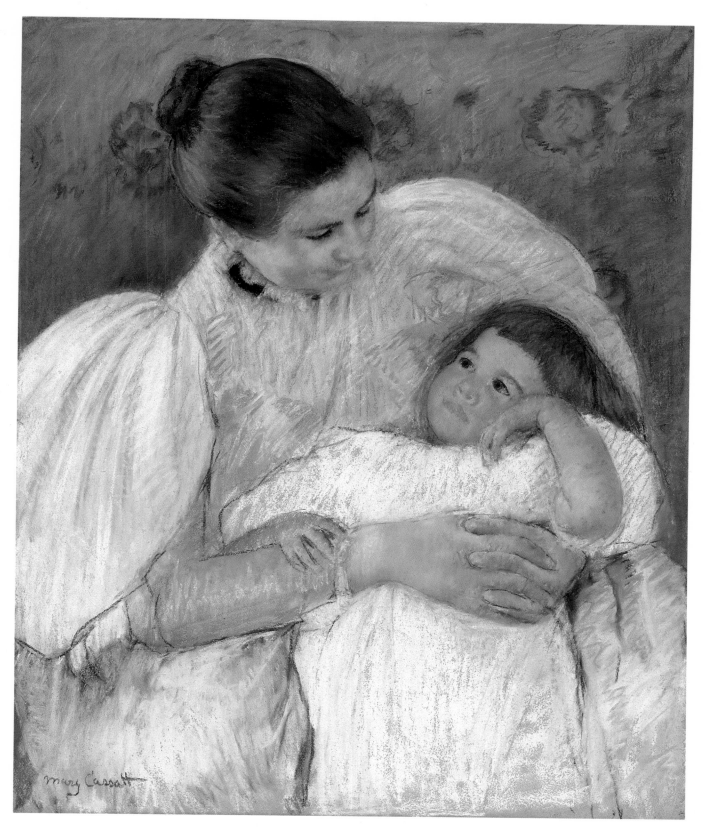

101 *Nurse and Child*

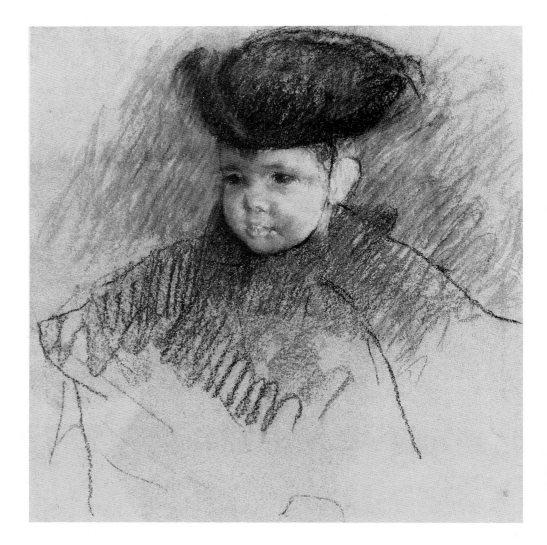

102 *Head of Master Hammond*

c. 1898. Pastel, 20 × 19½″
Phoenix Art Museum
Gift of Mr. and Mrs. Donald D. Harrington

After completing two pastel portraits of the children of Mrs. Gardiner Greene Hammond of Boston, Cassatt decided on the spur of the moment to do a third; this quick sketch of the eldest son, Gardiner, Jr., dressed for a walk, was used as a model for a finished version of the same composition.

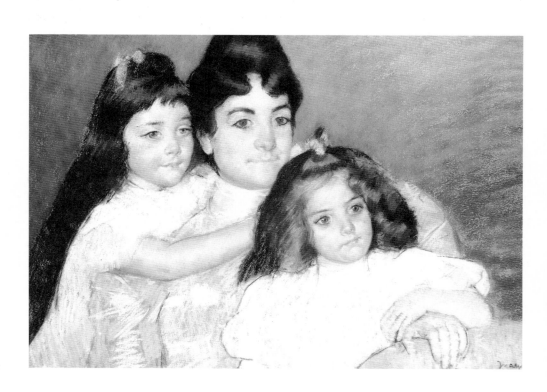

103 *Portrait of Mme. A.K. Aude and Her Two Daughters*

1899. Pastel, 21¼ × 31⅞″
Courtesy Durand-Ruel, Paris

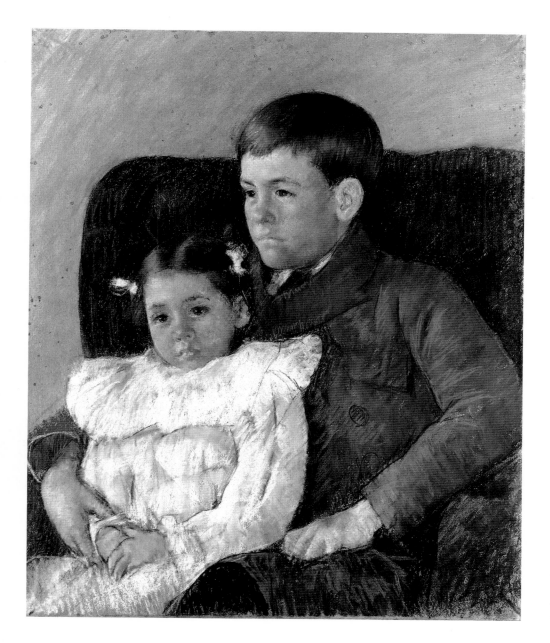

104 *Gardner and Ellen Mary Cassatt*

1899. Pastel, 25 × 18¾″
The Metropolitan Museum of Art, New York
Gift of Mrs. Gardner Cassatt, 1957

Cassatt arrived in Philadelphia in January of 1898 and while staying with her brother Gardner executed this pastel portrait of her niece (see also fig. 88) and nephew (see also figs. 60, 87).

Whistler's. Furthermore, her incisive line and her avoidance of conventional beauty prevent her from being categorized with artists like William Merritt Chase, J. Alden Weir, Edmund Tarbell, and other American Impressionists to whom she had friendly ties in the 1890s. While her work was not radically different from that of her contemporaries in Europe and America, it had a quality that Cassatt prized beyond all others: individuality.

In the decade of the nineties, Cassatt established herself as a major artist. Although she had begun the decade in step with avant-garde circles in Paris, producing the color prints and the *Modern Woman* mural, the experience she gained in both these projects resulted in the establishment of her own distinctive style. This style blended several components—old master techniques, adherence to material reality, experimentation with decorative detail in costume and setting, and themes chosen for their universal meaning and appeal. She had become a "public" artist as a result of the mural and her several solo exhibitions in Paris and New York, and her work and life reflect this new responsibility.

105 *Portrait of Mrs. Cyrus J. Lawrence with Grandson R. Lawrence Oakley*

c. 1899. Pastel, 28 × 23"
Sterling and Francine Clark Art Institute
Williamstown, Massachusetts
Gift of Mrs. R. Lawrence Oakley

While Cassatt was staying in New York in 1898, she worked on two portraits—this pastel and a sketch of his daughter, Mary Say Lawrence, for Cyrus J. Lawrence, who had been buying her works since 1895 and eventually formed a collection of eight paintings and pastels.

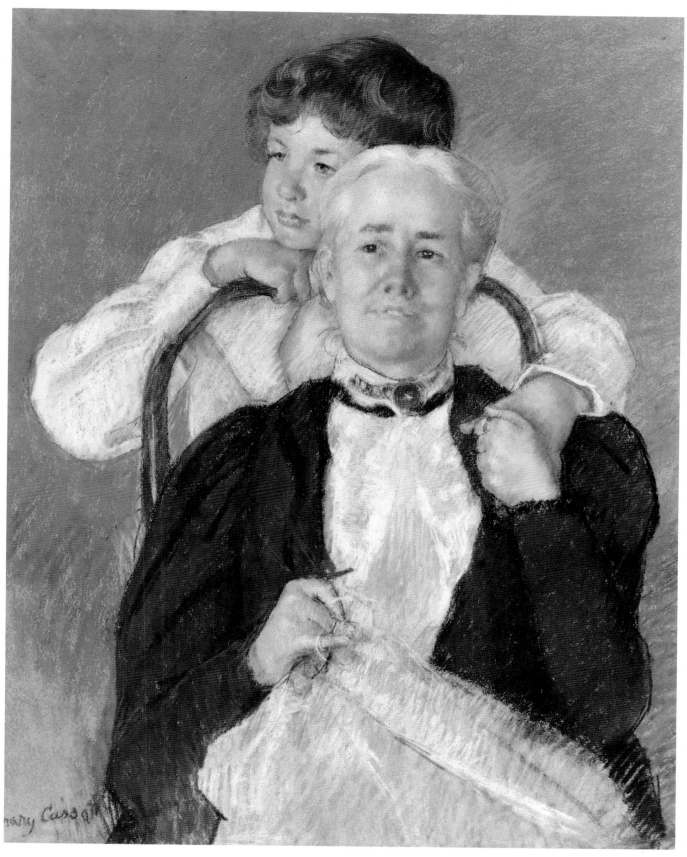

105 *Portrait of Mrs. Cyrus J. Lawrence with Grandson R. Lawrence Oakley*

106 Photograph of Mary Cassatt

IV. The Late Period (1900–1926)

I N THE LAST YEARS OF Cassatt's active career (1900–1915) she began to receive the type of recognition that she had renounced when she joined the Impressionists in 1877—that of the official art world. In 1904 she was named a Chevalier of the Legion of Honor, while her painting *The Caress* won the Lippincott Prize of the Pennsylvania Academy of the Fine Arts and the Norman Wait Harris Prize of the Art Institute of Chicago. After her trip to the United States in 1898–99, she was accepted as one of America's great living artists and was accorded the honors that also came to such contemporaries as Eakins, Homer, and Sargent. Her works sold briskly through the Durand-Ruel, Vollard, and other galleries in Europe and the United States. In 1913 the first book-length study of her work, by Achille Segard, was published. Although she made light of the attention and declined to accept the prizes awarded her, she was nevertheless profoundly affected by the position in which she found herself.

In her art she began to practice a new "grand manner" as if to match her new stature. *The Caress* (fig. 108), the painting so much admired in 1904, reveals an almost baroque handling of paint, which constitutes a change from the simpler, more linear style of the 1890s. Furthermore, she began to produce and distribute more works than ever before to meet the demand. For the first time, Cassatt allowed works—drawings, pastels, oil sketches, and paintings—to leave her studio before she had brought them to their final state. Consequently in the late period there is less of the polish and precision that had typified her work since the mid-1880s and there is a less original handling of inherently sentimental themes. But despite these flaws in the body of work after 1900 there are still many examples of masterly technique. And, since Cassatt was intellectually involved in the issues of her day, her art is of great interest for its reflection of early-twentieth-century social and cultural concerns.

After 1900 Cassatt was known primarily as a painter of mothers and children. Segard's book was titled *Mary Cassatt, Un Peintre des enfants et des mères*. While she had become famous for this subject in the 1890s, she was then known equally well for her drypoints and color etchings, for the mural *Modern Woman* for the Chicago Exposition, and for her portraits. But in the following decade mother and child compositions and studies of children outstripped any other theme. This was in part due to public demand and the urging of dealers like Durand-Ruel, who were also close friends. But it also may have reflected the two major interests Cassatt shared with her friend Louisine Havemeyer in this period: old master art and the position of women in modern society.

106 Photograph of Mary Cassatt

After 1900
Frederick Arnold Sweet Papers
Archives of American Art
Smithsonian Institution, Washington, D.C.
Courtesy of The Art Institute of Chicago

Cassatt particularly disliked having her picture published alongside her work. She wrote in reply to one request, "It is always unpleasant to me to see the photographs of the artists accompany their work, what has the public to do with the personal appearance of the author of picture or statue? Why should such curiosity if it exists be gratified?"

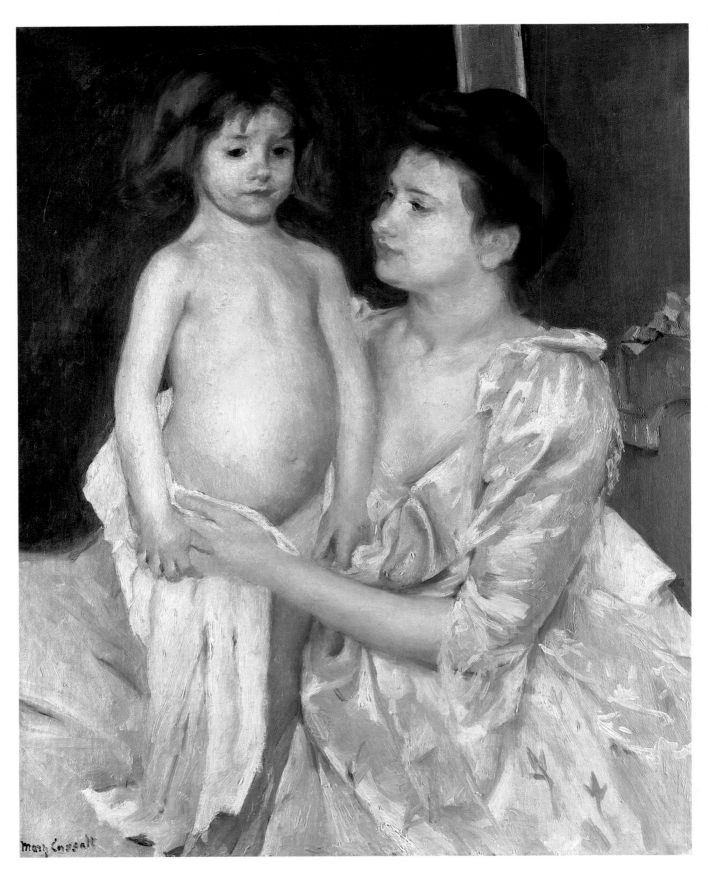

107 *Jules Being Dried by His Mother*

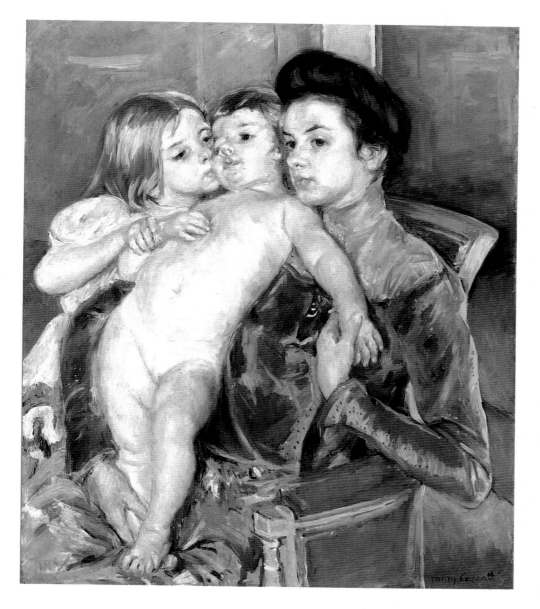

108 *The Caress*

1903. Oil on canvas, $32^{13}/_{16} \times 27^{5}/_{16}''$
National Museum of American Art
Smithsonian Institution, Washington, D.C.
Gift of William T. Evans

In declining to accept the Lippincott Prize, which The Caress *was selected to receive from the Pennsylvania Academy of the Fine Arts, Cassatt wrote to the director: "Of course it is very gratifying to know that a picture of mine was selected for a special honor and I hope the fact of my not accepting the award will not be misunderstood.... I, however ... must stick to my principles, our principles, which were, no jury, no medals, no awards."*

107 *Jules Being Dried by His Mother*

1900. Oil on canvas, $36^{3}/_{8} \times 28^{3}/_{4}''$
Private collection, Norfolk, Virginia

The two models that appear in this painting were used by Cassatt for at least eight major works and numerous related sketches between 1898 and 1900. As the series went on, Cassatt's technique became progressively more painterly.

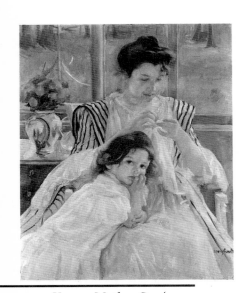

109 *Young Mother Sewing*

1902. Oil on canvas, 36⅜ × 29"
The Metropolitan Museum of Art, New York
Bequest of Mrs. H.O. Havemeyer, 1929
The H.O. Havemeyer Collection

Cassatt had begun to advise the Havemeyers on matters of art and collecting with increasing frequency in the 1890s; this role grew to larger proportions after the turn of the century. The Havemeyers were intent on building a collection that represented old master and modern art equally well. Their dealer in most transactions was Durand-Ruel, but it was often Cassatt who followed the market in Paris and acted on their behalf to secure fine pieces. Occasionally she traveled with them to Italy and Spain, following the twisting paths that led to the discovery of a rare Velázquez, Titian, or El Greco; a major months-long journey began early in 1901. Cassatt's early study of old master art in Italy and Spain proved invaluable in this pursuit, and it was inevitable that the training of her eye that enabled her to judge the quality and authenticity of the paintings they discovered in their travels would also lead her to incorporate old master techniques into her own work.

In the 1890s Cassatt's study of the art of the past had been limited, by and large, to the Italian Primitives and the great pastellists. Now, however, examining paintings of the sixteenth and seventeenth centuries brought her into contact once again with masters of the brush. In her own work we see a corresponding increase in the number of oil paintings. In such paintings as *Jules Being Dried by His Mother, The Caress,* and *Young Mother Sewing* (figs. 107–9) brush strokes are long and loose, at times approximating the bravura strokes of Velázquez and his contemporaries. The paint surface often appears heavy, unlike that of her earlier painting, in which it was carefully built up with short strokes that seemed to float on the canvas. In *Lady at the Tea Table* (fig. 52), for example, the delicacy of the parallel strokes gives piquancy to the drawing of the head, face, and hand. In these later oils there is no sense of an underlying drawing of fine edges; instead, the rather imprecise contours produced by a loaded brush are in evidence. There is often a dense quality in the flesh areas, where the paint is applied thickly to suggest the creamy texture of a female face or a child's body.

In these paintings Cassatt also returned to more traditional modeling techniques, using a graduated range of values, from browns in backgrounds and shadows to bright white highlights in flesh tones. This was a rejection of one of the most important tenets of Impressionism—that form could be suggested without using black or brown for shadows. In her pastels and in her earlier oils Cassatt used blue or green to indicate the turning of a cheek or an arm away from the light.

Another change after 1900 in the mother and child compositions (both oils and pastels) that suggests Cassatt's interest in grander effects is in the handling of space and proportion. This is apparent if such examples as *Mother Combing Her Child's Hair* and *After the Bath* (figs. 111, 112) are compared to pastels of a few years earlier, such as *Mother's Goodnight Kiss* (fig. 65), which has virtually no background. In the two later works the figures are framed in a setting that is fairly elaborate. Furthermore, the figures are set back from the viewer, so that the foreground is substantially enlarged. Since they are farther back, they are seen in three-quarter view rather than in the half-length view that Cassatt had earlier favored. This makes the figures appear larger and opens the scene to more figures

and greater activity. The result is very different from the stark simplicity of the earlier "Primitive" versions of mothers holding their children (see fig. 63).

Along with increasing the complexity of setting and composition, Cassatt changed her handling of costume slightly. Always sensitive to the interrelation of art and fashion—first as a genre painter and then as a painter of contemporary life—she had seen in clothing both its symbolic and its design potential. In the various phases of her work Cassatt stressed different aspects of costume, but usually the specific texture and pattern were less important to her than the effects of silhouette and cut, which were a means of articulating the body underneath. In the late period Cassatt's handling of costume is more obvious: attention is paid to the texture of heavy materials such as the green satin of the mother's gown in *The Caress* and to insistent linear patterns such as those of the garments in *After the Bath* and *Young Mother Sewing*. In these cases the underlying structure, the shape and movement of the figure, is less clear.

Because of these changes in Cassatt's signature subject—mother and child—later examples are weighted by material reality, less touched with the spiritual quality of the early, more abstract versions. Inspired though they may have been by her renewed involvement with old master art, the later works are less like traditional Madonnas than the earlier ones. These mothers and children are not simply sharing the joys of childhood, as their earlier counterparts had done in works like *Women Admiring a Child* (fig. 98). The serious mood, linked with a frequent use of mirrors and grooming motifs, can be read as suggesting women's responsibility for the improvement of their children and, by implication, for the improvement of society itself. Cassatt's firm conviction, often articulated, that women were the primary civilizing force in society and that they could have this broader impact only if they were given a voice inspired her strong support of the American women's suffrage movement.

In the course of revising her approach to the mother and child theme Cassatt embarked on a series of pastels, drawings, and drypoints of children that preoccupied her for the rest of her working career. She had painted children many times before, but there had always been an obvious incentive, either a portrait commission or contact with her young nieces and nephews. This series seems to have had no such motivation. Cassatt's nieces were now older than her preferred child models, who appear to be five or six years old. For these pictures, children from the nearby village were engaged as models, yet they are not portraits.

What triggered this explosion of images may never be discovered: Cassatt may simply have been reflecting the interest in children that was so much a part of the culture of the time. The nineteenth century has been called "the century of the child," but in the early twentieth century the subject may have been given even more attention. The era Freud ushered in had a new attitude: the child became the unconscious repository of adult characteristics. To some extent Cassatt's exploration of the child—not the baby—in adult costume, pose, and expression reflects aspects of early-twentieth-century psychology, absorbed by Cassatt in her wide reading of sociological, psychological, and parapsychological literature.

110 Ceramic vase

c. 1903
Musée du Petit Palais, Paris
Gift of Ambroise Vollard, 1937

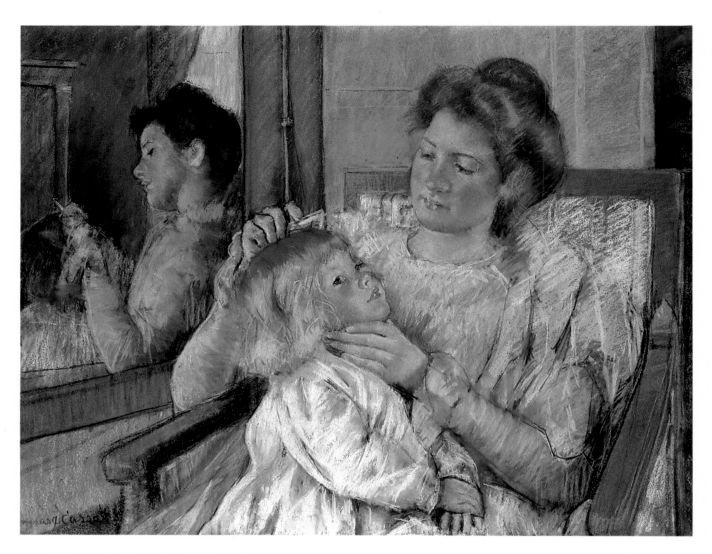

111 *Mother Combing Her Child's Hair*

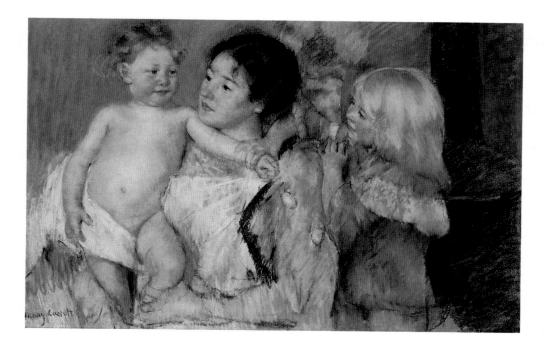

112 *After the Bath*

1901. Pastel, 25¾ × 39¼"
The Cleveland Museum of Art
Gift of J. H. Wade

After 1900, as is noticeable in After the
Bath, *the pastel is applied in longer
strokes, to give a richer, thicker surface;
this corresponds to a change in Cassatt's
handling of paint.*

Of all Cassatt's works, these images of children have the greatest popular appeal. They combine a number of the winning qualities of young girls—soft, satiny skin, "pretty" features, guileless expressions, charmingly awkward poses, and the frilliness of their clothes. Any surfeit of sweetness is counteracted by the masterly handling of every aspect. Lighter and simpler than the mother and child compositions of this period, the pastels of children are without detailed backgrounds and thus are more directly engaging. The drawing comprises long, sweeping lines; in the pastel *Child in Orange Dress* (fig. 113) the pattern of radiating lines in the folds of the dress and the curves of the arms lends sophistication to the prevailing fluffiness.

The interest in linear design evident in the pastels was being simultaneously expressed in drawings and drypoints of these same children, for example, *Jeannette Wearing a Bonnet, No. 4* (fig. 114). Although in these the setting is undefined, Cassatt makes much of the relation between the seated child and the chair occupied. In the sketch *Simone Seated with Hands and Feet Crossed* (fig. 115) the chair back has been carefully constructed with both outline and hatching so that its curve and solidity are realized. The rough outlines of the girl's figure fit into the design of the chair and in some places (such as her left shoulder and side of her skirt) even blend into it. This attention to the abstract relation of figure and chair can also be seen in a related drawing of a child, the *Portrait of Henry Jacoby* (fig. 116). The bow shape of the molding on the chair back is echoed in the shape of the boy's mouth and the sloping, curved lines of his jacket front. Cassatt's interest in abstract shapes extends occasionally to patterns in the sitter's costume. Thus in the pastel *Child in a Green Coat* (fig. 117) the concentric circles of the bonnet, which act as a foil for the face, and the repeating crescent shapes on the coat take on an abstract life, and an importance, of their own.

111 *Mother Combing Her Child's Hair*

1898. Pastel and gouache on tan paper
The Brooklyn Museum, New York
Bequest of Mary T. Cockcroft

*This pastel, executed after Cassatt's return
from the United States in 1898, shows the
beginning of an interest that continued
throughout the next decade—an interest
in the complex setting.*

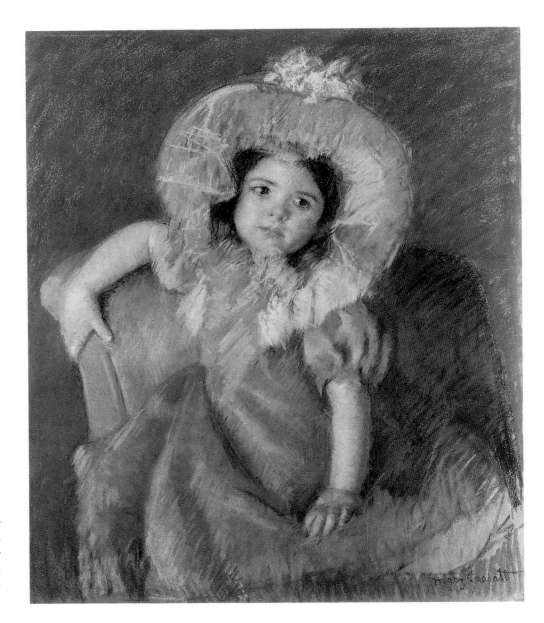

113 *Child in Orange Dress*

c. 1902. Pastel, 28⅝ × 23⅝″
The Metropolitan Museum of Art, New York
From the collection of James Stillman
Gift of Dr. Ernest G. Stillman, 1922

Even in the earliest of her studies of children, which date from about 1900, Cassatt portrayed her models wearing large, elaborate hats. This was a new practice for Cassatt, and one that may have been prompted by a new fashion. Aware of the design possibilities of a small face and a large hat, Cassatt seldom thereafter depicted a young girl hatless.

In contrast to the control of Cassatt's drawing technique, her application of the colored pastel is a vigorous outburst. Again, this is most evident in a sketch such as *Child with Red Hat* (fig. 118), in which the reds of the hat are laid down in strong, quick, scumbling lines that produce intense and vibrant color. The face, although more finished, also shows vigorous treatment: the pigment was crushed onto the paper and then rubbed to produce the texture of skin and the contours of the features. One gets the sense of physical effort, somewhat akin to that of the sculptor, in the manipulation of the thick layer of chalk.

Cassatt's palette varies widely in her depictions of children. At times she uses white as her central color in a manner reminiscent of her Impressionist days. In *Simone in a White Bonnet* (fig. 119) the white of the child's dress and hat is freely applied in a spontaneous Impressionist manner, often extending beyond the outlines.

Although Cassatt's depictions of young girls are invariably charming, they have a puzzling aspect. These youngsters, in costumes that could not possibly accommodate childlike behavior, appear not only overdressed but dressed in oversized clothes. The hats, coats, and bows—sometimes even the chairs they sit in—engulf the tiny figures. The impression is created of the child playacting in its mother's castoffs, acting out a role in an outsized world. These children are far more composed than those in Cassatt's early paintings, such as *Little Girl in a Blue Armchair* (fig. 27), in which the sitter, pouting and out of sorts, is utterly childish. They are more grown-up; they understand the social responsibility that goes along with their clothes. While parodying adult behavior is one of the charming games of childhood, it also relates to one of the key issues of child psychology: how and when should conformity to social mores be instilled? The fact that Cassatt in this series is not presenting individuals in their own clothes with their own manners but is painting children of her village, chosen as models and dressed in costumes she has selected or commissioned, suggests that the puzzling aspect of these children is a deliberate choice on Cassatt's part.

An interesting corollary to Cassatt's series of children is her work in vase painting during the same period. She was not unaffected by the burst of interest in the decorative arts inspired by the Arts and Crafts and the Art Nouveau movements in Europe and America. Indeed the sinuous curved lines in some of her compositions hint at an Art Nouveau influence, and certainly her interest in fashion and decorative patterning in fabric was in harmony with this movement. In a letter of 1903, to the dealer Vollard, she speaks of using floral designs for vases she is working on at the time, but the only known example of her output in this medium (see fig. 110) shows a band of dancing children. These nude figures are a far cry from the well-dressed children in her pastels and paintings, but they show how easily she adapted this motif to classical decorative purposes.

Almost midway into this decade Cassatt, approaching sixty, regarded her life as centered on her art. "I work, & that is the whole secret of anything like content with life, when everything else is gone," she wrote to a bereaved friend in 1903. Although she now lived alone and still missed her parents and Lydia, her life was by no means a solitary one. She entertained friends and family in her apartment in Paris, her chateau in Mesnil-Théribus, and her rented villa in Grasse. She had friendly relations with several major dealers not only because of the popularity of her own works but because she bought Impressionist and old master works for herself and her friends and as an acknowledged art expert advised some of the most important collectors. She took a keen interest in the intricacies of the Parisian art market. Her old friends included the other Impressionists Degas, Pissarro, and Renoir, whom she saw regularly, and she made new friends as well, mostly from the ranks of young American artists who found their way to her doorstep with letters of introduction from J. Alden Weir and other American artists with whom she kept in contact.

In addition to exhibitions and awards, Cassatt received from many museums—the Carnegie Institute, the Pennsylvania Academy of the Fine Arts, and

114 *Jeannette Wearing a Bonnet, No. 4*

c. 1904. Drypoint, 9½ × 6½"
Philadelphia Museum of Art
Given by Mrs. Charles P. Davis and
Gardner Cassatt in memory of Mary Cassatt

115 *Simone Seated with Hands and Feet Crossed*

c. 1903. Pencil, 8⅝ × 6³⁄₁₆″
The Cleveland Museum of Art
Gift of Leonard C. Hanna, Jr.

116 *Portrait of Henry Jacoby*

c. 1905. Pencil and watercolor
on rice paper, 8 × 10″
Collection Everett D. Reese, Columbus, Ohio

the Art Institute of Chicago—requests that she sit on a jury or donate a work. American and French journalists wrote laudatory articles and pursued her for interviews. In 1909 an article about her in the American magazine *Current Literature* was titled "The Most Eminent of All Living American Women Painters."

All this attention had one advantage for Cassatt: it gave her a forum for her ideas about art and artists—ideas that until now she had been able to express only privately. From her earliest days, when her strength of purpose and well-developed sense of her own direction had enabled her to circumvent the restrictions of established art institutions—the Pennsylvania Academy, the Ecole des Beaux-Arts, and the Paris Salon—she had developed the firm opinion that restriction, whether exercised in art training or in juried exhibitions, was antithetical to great art. In a letter of September 5, 1905, to John W. Beatty, of the Carnegie Institute, she had explained her "principles in regard to jurys of artists":

I have never served because I could never reconcile it to my conscience to be the means of shutting the door in the face of a fellow painter. I think the jury system may lead, & in the case of the Exhibitions at the Carnegie Institute no doubt does lead to a high average, but in art what we want is the certainty that the one spark of original genius shall not be extinguished, that is better than average excellence, that is what will survive, what it is essential to foster—The "Indépendents" in Paris was originally started by one group, it was the idea of our exhibitions & since taken up by others, no jury, & most of the artists of original talent have made their début there in the last decade, they would never have had a chance in the official Salons. Ours is an enslaved profession, fancy a writer not being able to have an article published unless passed by a jury of authors, not to say rivals—

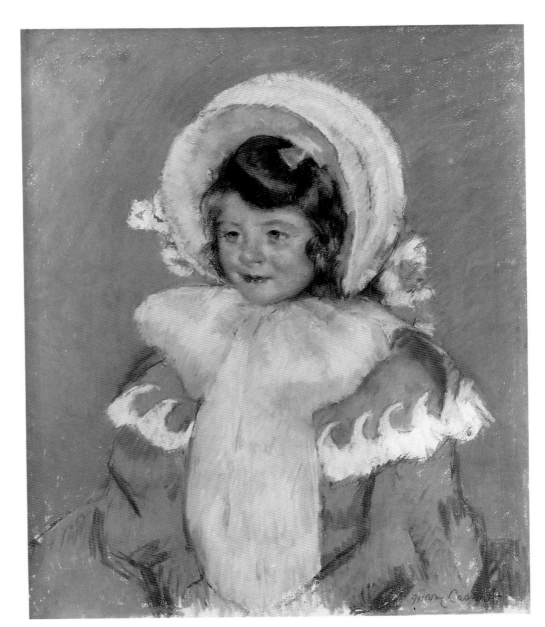

117 Child in a Green Coat

c. 1904. Pastel, 23½ × 19½"
The Metropolitan Museum of Art, New York
From the collection of James Stillman
Gift of Dr. Ernest G. Stillman, 1922

*In her studies of children Cassatt paid
such close attention to her subjects' facial
features that the works appear to have
been done as portraits; however, for the
most part they were intended for public ex-
hibition and sale, not to be given or sold to
the sitter's family.*

118 Child with Red Hat

c. 1901. Pastel, 20¾ × 17⅛"
Sterling and Francine Clark Art Institute
Williamstown, Massachusetts

*Cassatt's unfinished studies of children
from this period were just as much in de-
mand as her finished works. An avid ad-
mirer and promoter of her work in this
category was the dealer Ambroise Vollard,
who persuaded the artist to let him sell
sketches that normally would never have
left her studio.*

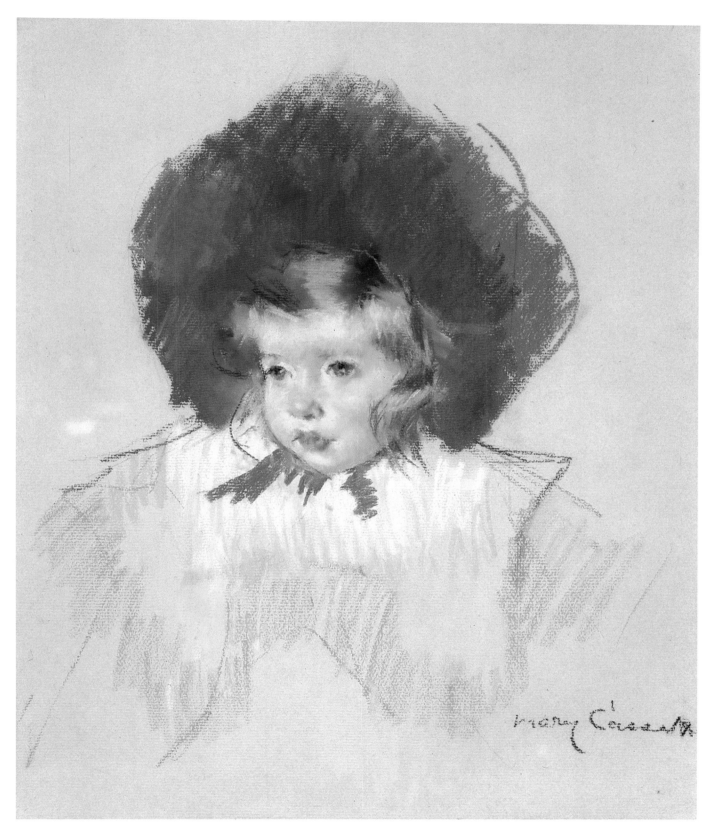

118 *Child with Red Hat*

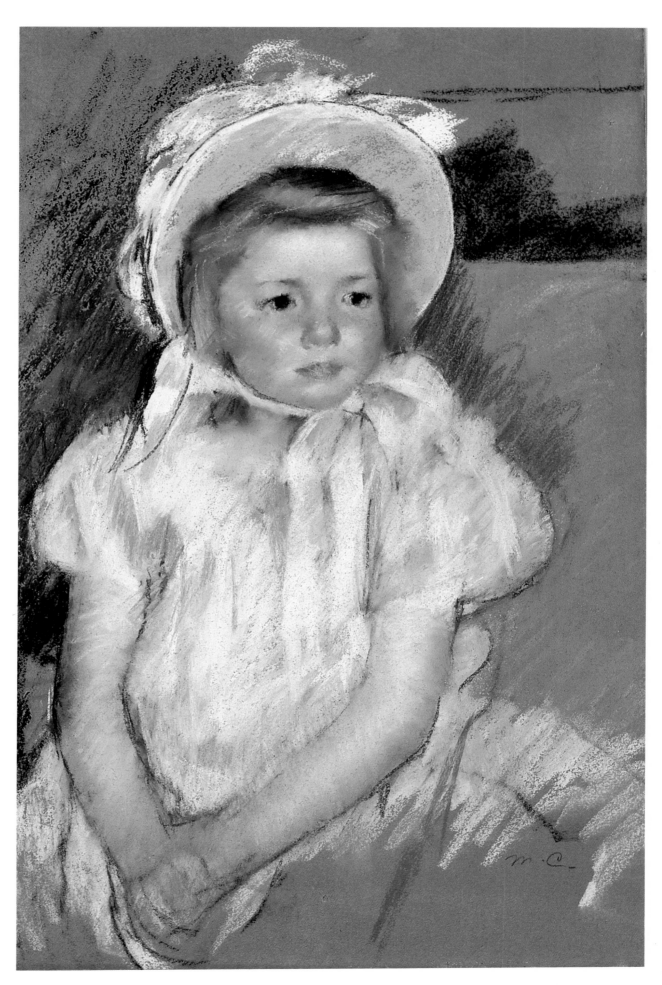

119 *Simone in a White Bonnet*

In the midst of this give-and-take with the American art establishment, Cassatt decided to try her hand once again at public art. The occasion was an American competition for the decoration of the new Statehouse in Harrisburg, the capital of Pennsylvania, not far from her childhood home in Lancaster County. She completed two tondos before word that the project was riddled with graft reached her and caused her to withdraw from the competition. The theme of the tondos was again mother and child but in a more complex version, with the addition of a third figure and a specific background (see fig. 120).

In much the same way that the *Modern Woman* mural had been followed by a series of related works, the tondos were followed by works carrying out their design ideas. In two of the related paintings, *Children Playing with a Cat* and *Young Mother and Two Children* (figs. 121, 122), the figures show a certain immobility that is in part inherent in the poses but also comes from the different approach to design that Cassatt takes in this period. In previous works, such as *Woman in Raspberry Costume Holding a Dog* (fig. 124), the abstract design was crisp and dynamic, usually the result of a pattern of long rising lines in pose and costume. The dynamic lines can still be seen in pastel sketches like *Sketch of Mother and Daughter Looking at the Baby* (fig. 123), but in the finished work *Young Mother and Two Children* the lines of the costumes droop downward, without any contrasting directional emphasis. This may reflect the new lines in fashion. Abandoned now is the exaggerated shoulder that Cassatt made so much of in the 1890s; instead the line of the shoulder is soft and heavy, ending in a frill or ruffle. In *Children Playing with a Cat* fashion is markedly emphasized in the figure of the little girl. Like the children in Cassatt's recent series of pastels, she is elaborately dressed, her clothes virtually dominating the overall design.

Particular interest attaches to Cassatt's use of color in these works. In the pastel *Sketch of Mother and Daughter Looking at the Baby* we have a very loose but still pure example of Impressionist modeling through the use of color. Blue and green are found in the shaded areas and a multitude of hues are found throughout the areas of skin, hair, and dress. In *Children Playing with a Cat* color is more self-consciously deployed; in fact this is one of the most unusual arrangements in Cassatt's oeuvre. Rather than finding all the colors of the spectrum within a few square inches of flesh, we find them in discrete areas on the canvas. From the red-blue of the vase on the mantel to the blue-green of the child's dress, to the yellow of the mother's dress and its yellow-orange accents, and finally to the red of the chairback behind her, Cassatt arranged the colors in the order in which they would appear on a color chart.

It is surprising to find this kind of color experimentation in Cassatt's work at this time. It hints not only at an awareness of current Divisionist color theories being proposed by Matisse and other radical artists but also at an interest, albeit restrained, in putting them into practice. Despite her well-known disdain for Matisse's work and his followers, Cassatt, like most older artists in Paris during this tumultuous decade, could not shut out his influence entirely.

Cassatt was well acquainted with Matisse's experiments. Through Mrs. J. Montgomery Sears, an artist and art patron from Boston who was a member of

119 *Simone in a White Bonnet*

1901. Pastel, 25½ × 16½″
Collection Dale F. Dorn
Courtesy McNay Art Museum, San Antonio

On the basis of works like this, influential critics such as Camille Mauclair and Gustave Geffroy, who had long followed the Impressionist group, judged Cassatt to be the greatest painter of children of her generation.

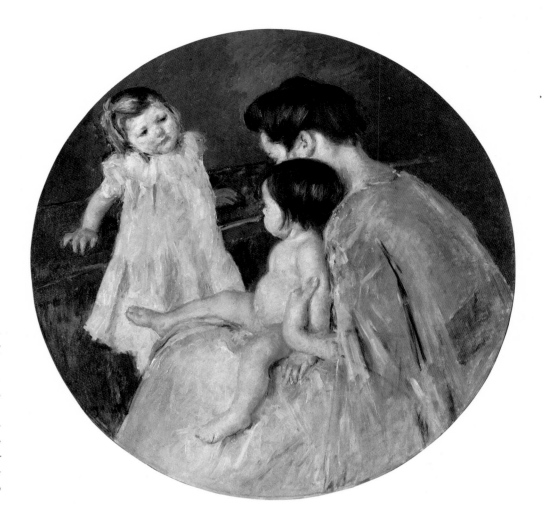

her American circle in Paris, she had met Leo and Gertrude Stein. This contact and the widespread publicity in the American press were ample sources of information. In a letter to a niece answering some of her "questions about cubists and others," she wrote scornfully about the hoax she felt Matisse had perpetrated:

No Frenchman of any standing in the art world has ever taken any of these things seriously. As to Matisse, one has only to see his early work to understand him. His pictures were extremely feeble in execution and very commonplace in vision. As he is intelligent he saw that real excellence, which would bring him consideration, was not for him on that line. He shut himself up for years and evolved these things; he knew that in the present anarchical state of things—not only in the art world but everywhere—he would achieve notoriety—and he has. At his exhibition in Paris you never hear French spoken, only German, Scandinavian and other Germanic languages; and then people think notoriety is fame and even buy these pictures or daubs. Of course all this has only "un temps"; it will die out. Only really good work survives.

But some of the excesses of Cassatt's work during this decade raise the question whether the occasional exaggerations in costume and color were not made possi-

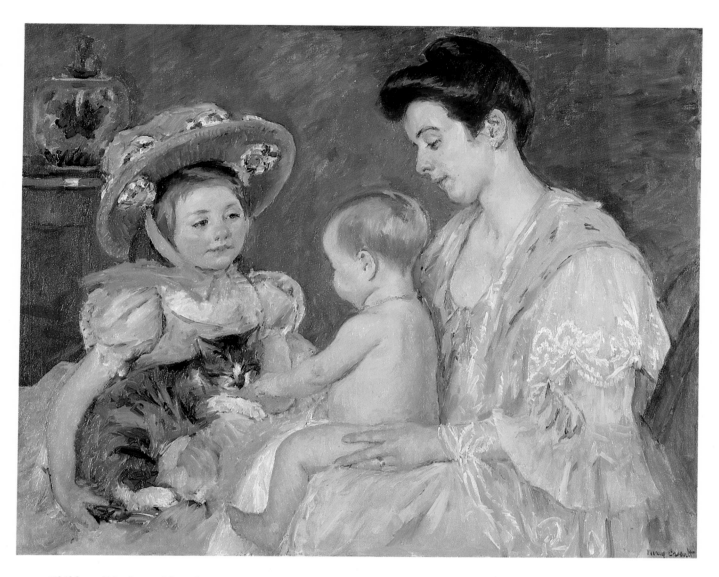

121 *Children Playing with a Cat*

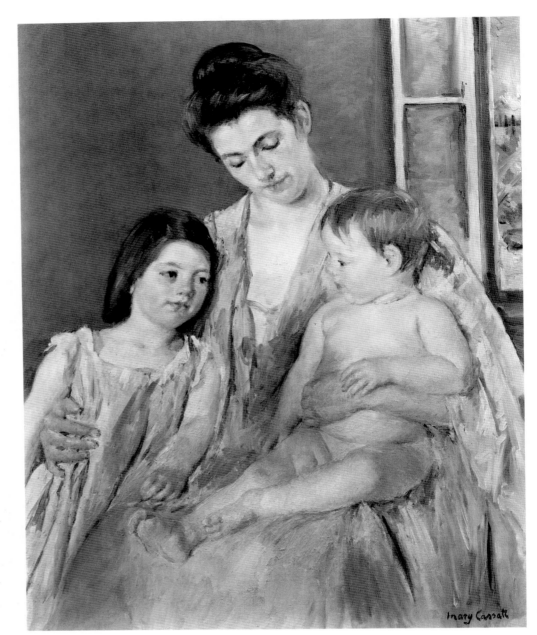

122 *Young Mother and Two Children*

1905. Oil on canvas, 36¼ × 29″
White House Collection, Washington, D.C.

In the homely features of the model Renée Chauvet, a woman from the village near Cassatt's chateau, the artist found the kind of strength and feeling she liked to portray. Chauvet can be recognized in a series of paintings dating from the years 1905 to 1910, including Young Mother and Two Children, Children Playing with a Cat *(fig. 121), and* Sketch of Mother and Daughter Looking at the Baby *(fig. 123).*

123 *Sketch of Mother and Daugh-ter Looking at the Baby*

c. 1905. Pastel, 36½ × 29½″
Maier Museum of Art
Randolph-Macon Woman's College
Lynchburg, Virginia

This sketch was acquired by the American collector Payson Thompson, who, like Ambroise Vollard, was especially interested in Cassatt's drawings, sketches, and unfinished works. Thompson visited Cassatt's studio and she inscribed the work to him, but he actually bought it from Durand-Ruel, in accordance with Cassatt's long-standing contract with that gallery.

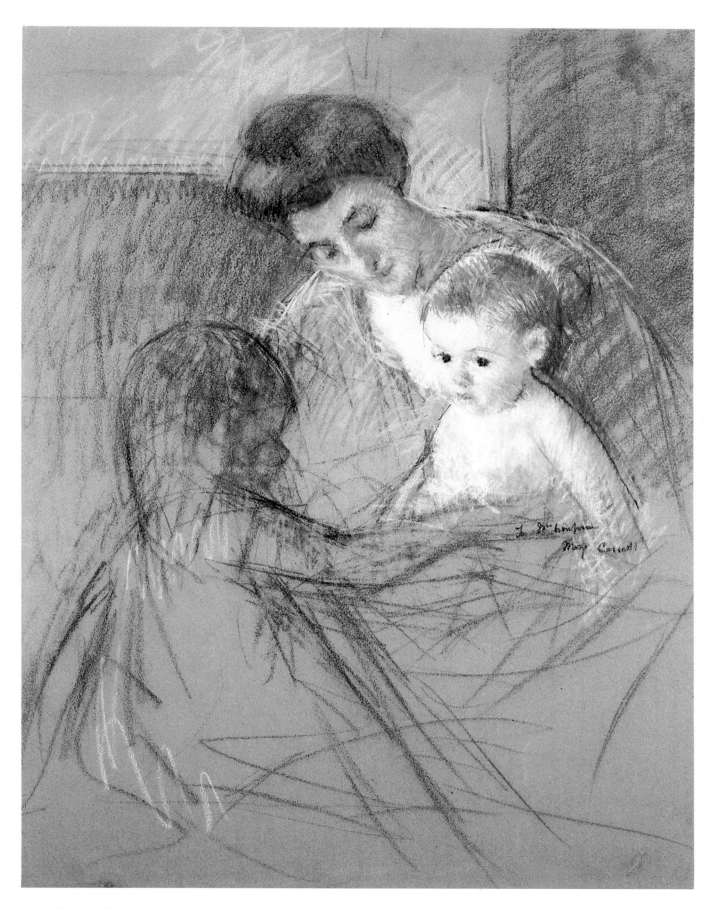

123 *Sketch of Mother and Daughter Looking at the Baby*

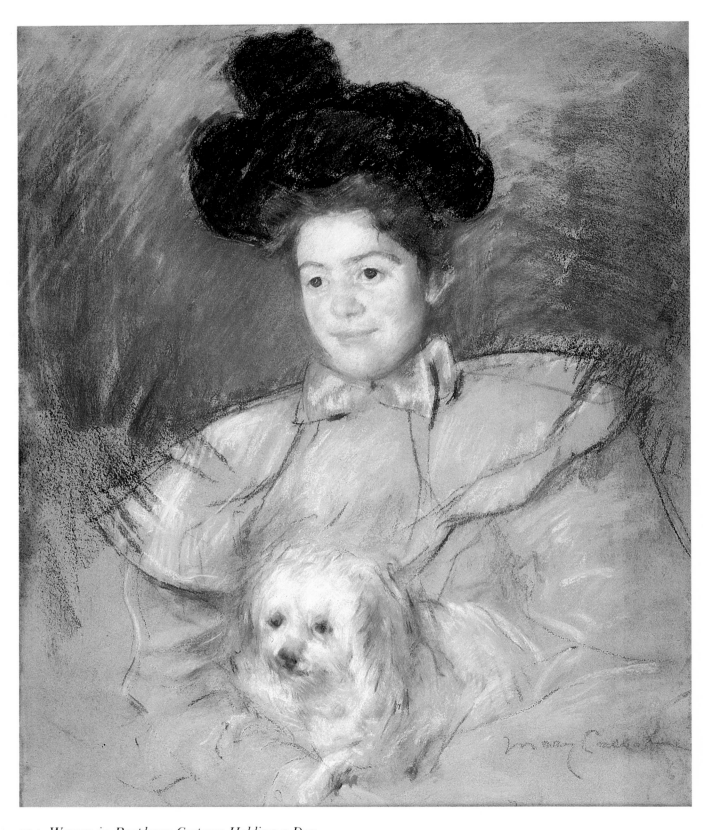

124 *Woman in Raspberry Costume Holding a Dog*

ble by the liberation of style initiated by Matisse and the Cubists. The attention paid to the twists and turns of a hat like the one in *Françoise in a Very Big Hat, Trimmed with Ribbon Flowers* (fig. 125) borders on the spirit behind the distortions in more radical works.

Despite the correspondences between her work and the radical styles of her day, Cassatt cannot be considered an active participant in the continuing experiments with artistic form. She steadfastly continued on her own course, painting the portraits, figure studies, and mother and child subjects that interested her most. For her, figure painting was the apex of artistic achievement. She wrote that her answer to a friend who asked why America's landscapes were better than its figures, and why there were more of them, would be: "I will tell her how much easier it is to paint and especially to draw a landscape, & how much our modern painters use the camera. And what a long apprenticeship is needed to make a figure painter."

In Cassatt's late work the drawing of the figure was no longer consistently fine, but she always brought a magic touch to some part of the composition. In her pastel technique Cassatt was still capable of kindling a glow within the layers of pigment, as the delicate play of light on the child's face and dress in *Young Girl Reading* (fig. 127) poignantly attests. In her portraits Cassatt's control over the medium is seen to be even more forceful. The *Portrait of Charles Dikran Kelekian* (he was the son of her friend the art dealer Dikran Kelekian) sensitively combines smooth modeling in the face and almost abstract linearity in the costume (fig. 126). The lines of jacket, shirt, and tie, suggesting the slightness of the physical self, are as revealing as the gaze of the child's dark eyes.

Cassatt's process from sketch to finished pastel can be studied in two related works from the same year as Charles Kelekian's portrait: *Sleepy Baby* and *Baby John on Mother's Lap* (figs. 128, 129). The sketch shows the familiar dynamic scumbled line with which Cassatt effects her rapid outlining of the subject; the activity of the line extends into the background as Cassatt immediately thereafter works out the relation of figure and setting. In the finished pastel, however, the strokes are short and nervous, and in the background the lines have been tamed into a light parallel hatching that covers the entire surface. The colors are somewhat unusual in the brilliance of the pink and blue combination, and Cassatt's eye for abstract design once more leads to an interesting pattern of intersecting arms and hands.

It was at the end of the decade that Cassatt produced one of her most ambitious works, *Two Mothers and Their Nude Children in a Boat* (fig. 130), which was hailed as a masterpiece by contemporary critics. Cassatt was praised for her skillful portrayal of the varied moods, for her psychological interpretation of each one of the individuals that make up the painting's design. The painting was purchased by James Stillman, a leading American banker who had moved from New York to Paris in 1909 and had become a friend and frequent companion of Cassatt's. Among their shared interests was a love of touring the countryside, especially the south of France. Like the Havemeyers, Stillman was eager for Cassatt's advice on acquiring works of art for his collection (which eventually included over a score of her works).

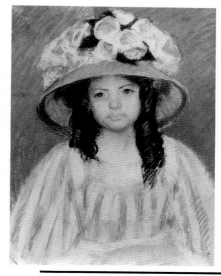

125 *Françoise in a Very Big Hat, Trimmed with Ribbon Flowers*

c. 1908. Pastel, 23½ × 17¾″
Henry E. Huntington Library and Art Gallery
San Marino, California

124 *Woman in Raspberry Costume Holding a Dog*

c. 1901. Pastel, 28⅞ × 23½″
Hirshhorn Museum and Sculpture Garden
Smithsonian Institution, Washington, D.C.

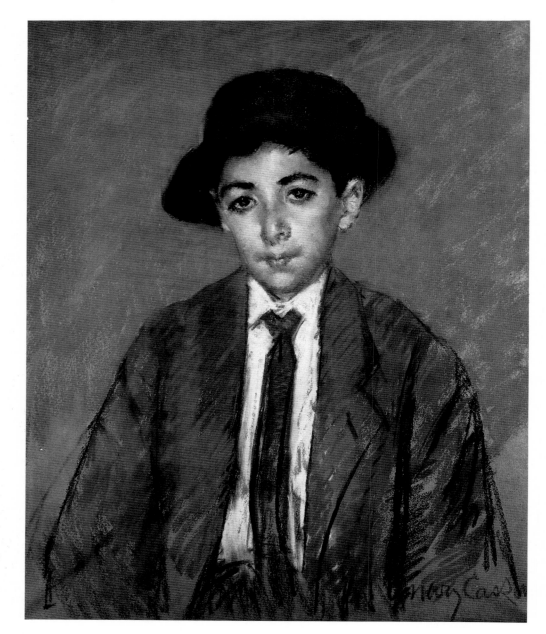

126 Portrait of Charles Dikran Kelekian

1910. Pastel on tan paper, 26 × 20½″
Collection Mrs. Charles D. Kelekian

Charles's father, the American art dealer Dikran Kelekian, became friendly with Mary Cassatt and Louisine Havemeyer around 1910. His knowledge of the Middle East through his trade in Persian art objects was helpful to Mary and her brother Gardner in the planning of their trip to Egypt in 1910–11.

127 Young Girl Reading (Fillette en Robe Bleue)

c. 1908
Pastel on oatmeal paper, 25⅝ × 19¾″
Seattle Art Museum
Gift of Mr. and Mrs. Louis Brechemin

A series of pastels and paintings using the young model Françoise (see also fig. 125) was Cassatt's major interest in the year after her last trip to the United States, in 1908–9.

Disciplined and tireless when it came to her art, Cassatt had worked steadily and with great concentration from her earliest student days. As the head of a household that included her aging father and mother and her ailing sister, Lydia, she had been no less dedicated an artist for being a devoted nurse and companion to them through their final illnesses. In these later years she had to cope not only with further bereavement (her beloved older brother, Aleck, died in 1906) but with her own physical problems. A two-year period when she could do no work at all began in 1911 following what had begun as a pleasure trip. In December 1910 she had embarked on a long journey through the Mediterranean and up the Nile with her brother Gardner, his wife, and their two daughters. Gardner became ill and died a few months later in Paris, on April 5. Cassatt was overwhelmed by her loss and exhausted by the rigors of the expedition.

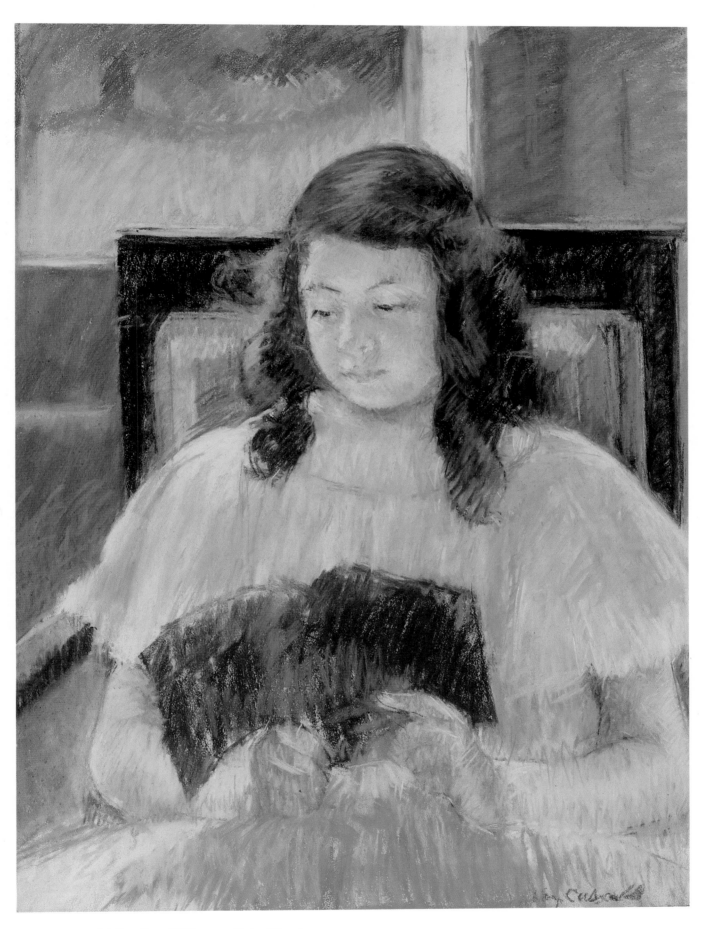

127 *Young Girl Reading (Fillette en Robe Bleue)*

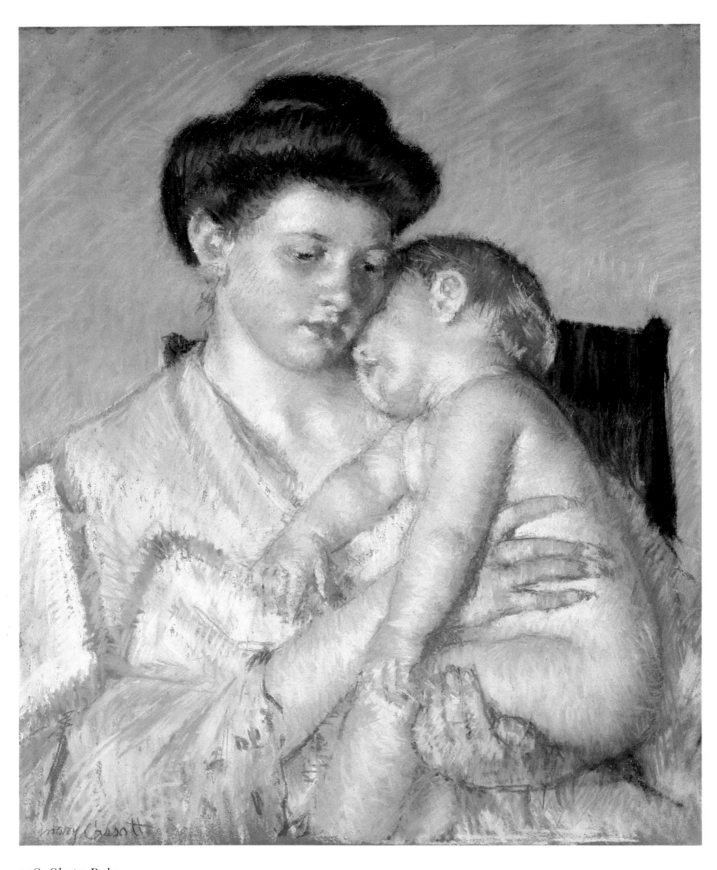

128 *Sleepy Baby*

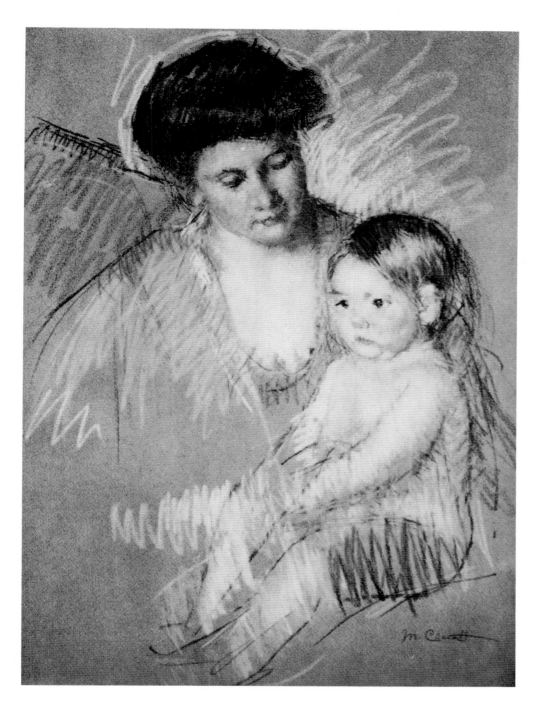

129 *Baby John on Mother's Lap*

1910. Pastel, 31 × 23½"
Collection Fisher Governor Foundation
Marshalltown, Iowa

Her biographer Achille Segard thought
that Cassatt was at the height of her powers
when he interviewed her at Beaufresne in
1912. In pastels like this one he saw a
union of design and content; her idea of
the love between mother and baby he found
to be "in intimate accord with the elegance
of her lines, the arabesques which part and
are rejoined, the delicate tonalities and the
caress of her brush."

128 *Sleepy Baby*

c. 1910. Pastel, 25½ × 20½"
Dallas Museum of Fine Arts
Munger Fund

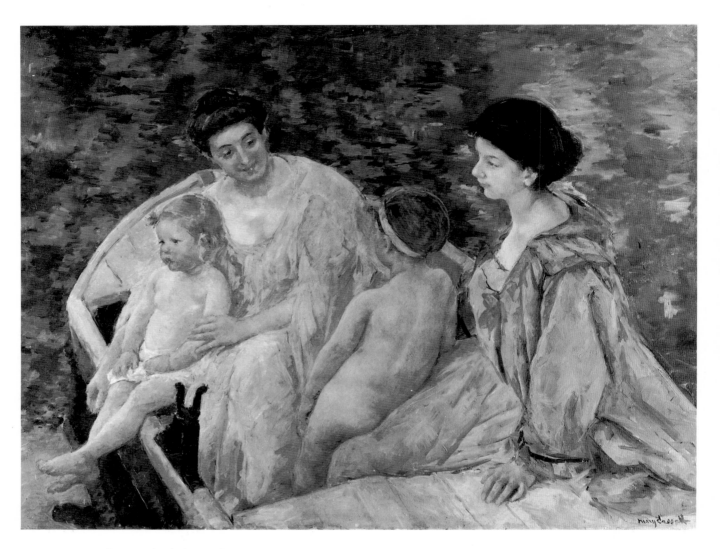

130 *Two Mothers and Their Nude
Children in a Boat*

1910. Oil on canvas, 38⅞ × 50¾″
Musée du Petit Palais, Paris

131 *Mother and Child*

1914. Pastel, 32 × 25⅝″
The Metropolitan Museum of Art, New York
Bequest of Mrs. H. O. Havemeyer, 1929
The H. O. Havemeyer Collection

This pastel and Young Woman in
Green, Outdoors in the Sun *(fig. 132)
were completed in the winter of 1914 in
Grasse, where Cassatt rented a villa.*
Mother and Child *was exhibited in the
Suffrage Loan Exhibition held in New
York the following spring. Mrs. Have-
meyer, the organizer of the event, praised it
as "the most appealing as well as the most
masterly" of Cassatt's latest works.*

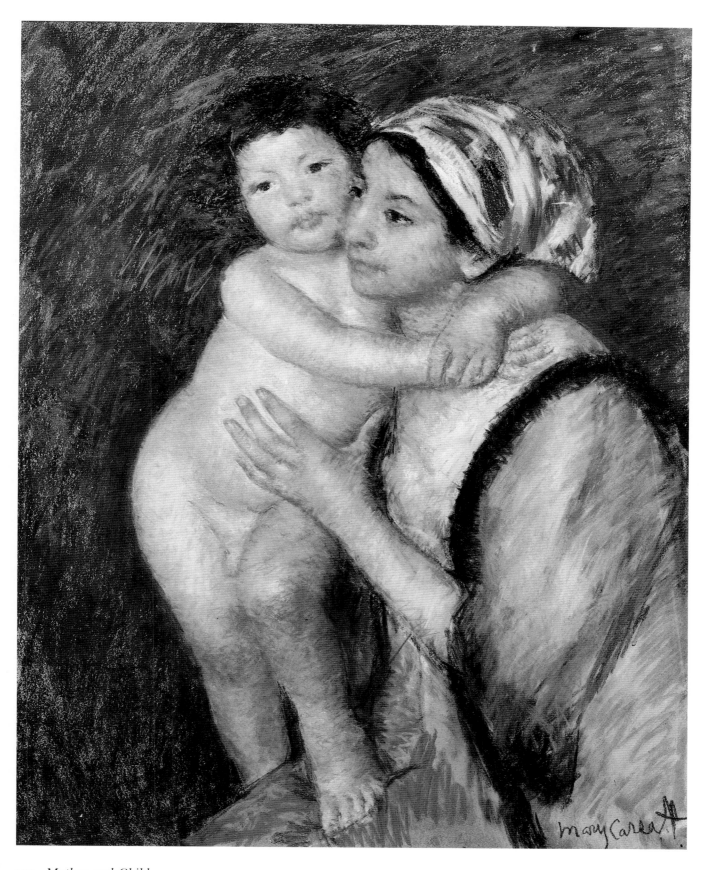

131 *Mother and Child*

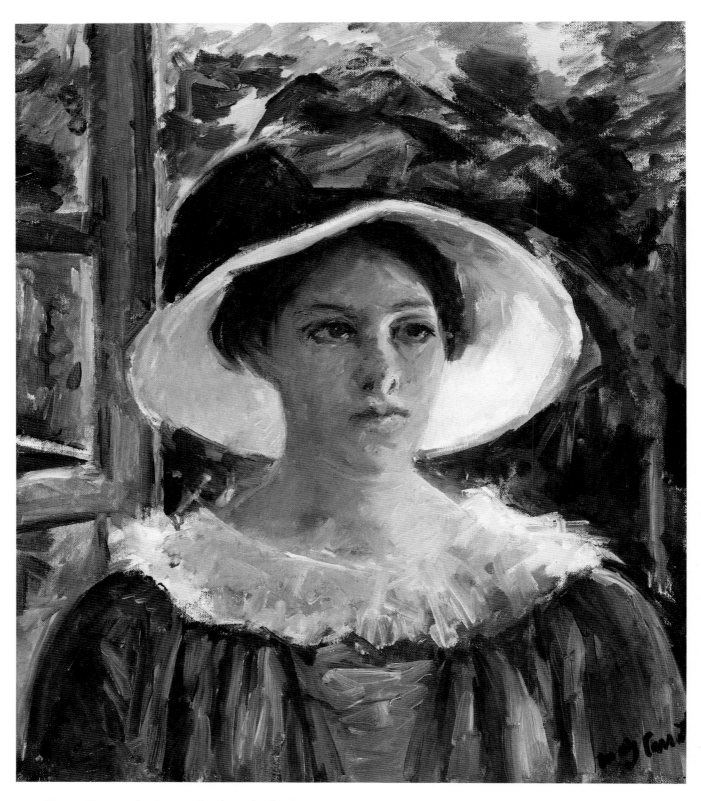

132 *Young Woman in Green, Outdoors in the Sun*

Recovering from the emotional and physical strain of the Egyptian trip and its aftermath, Cassatt slowly returned to her art. In the years from 1912 to 1915, when she finally had to abandon it, her work was more sporadic than it had ever been. These were stressful years: in a Europe where war clouds were gathering, Cassatt was struggling with the problem of declining vision. In such works of this period as *Mother and Child* and *Young Woman in Green, Outdoors in the Sun* (figs. 131, 132) there is an understandable loss of technique. In the pastel the strokes have a random quality and in the oil there is a lack of precision. Yet despite certain weaknesses, Cassatt's late work continued to garner praise and to be exhibited and sold. She herself was confident that her latest work was her strongest.

Five of these oils and pastels—including the *Mother and Child* and the *Young Woman in Green, Outdoors in the Sun*—were shown in an exhibition in New York that was close to her heart and to her convictions. This was the *Suffrage Loan Exhibition of Old Masters and Works by Edgar Degas and Mary Cassatt* held at M. Knoedler & Co., New York, April 7–24, 1915. The idea came from Louisine Havemeyer, who was deeply involved in the American suffrage movement. The purpose of the exhibition was to gain the support of the art-collecting circles of New York for the suffrage effort through admission fees and actual sales of some of the works. Despite the best efforts of both Cassatt and Havemeyer, the exhibition failed in its fund-raising purpose. But it was a landmark event in that it demonstrated the feasibility of the idea shared by the artist and the collector who were the prime movers: that the nineteenth-century moderns could be exhibited together with their heroes and forerunners, the European old masters. Cassatt quailed at her own presumption in showing her work along with that of Degas (even more, Titian and Correggio) but agreed because of the paramountcy of the cause. At one point her efforts in behalf of the exhibition brought Cassatt full circle back to the beginning of her pivotal association with Degas; in a letter appealing to a collector to lend his Degas to the exhibition she wrote: "The sight of that picture may be a turning point in the life of some young American painter. The first sight of Degas pictures was the turning point of my artistic life."

There were now eleven years remaining to Cassatt, years that were largely taken up with art though she was no longer a practicing artist. She kept up with her friends in the art world, and she oversaw the placement of her works, as well as Degas's, in appropriate collections. She watched the market assiduously for her own work and that of her former colleagues and did whatever she could to direct these works toward American museums and collections. An outstanding example is *Lady at the Tea Table* (fig. 52), which Cassatt had put aside in 1886 after it was rejected by the sitter's family. She had come across it in 1914, when she was gathering works to go in an exhibition Durand-Ruel was holding in Paris in June of that year. When it was shown, both the Luxembourg and the Petit Palais bid for it. But Cassatt sent it the next year to the suffrage exhibit in New York, and when the Metropolitan Museum of Art also made a bid, she chose to have it stay in her own country.

132 *Young Woman in Green, Outdoors in the Sun*

1914. Oil on canvas, 27¹¹⁄₁₆ × 18¼"
Worcester Art Museum, Massachusetts
Gift of Dr. Ernest G. Stillman

133 *Jeannette Leaning Against Her Mother*

c. 1901 (printed 1923)
Drypoint, 9¾ × 6¾″
Philadelphia Museum of Art
Given by Mrs. Charles P. Davies and
Gardner Cassatt in memory of Mary Cassatt

Cassatt, to the end, believed that this drypoint (and the rest of the series of 25) had not been printed before 1923—a misjudgment, as comparison with fig. 134 demonstrates. In the course of the controversy over this issue, Cassatt wrote with great feeling to William M. Ivins, curator of prints at the Metropolitan Museum of Art, "But I have had a joy from which no one can rob me—I have touched with a sense of art some people once more—They did not look at me through a magnifying glass but felt the love & the life.... Can you offer me anything to compare to that joy to an artist—"

A flurry surrounding Cassatt's work occurred in 1923, when a set of copperplates that had drypoint designs worked on them came to light; they had been in storage for over twenty years. Not depending on her own unreliable eyesight, she showed them to an artist friend who was also an engraver and to her printer, both of whom found evidence that the plates had not been printed. On this basis Cassatt had six sets printed; two were sent to Mrs. Havemeyer, who showed them to William M. Ivins, curator of prints at the Metropolitan. That Cassatt had been ill advised was at once apparent to him, as it must be to anyone who compares the earlier and later impressions of a subject in this set, for example, *Jeannette Leaning Against Her Mother* (figs. 133, 134). The later printing is clearly from a "worn out" plate; many of the more delicate lines have been worn away and the major lines have become weaker. However, Cassatt was unable to accept Ivins's negative judgment, which seemed to her to impugn her motives in offering the new printing, and became incensed at him and at Mrs. Havemeyer. The reprinting of these plates, while not contributing to the body of Cassatt's work, certainly added problems to Cassatt print connoisseurship. Far worse, the incident led to Cassatt's breaking off with her beloved lifelong friend, who had been the intermediary in this situation.

This same impatience and impetuousness, now exacerbated by the frustrations of ill health, had often dictated the course of her career, from her entry into the Pennsylvania Academy of the Fine Arts in 1861. Her passion for her art led her at the age of fifteen to the be first to register for the fall term at the Academy; it impelled her to travel throughout Europe pursuing the training and inspiration she needed for artistic excellence; it led her to install herself in Paris to battle for her place in the art capital of the world; and it inspired her to turn her back on the Salon in favor of the small exhibitions of a group of radicals. For the rest of her career she continued to make choices that suited her fierce personal and artistic independence—in abandoning Impressionism, in taking on the challenge of color prints and murals, and in distinguishing herself in the highly populated field of mother and child painting. She was one of the most important connoisseurs of her day and directed the course of several major private art collections. She was embraced by her contemporaries, including the preeminent artists and writers of the nineteenth century. But her most extraordinary accomplishment, the one that she dared not hope for, was in achieving a lasting place in the history of art.

134 *Jeannette Leaning Against Her Mother*

c. 1901. Drypoint, 9¾ × 6¾″
The Library of Congress, Washington, D.C.

134 *Jeannette Leaning Against Her Mother*

Biographical Outline

1844 Mary Stevenson Cassatt is born on May 22 in Allegheny City, Pennsylvania (now part of Pittsburgh).

1850–55 With her family, travels in Europe, spending long periods in Paris, Heidelberg, and Darmstadt.

1855–60 Returns from abroad with family and lives at home in Lancaster County, Pennsylvania, and then in Philadelphia.

1860–62 Attends classes at the Pennsylvania Academy of the Fine Arts in Philadelphia.

1863–65 Studies art on her own and maintains sporadic contact with the Pennsylvania Academy while living with her family near West Chester, Pennsylvania.

1866 (or late 1865) Travels to Paris, where she studies with Charles Chaplin and Jean-Léon Gérome and copies masterworks at the Louvre.

1867–70 Studies genre painting with Edouard Frère, Paul Soyer, Thomas Couture in art colonies outside Paris and travels in Italy (summer of 1870 in Rome).

1868 Her first painting is accepted for the Salon (*A Mandolin Player*).

1870–71 Returns home to the United States owing to the outbreak of the Franco-Prussian War and lives with her family in Philadelphia and Hollidaysburg, near Altoona. Travels to Pittsburgh and Chicago, where she tries, without success, to sell her paintings.

1872 Travels to Italy with her friend Emily Sartain and spends eight months in Parma, copying paintings by Correggio and studying printmaking with Carlo Raimondi.

1872–74 Paints in Seville, Antwerp, Paris, and Rome, submitting works to the Salon and to exhibitions in the United States.

1874 Her painting *Ida*, shown in the Salon, impresses Degas. Meets Louisine Elder (later Mrs. H. O. Havemeyer).

1875 Is settled in Paris, after spending summer in Philadelphia. Catches first glimpse of Degas's work, a turning point in her life.

1877 Is invited by Degas to exhibit with the "Independents," soon to be known as the Impressionists. Her parents and her sister, Lydia, come to live with her in Paris.

1879 Participates for the first time in an Impressionist exhibition (the fourth), presenting eleven works.

1880 Participates in fifth Impressionist exhibition. Visit of her brother Alexander with his wife and four children makes her nieces and nephews (who spend the summer with their grandparents and aunts in their country house outside Paris) available as models.

1881 Participates in sixth Impressionist exhibition.

1882 Her sister, Lydia, dies of Bright's disease November 7.

1886 Participates as both organizer and exhibitor in the eighth and last Impressionist exhibition. Is represented in Durand-Ruel's exhibition of Impressionist works held in New York.

1889 Exhibits with the Société des peintres-graveurs français.

1890 Exhibits for the second time with the Société des peintres-graveurs français.

1891 Excluded (as a non-French artist) from showing with the Société des peintres-graveurs français, shows ten recently completed color prints, together with four mother and child paintings and pastels, at the Durand-Ruel gallery—her first solo exhibition. Her father, Robert Simpson Cassatt, dies December 9.

1892 Receives commission for a *Modern Woman* mural to decorate a tympanum of the Hall of Honor of the Woman's Building of the 1893 World's Columbian Exposition in Chicago and spends the summer and fall working on it.

1893	In January, ships *Modern Woman* mural to Chicago. In November is given her first major showing (her second solo exhibition) by Durand-Ruel in Paris.
1894	Purchases and renovates the Château de Beaufresne (her country home for the rest of her life) at Mesnil-Théribus, fifty miles northwest of Paris.
1895	Her first major solo exhibition in her native country is held at the Durand-Ruel gallery in New York. Her mother, Katherine Kelso Cassatt, dies October 21.
1898–99	Returns to the United States for her first visit in over twenty years.
1899	Her brother Alexander becomes president of the Pennsylvania Railroad.
1901	Joins her friends Louisine and Henry O. Havemeyer in a collecting trip to Italy and Spain.
1904	Is named a Chevalier of the Legion of Honor.
1906	Her brother Alexander dies December 28.
1908–9	Makes her last trip to the United States.
1910–11	Joins her brother Gardner and his family in a trip to Egypt, during which Gardner contracts an illness that causes his death on April 5, 1911.
1913	Is the subject of Achille Segard's book *Mary Cassatt, Un Peintre des enfants et des mères*.
1914	Soon after the outbreak of World War I, leaves Beaufresne and retreats to the south of France because of the fighting near Mesnil-Théribus. Is awarded Gold Medal of Honor by the Pennsylvania Academy of the Fine Arts.
1915	Participates in the *Suffrage Loan Exhibition of Old Masters and Works by Edgar Degas and Mary Cassatt*, held at the gallery of M. Knoedler & Co. in New York, in support of the cause of women's suffrage.
1923–24	Becomes embroiled in a controversy over a set of her drypoints mistakenly thought by her never to have been printed, and becomes estranged from Louisine Havemeyer, her close friend since 1874.
1926	Dies at Beaufresne June 14.

Photograph Credits

The author and the publisher thank the museums, galleries, libraries, and private collectors who permitted the reproduction of works of art in their possession and supplied the necessary photographs. Other sources of photographs (listed by page number) are gratefully acknowledged below.

Allen Studio, Middleburg, Va., 24; Henry B. Beville, Annapolis, Md., 7; E. Irving Blomstrann, New Britain, Conn., 74; Joan Broderick, Philadelphia, 129; Will Brown, Philadelphia, 40, 53; J.E. Bulloz, Paris, 36, 125, 146; Chisholm-Rich & Assoc., Houston, 54; Christie's, New York, 26, 34; Coe Kerr Gallery, Inc., 28, 52; Durand-Ruel, Paris, 116; Helga Photo Studio, Upper Montclair, N.J., 84 (Courtesy Hirschl & Adler Galleries), 138; Hirschl & Adler Galleries, New York, 22; Jim Keller, San Antonio, 134; McNabb Studio, Winston-Salem, N.C., 137; Joan Michelman, Ltd., New York, 96; Eric Mitchell, Philadelphia, 63; David F. Penney, Des Moines, 87; John D. Schiff, New York, 142; Richard A. Stoner, Greensburg, Pa., 136; Todd A. Weier, Columbus, Ohio, 131; David Wharton, Dallas, 144.

Selected Bibliography

BOLLER, WILLY. *Masterpieces of the Japanese Colour Woodcut*. London: Elek Books, 1957.

BREESKIN, ADELYN DOHME. *Mary Cassatt: A Catalogue Raisonné of the Oils, Pastels, Watercolors, and Drawings*. Washington, D.C.: Smithsonian Institution Press, 1970.

————. *Mary Cassatt: A Catalogue Raisonné of the Graphic Works*. Second edition, revised. Washington, D.C.: Smithsonian Institution Press, 1979.

CARTER, S.N. "Exhibition of the Society of American Artists," *The Art Journal*, vol. 5 (1879), p. 157.

CHIPP, HERSCHEL, with Peter Selz and Joshua C. Taylor. *Theories of Modern Art: A Source Book by Artists and Critics*. Berkeley: University of California Press, 1971, p. 92.

DAVIS, PATRICIA T. *End of the Line: Alexander J. Cassatt and the Pennsylvania Railroad*. New York: Neale Watson Academic Publications, Inc., 1978.

HALE, NANCY. *Mary Cassatt*. Garden City, New York: Doubleday & Company, 1975.

[HAVEMEYER, LOUISINE W.] "Mrs. H.O. Havemeyer's Remarks on Edgar Degas and Mary Cassatt: Address delivered by Mrs. H.O. Havemeyer at Loan Exhibition Tuesday, April 6th, 1915" [p. 2].

HAVEMEYER, LOUISINE W. *Sixteen to Sixty, Memoirs of a Collector*. New York: Privately printed, 1961.

HEMMINGS, F.W.J. *Culture and Society in France 1849–1898*. New York: Charles Scribners Sons, 1971.

HOUGHTON, WALTER E. *The Victorian Frame of Mind, 1830–1870*. New Haven: Yale University Press, 1957.

HUBER, CHRISTINE JONES. *The Pennsylvania Academy and Its Women, 1850–1920*. Philadelphia: Pennsylvania Academy of the Fine Arts, 1974.

HUYSMANS, J.K. *L'Art Moderne*. Paris: G. Charpentier, 1883, p. 232.

IVES, COLTA FELLER. *The Great Wave: The Influence of Japanese Woodcuts on French Prints*. New York: The Metropolitan Museum of Art, 1974.

JAMESON, ANNA. *Legends of the Madonna as Represented in the Fine Arts*. London: Longmans, Green & Co., 1909.

LAFENESTRE, GEORGE. "Les Expositions d'Art," *Revue des deux mondes*, May–June, 1879, p. 481.

LINDSAY, SUZANNE G. *Mary Cassatt and Philadelphia*. Philadelphia: Philadelphia Museum of Art, 1985. (Exhibition catalogue.)

MATHEWS, NANCY MOWLL, ed. *Cassatt and Her Circle: Selected Letters*. New York: Abbeville Press, 1984.

MATHEWS, NANCY MOWLL. *Mary Cassatt and Edgar Degas*. San Jose, California: San Jose Museum of Art, 1982. (Exhibition catalogue.)

NOCHLIN, LINDA. *Impressionism and Post-Impressionism 1874–1904: Sources and Documents*. Englewood Cliffs, New Jersey: Prentice-Hall, Inc., 1966, p. 24.

QUICK, MICHAEL. *American Expatriate Painters of the Late Nineteenth Century*. Dayton: The Dayton Art Institute, 1976.

REWALD, JOHN. *The History of Impressionism*. New York: The Museum of Modern Art, 1961.

SEGARD, ACHILLE. *Mary Cassatt, Un Peintre des enfants et des mères*. Paris: Librairie Paul Ollendorf, 1913, pp. 184–85.

SHAPIRO, BARBARA STERN. *Mary Cassatt at Home*. Boston: Museum of Fine Arts, 1978.

SWEET, FREDERICK. *Miss Mary Cassatt, Impressionist from Philadelphia*. Norman: University of Oklahoma Press, 1966.

TRUDGILL, ERIC. *Madonnas and Magdalens: The Origins and Development of Victorian Sexual Attitudes*. New York: Holmes & Meier, 1976.

WAERN, CECILIA. "Some Notes on French Impressionism," *Atlantic Monthly*, April 1892, p. 535.

WATTENMAKER, RICHARD J. *Puvis de Chavannes and the Modern Tradition*. Toronto: Art Gallery of Ontario, 1975.

Index

Page numbers printed in *italic* refer to the illustrations.

37, 62, 100, 107; mother and child, *see* mother and child motif in the work of; nudes, 63, 80; opera and theater scenes, 38, 40, 43, 46, 47, 48, 69, 92; *toilettes*, 55, 63, 80, 82; tree of knowledge, 86, 89; women, 23, 62, 63, 75, 80, 82, 89, 94 (contemplative, 91–92; picking fruit, 86, 89, 91; sewing, 57, 59, 63); *see also* genre paintings by

mural of, 69, 82, 84–86, 91, 92, 97, 118, 121; works based on, 85–86, 89, 91–92, 110, 135

mysterious quality in the work of, 107

national (American) identity of, 46, 47

naturalism in the work of, 35, 43

in New York, 118

old master art, interest in, 121, 124, 125, 129

painterliness in the late work of, 121, 123, 124, 127

in Paris, 9, 13–14, 26, 29, 30, 33, 57, 66, 114, 129

Paris art establishment and, 9, 14, 29, 69, 131

in Parma, Italy, 9, 14, 20, 23, 30

Parma style of, 7, 18

pastels by: Impressionist, 43, 45, 50, 52, 59, 60, 63, 69, 72; late period, 124, 125, 127, 128, 135, 141, 145; mature period, 72, 75, 91, 92, 107, 109, 110, 113, 114, 116, 117, 118

at the Pennsylvania Academy of the Fine Arts, 10–11, 13, 55, 84, 131

personality of, 9, 45, 62, 150

in Philadelphia, 9, 10, 11, 13, 19, 117

photographs of, *4, 6, 106*

photography, attitude toward, 121

plein air settings in the work of, 50, 57, 59, 110, 113

popularizing style of, 37

portraits by: early period, 20, 23, 24, 25, 26, 29, 30; family, 24, 25, 29, 35, 37, 50, 55, 57, 59, 60, 62, 63, 70, 75, 97, 100, 102, 113, 117; Impressionist, 33, 35, 37, 43, 45, 50, 52, 55, 57, 59, 60, 62; late period, 121, 141; mature period, 69, 75, 104, 109, 113, 114, 116, 117, 118; of men, 37; serial, 75

portraits of (Degas), 45, 52, 109–10; *37*

as printmaker, 43, 46, 47, 50, 52, 55, 69, 70, 79, 80, 82, 89, 91, 110, 150

psychological implications in the work of, 13, 43, 92, 94, 97, 109, 125, 129, 141

public art of, 82, 84, 135

realism in the work of, 37, 43, 48, 125

reductionism in the work of, 70, 72, 79

rejection of academic techniques, 11, 19, 23–24, 29, 30, 35, 37, 52, 66

religious overtones in the work of, 75–76, 97

in Rome, 19, 29, 30, 33

the Salon and, 7, 13, 14, 18–19, 23, 26, 29–30, 35, 69, 131

in Septeuil, France, 75

serial approach to painting, 75, 97

series of ten color prints, 76, 79, 80, 82, 84, 97

severe style of, 62–63, 70

in Seville, Spain, 16, 20, 24–26, 30

Seville period of, 26

social and cultural concerns of, 121

as social critic, 47

social life of, 11, 43, 46–47, 97, 100, 129, 135–36

space and proportion in the work of, 124–25, 127

in Spain, 16, 18, 19, 20, 24–26, 29, 30, 124

spiritual qualities in the work of, 72, 76, 125

still-life painting by, 57

success and recognition: for early work, 7, 9, 13, 16, 18, 24, 30; financial, 97; for late work, 121, 150; for mature work, 82, 118; as a printmaker, 52, 82

sunlight and open air in the work of, 50, 57, 62, 63

support from Degas, 29–30, 62, 63, 66, 85

ugliness vs. beauty in the work of, 66, 92, 94

vase painting by, 129; *110*

in Villiers-le-Bel, France, 14, 18

visits to America, 24, 30, 33, 110, 114, 117, 118, 121, 127, 142

writings of, 25–26, 30, 109

Cassatt, Robert Kelso (Robbie), 52, 57, 63; portraits of, 52, 57, 59, 62–63, 97; *44, 53, 54*

Cassatt, Robert Simpson: correspondence of, 35, 48, 60, 63; death of, 97, 100; family background of, 9; move to Paris, 35, 55, 59; portraits of, 20, 37; support for Mary, 13; travels of, 9

ceramic painted vase, 129; *110*

Cézanne, Paul, 114

Chaplin, Charles, 14, 29

Chase, William Merritt, 118

Chateau de Beaufresne, Mesnil-Théribus, France, 48, 97, 100, 109, 114, 138, 145

Chauvet, Renée, 138; paintings of, 135, 138; *121, 122, 123*

Chicago, 69, 82; Fire of 1871, 20

Child in a Green Coat, 127, 132; *117*

Child in Orange Dress, 127, 128; *113*

Children Playing with a Cat, 135; *121*

Child with Red Hat, 128, 132; *118*

Civil War, 13

Clarissa Turned Right with Her Hand to Her Ear, 91–92; *84*

Coiffure, The, 79, 80; *69*; preliminary drawing for, 79; *67*

Collins, Alfred Q., 30

Conversation (Two Sisters), The, 109; *94*

Coronation of the Virgin (Correggio), 23

Correggio (Antonio Allegri), 9, 20, 23, 72, 84, 149

Courbet, Gustave, 9–10, 29, 98

Couture, Thomas, 16, 18, 30

Cubists, 141

Cup of Tea, The, 50, 57; *43*

Current Literature magazine, 131

Debucourt, Philibert-Louis, 79

Degas, Edgar, 47, 62, 94; artistic methods of, 38, 60; artistic philosophy and style of, 37, 63, 66; *At the Louvre: Mary Cassatt in the Etruscan Gallery*, 45, 52, 109–10; *37*; boycott of Impressionist exhibitions by, 60, 62; Cassatt and, 29–30, 33, 35, 37, 45, 46, 48, 52, 62, 63, 66, 85, 114, 129; classicism in the work of, 63; as collector, 66; correspondence of, 48; death of, 66; exhibitions of the work of, 40, 50, 63, 149; friendships of, 29, 33, 45, 114, 129; Impressionism and, 33, 35, 37, 40, 45, 63; influenced by Japanese prints, 79, 80; influence on Cassatt, 33, 35, 37, 38, 43, 45, 55, 149; *Le Jour et la nuit* and, 50, 52, 69; in Louisiana, 20; motifs of, 45, 109–10; portrait of (Cassatt), 37; as printmaker, 43, 50, 52, 69, 70, 79; review of the work of, 50; sales of the work of, 33; the Salon and, 33; Synthetism and, 72

Déjeuner sur l'herbe, Le (Manet), 59

Delacroix, Eugène, 9

Deliverance of Leyden from the Siege by the Spaniards under Valdez in 1574, The (Wittkamp), 10, 11; *3*

Desboutin, Marcellin, 37

Divisionism, 135